Interrupted
Aria

Interrupted Aria

The First Baroque Mystery

Beverle Graves Myers

Poisoned Pen Press

Poisoned Pen Press
6962 E. First Ave., Ste. 103
Scottsdale, AZ 85251
www.poisonedpenpress.com
info@poisonedpenpress.com

Printed in the United States of America

For Lawrence

Part One–*Canzona*

Chapter 1

Bad luck that my first glimpse of Venice was marred by an insult.

"Capons, worthless twittering trash," wafted half-whispered toward us from a group of young merchants gathered at the rail of the small ship nearing the Porto di Lido. One pursed his lips in a pout and mimicked the fluttering of a fan while another extended his meaty hand in a limp-wristed gesture. They all laughed dismissively as they strolled farther up the deck.

Felice and I kept our eyes carefully lowered to the sparkling green water of the lagoon. It was not as though we hadn't had our share of sneers and remarks since leaving Naples, but they still rankled.

My friend and I were *castrato* singers. As young boys, we had been gelded for the sake of our beautiful, soprano voices which had then been trained to the pinnacle of technical brilliance by the most exacting voice maestros in Italy. At the Conservatorio San Remo, we had learned that we had the blessed Saint Paul to thank for our condition. "Let your women be silent in the churches," he had proclaimed. Generations of churchmen had taken that command to heart. Taking a leaf from the Persians' book, the papal choir directors had created *castrati*, not to serve as compliant slave boys, but to honor God with the closest approximation of heavenly voices that this earthly realm could produce.

Angelic *castrati* voices still filled the cathedrals, but every young eunuch at San Remo knew that the popular demand for our unique talents had shifted to the courts and opera houses. A talented *castrato* soprano was a valuable commodity, especially in mercantile cities like my Venice where every patrician was also a businessman and every citizen so infatuated with the opera that La Serenissima's theaters were packed to the rafters every night.

Naples had loved us. As students, we sang at festival masses in all the great churches and entertained the wealthy and powerful over banquets and intimate dinners. Neapolitans by the hundreds crowded the *conservatorio* theater for every concert. As our maestros marched us through the streets of the beautiful city on the bay, two orderly lines of well-scrubbed boys in the yellow-sashed San Remo uniform, we heard whispers of praise, not insults.

"Watch that little dark one there, the voice of a cherub" or "That one is divine. He will be another Farinelli."

On our own for the first time, Felice and I were just beginning to understand that the same people who applauded our singing from the lofty perspective of their theater boxes were often disgusted and embarrassed when confronted by physical reminders of how we acquired our luscious voices.

The merchants by the rail had started arguing about the price of Turkish tobacco, and I realized they had probably forgotten the two young singers so anxiously peering through the breezy, late autumn sunshine at our long awaited destination. What would Venice make of Tito Amato, her returning son? In this year of our Lord 1731, my musical training was complete, and I was headed home to sing at the Teatro San Stefano. The noble Viviani family had acquired the theater several years before and had spared no effort to make it one of the city's premier opera houses. The Governors of San Remo had negotiated my new position with theatrical agents scouting the Neapolitan schools for fresh singers to thrill the jaded Venetian audiences. Since I was obligated to repay San Remo for my years of training, I had

little say in the matter, but nevertheless, the prospect of returning home had tantalized me in a way I couldn't ignore.

When the maestros had given us their parting blessings, I had been fresh from a triumph in a student production and overflowing with the confidence that only sheer, untried youth can inspire. Now, as the golden towers and domes of Venice rose like a magic island on the horizon, I wondered what I could have been thinking. Venetian audiences had enjoyed the world's greatest singers: Farinelli, Caffarelli, Senesino. And Venetians weren't shy about demonstrating their disapproval if a singer failed to please. We had all heard tales of rotten fruit and tomatoes used as missiles, of shouting so loud a performer couldn't hope to make himself heard above it. A Venetian mob had once even swarmed over the orchestra, grabbed a foundering *castrato,* and thrown the unfortunate fellow in the stinking canal. My stomach began rumbling and my chest tightened as I wondered why I hadn't begged the maestros to let me stay in Naples to teach the younger boys, compose music, anything. Then I caught sight of Felice's tight expression and felt a pang of guilt. My worries paled in comparison to my friend's predicament.

Felice Ravello had come home with me on the slender hope of finding work as a chapel singer in one of Venice's many churches. Already past twenty, Felice had overstayed his training more than most. When I was exiled to San Remo, my friend had been a rosy-cheeked, cheerful scarecrow whose wrists and elbows were always poking out of his sleeves. He delighted in eluding the composition maestro and hiding in the back of the theater to hear the senior students rehearsing for upcoming productions. Felice would cheerfully take a beating if it meant he could lose himself in their ravishing voices for even a few minutes. Singing was Felice's overriding passion. While the rest of us watched the hourglass, waiting for the signal that would let us run and play ball in the courtyard, Felice begged for extra instruction. No exercise was too tedious or time consuming if my friend thought it would help him perfect his already remarkable soprano.

It was in our eighth year at the *conservatorio* that disaster struck. One morning, in the middle of a cadenza he could sing as easily as walking across the floor, Felice's golden throat failed him. His voice cracked. And kept cracking. Despite enforced rest, therapeutic exercises, and foul-smelling herbal concoctions painted on his tonsils by the school physician, Felice's vocal apparatus relentlessly coarsened and thickened. Sometimes it happened that way; the cutting we had both endured carried no guarantee.

I had watched helplessly as my friend's laughter faded and he spent more and more time in our third-floor sleeping room staring out the window or curled up under the bedcovers. The maestros shook their heads discouragingly. To his horror, Felice was advised to take up the harpsichord or the violin. He practiced those instruments under duress, but I knew that he had never stopped cosseting his rebellious throat or burning candles at the shrine of Saint Cecilia, praying for a miracle.

At the ship's rail, Felice nudged my arm and pointed to the island over the water. "Tito, this city is amazing. It glitters like the bishop's Easter headdress. What's that tower? That enormous one?"

I shaded my eyes with a flat hand. Still scarcely believing that I was nearing home, I answered in the bald tones of a travelers' guidebook. "It's the Campanile, the bell tower on the Piazza San Marco. The reflection off its gilded roof is visible for miles. The sailors use it to lead them to port."

"And those columns by the water's edge?"

"Platforms for Venice's patron saints. On the left is Saint Theodore with his crocodile. On the right, the golden lion of Saint Mark."

"I'm afraid I'll need the intervention of both if I'm to find work," he whispered, bowing his head slightly.

"Not losing hope, are you?"

Felice gripped the railing with whitened knuckles, then leaned back with an unconvincing laugh. "Not a bit. This northern climate will surely help my throat. Not dry and dusty like Naples,

but not too cold. It will limber up my vocal cords and, before long, I'll have more offers than I can handle."

I nodded and tried to match my smile to his bravado, but my old friend wasn't fooled.

"You must have a few worries of your own," Felice observed. "You spent half the night walking the deck."

"My family *is* much on my mind," I slowly admitted.

"Yes?" he prompted, interested in my affairs as always.

"It has been so many years since I've seen any of them. What if they are no more overjoyed at having a eunuch in their midst as our friends over there?" I nodded toward the group of merchants.

"You know Annetta will welcome you with open arms. Every time Maestro Norvello huffed and puffed up the stairs to deliver our mail, he complained that her fat letters would be the death of him."

Felice was speaking of my older sister, Anna-Maria Amato, my dear Annetta. Only eighteen months separated us, but she had become my vigilant caretaker after our mother died when I was five and Annetta barely seven. After we were separated, she wrote every week and I always answered right away. How I had longed to see her and actually talk back and forth without waiting on the post for replies.

Annetta had often written of our younger sister, Grisella. The girl must be half-grown by now, but the Grisella I remembered was a chunky, little redheaded demon given to breath-holding, foot-stomping tantrums. Our mother had died at Grisella's birth. To care for the baby, Father had hired a *bambinaia* who declared the nursery off limits to the rest of us and seemed jealous of any attention that anyone else showed the poor little mite. Annetta always said old Berta had kept Grisella a baby far too long.

Our older brother, Alessandro, was away on one of his far-flung trading journeys. He had started out as a young seaman, still in his teens, on a state-sponsored trading galley and had gradually amassed enough capital to begin taking small shares in

the various cargoes. Now a merchant in his own right, he was off trading in the Levant, but expected back by Christmas Day.

My father completed our small household. Of him, I refused to think.

We were making slow progress across the lagoon because our three-sailed tartan was hemmed in by a line of larger vessels headed for the quay by the customs house. Restless and excited, Felice and I left the rail and paced a futile, circular path among the crates and barrels stacking the deck. Our activity only served to draw more contemptuous glances from the merchants scrambling to organize their cargo.

Then I noticed a few stout gondolas rowing across the lagoon. On inquiry, I soon learned that they meant to collect passengers who were willing to pay premium price to get into Venice quickly. I slid my hand under my cloak and fingered the slender purse tucked in my waistcoat pocket. Though I'd spent carefully throughout our journey, expenses for the both of us had nearly made me a pauper. No matter, I'd soon be earning enough to refill my little purse. I made hurried arrangements to have our trunks sent on by porter, grabbed our hand luggage, and practically pushed Felice down the ladder that descended to a waiting gondola.

"I suppose you've never even seen one of these." I ducked under the striped canopy and slid onto a leather-cushioned seat as Felice clambered in clumsily behind me. After giving the gondolier directions to the Campo dei Polli, where my father kept a small house, I had to laugh at Felice's ungainly attempts to settle himself and his bag. "You will soon get used to it. A gondola will take you almost everywhere you go."

He shook his head uneasily. "I have a feeling that travel by boat is not the only new thing I'll be getting used to."

The gondolier on the stern joined in with the curiosity of his kind. His rough face could have been fashioned of leather and his voice was a phlegmy rasp. "What brings such fine young gentlemen from Naples, the Carnival? Do you need a place to

stay? Amusements? Games of chance? Anything you want, I can show you where to get it."

Felice and I traded apprehensive glances as I replied, "I've come to sing at the opera house, the San Stefano. I'm engaged for the season."

Still twisted around to face the rear of the boat, I felt my cheeks blushing as his bloodshot eyes made a detailed inspection of my features.

"Ah, *castrati!* New blood for the San Stefano. About time! Their old eunuch, Crivelli, is a bag of bones with a wheeze like an old consumptive."

Intrigued, I answered, "You follow the opera then."

He laughed into the brisk breeze. "If you have the voice, we rowers will be your greatest admirers. The theater managers give us all the tickets that haven't been sold by curtain time. In return, we bring in the foreigners, the visiting dignitaries, anyone who wants a break from the gaming houses and the balls. We all have our favorite singers to recommend."

I considered as I watched him sweep the large oar back and forth. I suspected he had known what we were from the moment we had stepped in the boat. Felice particularly was developing the telltale signs of a mature *castrato*: tall height, dangling arms, and barrel chest. As might be expected, his cheeks were beardless and his ruddy complexion was finely pored. Another benefit of the cutting, besides the all-important voice, was thick, luxuriant hair. Felice's head was covered with deep black waves that he'd pulled into a solitary bow at the back of his neck, but his other features were not so pleasing. His unfortunate nose, wide and fleshy, tended to overbalance his narrow mouth and black button eyes. Even when his voice had been at its peak, my friend had never been the object of gushing love notes, and overwrought Neapolitan ladies had seldom swooned during his San Remo performances. Still, my friend had a good, honest face which I had cherished ever since he had taken this lonely, confused Venetian under his wing so many years ago.

I turned back to our boatman. "What else can you tell me about the San Stefano?"

Squinting his eyes against the glare of the lowering sun, he scratched the wide belly just covered by a short, black wool jacket. "It's bringing in a lot of ducats for its patrons, the Viviani. And a good thing, too. The Viviani spend like they have a Spanish galleon with the lost gold of the Americas tied up at their water gate."

Though we were alone atop the flashing waves, the nearest boat barely within shouting distance, he dropped his voice to a whisper. "The Viviani just finished building a fourth level on their *palazzo*. Two cupolas sheathed in gold! How can this be? No other family has been able to build so grandly for twenty years or more."

I held the gondolier's gaze, but I had no interest in hearing any more about a patrician's ostentatious display. I had come to Venice purely in the service of music, so I asked the only question that mattered. "The Signor Viviani, is he a great opera lover?"

My gondolier snorted and gave me a shrewd grin. "Domenico Viviani loves one thing about the opera…the prima donna, Adelina Belluna. He displays La Belluna on his arm everywhere in the city. You see him toasting her in the cafés, covering her bets at the Ridotto, nuzzling her neck in a box at the theater. Oh, he's bold all right. They don't even bother to wear masks although it is Carnival and they could go about unnoticed if they wore the *bauta* and *moretta* like almost everyone else."

"But is that so unusual? Even in Naples, we hear tales of the carousing that goes on. That's why half of Europe comes to Venice to take part in the carnival festivities."

"Almost anything goes for the foreigners, especially the ones with heavy purses, but not the heads of noble houses. Venice might be rolling like a barrel hoop down the path to hell, but the Tribunal sets a high standard of conduct for our leaders. And don't think there still aren't spies behind every post and pillar. Domenico Viviani's very public sins have been noted. No doubt about that."

Our boat slid past the lacy arcades of the Doge's palace, then the heavier bulk of the Zecca, and we soon entered the Grand Canal. The heavy traffic on the canal claimed our boatman's attention; the rest of our journey passed in silence. Felice crouched in his seat, marveling wide-eyed as we darted around barges and just missed scraping the pavements that lined Venice's watery highway, while I fretted over the reception that awaited us. It seemed as if the open-air tunnel of balconied palaces would never end, but then, I wasn't sure I wanted it to. Finally, with the mellow light of impending dusk softening the marble angles of the great houses, we left the width of the Grand Canal and threaded through progressively narrowing channels. I began to notice refuse gathered in corners and porticoes. Stucco was peeling off damp, dirty walls. This was not how I remembered my city, the jewel of the Adriatic. Times must be even worse than my sister had hinted in her letters.

In a few minutes, the gondola came to rest at the bottom of a familiar *calle*. I tightened the grip on my bag.

"This is it, Felice," I said with a gulp. "We're finally home."

As we mounted the smooth, well-worn stones of the landing, I found my doubts and worries turning to excitement. In a moment I would be hugging Annetta! Last words from our gondolier followed us: "I'll be watching for you at San Stefano, young *castrati*. Make Venice proud!"

Chapter 2

Two rows of pinched, three-floored houses marched up the *calle* and split to encircle the Campo dei Polli, a small square at the end of the street. There, a group of boys kicking at a leather ball jostled around the central stone well which supplied the neighborhood with drinking water. Their shouts echoed around the *campo* and startled a flock of pigeons into flight. The lingering warmth of the day had failed to tempt anyone else outside; the stone benches under the square's single tree were vacant. Like a hundred other *campi* in this district, my boyhood home displayed the humbler, more domestic face of Venice. The glorious spires and towers of the Piazza San Marco that had dazzled Felice as we entered the city were not so distant in space, but were a thousand miles removed in tone and mood.

Felice set his bag down and cleared his throat. "Which house is yours, Tito?"

I looked around, fighting a wave of foolish confusion. Which house was it? The square surrounded us with a hodgepodge of dingy plaster façades that each looked equally strange and familiar. Was it that one with the small balcony, or the next one with the withered vines hanging from a window box which should have been taken in weeks ago? Drawing a large breath, I let something like the instinct which leads a sheep to its own pen after a summer of grazing on the mountainside set me before a narrow, wooden door. As I raised my hand to pull the bell cord, we heard loud squeals of anger or laughter from inside.

Before I could ring, the door swung inward to reveal a stooped old man in a worn jacket and floppy red cap pulled down to meet bushy, white eyebrows. The bright blue eyes gazing at us in surprise were surrounded by more wrinkles than I remembered, but they told me I had chosen the right door.

"Lupo! It's me, Tito."

A woman carrying a small market basket pushed past our old house servant and threw herself in my arms. "Tito," she gasped, "I thought you would never arrive."

For a long moment we embraced as if our lives depended on it, then gently pushed away for a mutual inspection. How can I describe the woman my sister had become? There is a type of beauty that surpasses a harmonious arrangement of features, a beauty that no artifice can match. Annetta's brown eyes radiated that beauty from vast, calm depths. Her wide smile, generous and confident, was unfettered by the kind of self-doubt that tormented me daily. The glowing brown hair cascading down her back and unblemished complexion completed a picture of health and well-being.

"This must be Felice," she said, drawing us over the threshold. "Come in, come in. Take off your hats. Hang up your cloaks. There, on those pegs."

We crowded into the bare, narrow hall as Annetta pushed her basket and some coins into Lupo's hands.

"Go to the apothecary and get Grisella's elixir. He knows what she needs. And check to see if the baker is still open. Get some cakes if you can. Now that Tito has come, we must celebrate."

Lupo gave me a welcoming smile and backed out the door with a small bow to Annetta. Again we heard squealing. This time anger was evident in the shrill cries coming from the floor above.

"No. No, I won't. I want to wear that one. Give it here you old cow." Placating murmurs followed, then a loud slap, running feet, and the slam of a door. Annetta charged up the stairs, bidding us wait in the sitting room.

We entered to find a small table and a few chairs scattered about on a Persian carpet. An enameled stove containing some dying embers of coal filled one corner, but our chief interest lay in the delicate but well proportioned harpsichord set before the room's one window. Immediately, Felice took charge of the instrument and began to run through some scales.

"Come on, Tito, we've had no real practice since leaving Naples."

We launched into the elementary exercises so routine from our years at the *conservatorio*. Each session always began in the same way, with basic tasks to warm up the throat muscles followed by more vigorous exercises to build strength and stamina. *Castrati* are famous for having the small, delicately formed larynx of a woman and the prodigious lung capacity of a man. Hours of daily musical training results in a voice that can span three and one-half octaves, sing the highest and lowest notes with equal ease, and hold those notes for long minutes of swelling ecstasy. All of this, while the *castrato* soprano maintains control over the most complicated embellishments and plays nimbly up and down cascades and trills that no other singer could possibly produce.

I had once witnessed a virtuoso performance by the great Farinelli in Naples. During his arias, all eyes were glued to his face and gestures. Hundreds of ears strained to catch every vocal nuance. Some of the women, and even a few of the men, seemed transported by sensation. With their heads tipped back, watching through half-closed eyes, they appeared nothing short of enraptured. After the opera, the man's coach could hardly move through the streets for the crowds of people pressing in to give him flowers or just touch his sleeve. I saw one woman who cried her love for him over and over. She unlaced her bodice and bared her breasts before she was finally hustled away. But that had been the famed Farinelli. I reminded myself that I was only Tito Amato, a young Venetian of uncertain prospects, singing scales in my sitting room with my friend whose voice couldn't please a frog.

Felice fell silent and his roving fingers lit on the accompaniment to one of my arias from the opera that had crowned our student days. I grinned and joined in the melody. Despite our sea journey, my voice was in fine shape and I quickly warmed to the music. I sang the first section as written, then began to add my own embellishments. My throat was nearly bursting with the joy of singing again. I soon left the composer's intent behind and sounded the notes for their own sake, giving my imagination free rein. Felice gave up trying to follow me on the keyboard. He crossed his arms and nodded his chin in time to my rhythm. When I finally ran out of breath, he gestured to the door. I turned to face four amazed stares. The four broke into applause, and one of the group flew at me and began hugging my neck and covering my cheeks with kisses.

"Oh Tito, I didn't know you could sing like that," came in between enthusiastic embraces.

"Enough, Grisella. Don't strangle your brother. Let Tito catch his breath and have a look at you." Annetta attempted to pry our younger sister off my neck.

Grisella stepped back but retained my hand in hers. "So what do you think of me, Brother?"

How old was she now? Thirteen? Grisella had certainly left the garments of childhood behind. Her dark green dress was a copy of Annetta's brown one. Although Grisella's shoulders were slimmer, her trim waist and swelling breasts filled out the bodice to amply match her older sister's feminine contours. An oddly extravagant scarf jeweled with bits of colored glass, likely the source of the spat we had overheard, brushed her neckline and mingled with a luxuriant flow of red-gold hair. Where had she come by such hair? No one in our family that I could remember had such a striking mane. Her bright, dark eyes, shadowed by bluish smudges underneath, continued to question me.

"Well? What do you think? Have I changed much?" She playacted a demure expression.

With perfect truth I said, "Grisella, you've grown up while I was away." She smiled, seemingly pleased with both herself and my statement, and let Annetta draw her away to meet Felice.

The next to greet me was old Berta, shy and grinning in her apron and linen cap. She sidled close and said, "How wonderful you sing, Signor Tito, like the beautiful boys in church." Lupo followed, nodding agreement with his toothless smile.

I was wondering how Annetta managed the household with the help of only two elderly servants when the street door slammed and my father appeared at the sitting room doorway. Lupo scurried to take his overcoat and tricorne hat while Berta shuffled down the hallway toward the kitchen muttering about supper preparations. The group by the harpsichord was laughing at Grisella's boisterous efforts to convince Felice that Venice was more of a musical city than Naples or even Rome. My father met my eyes for a brief moment before finding it necessary to inspect the carpet that had covered his sitting room floor since long before I had crawled on it as an infant.

"We've been expecting you, Tito," he finally said. His Venetian accent was softer and more liquid than what I had been used to hearing in Naples, but his tone was sharp. He held himself rigidly and fiddled with the lace at the end of his sleeve. "How was your journey?"

"It went well, Father, only a few short delays," I answered slowly, trying to send unobtrusive signals to Annetta, mentally willing her to turn from the harpsichord and join the conversation. But the laughter by the window continued. I forced myself to raise my chin and keep my gaze steady. With my heart pounding so insistently, I could have been a novice on the *conservatorio* stage in my first singing role.

"I see you've brought your friend." The slight curl of Father's lip and his cool glance toward Felice told me what he thought of my friend.

Now Annetta came forward leading a subdued Felice by the elbow. "Father, this is Felice Ravello. He's agreed to stay with us

until he gets settled in Venice. I'm going to have Berta air out Alessandro's room."

To my great relief, my father's instinctive good manners came to the fore. "A pleasure, Signor Ravello. Is this your first time in Venice?"

"I've never been north of Naples, Signore. The *conservatorio* agents took me from a village near Palermo when I was very young. I've lived in Naples ever since."

"You were born in Sicily, then."

"Yes, east of Palermo…I think."

"You don't really know?" Annetta was quick to put a kind hand on his shoulder. "But what of your family, haven't you been back to see them?"

"I've had no contact with them. After the surgery, on the journey back to Naples, I came down with a raging fever. I think the men were surprised that I survived. Maybe that is why I remember almost nothing of my life before San Remo."

Annetta's questioning look prodded Felice to continue. "Only one picture stands out…my mother's face…very sad and fragile. Then there's a vague impression of noisy brothers and sisters riding in a farm wagon with huge wheels. And one old goose who used to chase me around the yard trying to nip me with her beak. Maybe I'd teased her and she wanted revenge. I don't know." Felice shrugged and smiled to show that these long ago events were of no consequence, but Annetta persisted.

"Didn't your family write or find some way to keep in touch?"

"They were peasants, Annetta. I doubt they could read or write."

"How sad!" My sister eyed Felice sympathetically.

"No, no," Felice replied. "I adored the Conservatorio San Remo. They made me work hard, but I had a soft bed and all the food I could eat for the first time in my life. And it was so exciting to be there. It seemed like I had stepped into a magic world created just for me. I can't imagine what it would have been like to grow up working the fields of a worn out farm in

Sicily. Besides, my father must have been very poor to take the money from the agents, to allow the operation."

The look on my father's face stopped Felice's reminiscences, and my friend continued in a different vein. "I'm grateful to you all for taking me into your home. I promise I'll be no trouble. I'm sure I'll find a position and be out on my own soon."

Concern impelled me to speak. "Father, do you know anyone at the Mendicanti or at your musicians' guild who might have a place for Felice? He's been working on choral music and can play the harpsichord and violin."

This put my father back on familiar ground. He had been the organist at the Ospedale Mendicanti for many years. The Mendicanti was one of Venice's four asylums for orphaned or abandoned girls. Unfortunately, the city overflowed with an abundance of waifs. Venice boasted several thousand courtesans whose names and addresses were published in a yearly guidebook distributed to foreign visitors. The Tribunal of State Inquisitors decried the loosening of morals in the declining Republic, but their protests were muffled. They understood that the ladies were a valuable complement to Venice's other attractions and allowed the practice to continue behind discreetly closed doors.

Like the other asylums, the Mendicanti had a *conservatorio* that educated the girls in music at the state's expense. The Republic recouped its investment by drafting the young musicians to perform at state occasions and in the pageants that filled Venice's crowded festival calendar. Of course, the girls were closely chaperoned. They usually sang behind grillwork screens and mingled with their admirers only under the watchful eyes of a phalanx of white-robed nuns. The very best sometimes went on to sing on the opera stage, but most ended up married or shut into a convent. My own mother had been a Mendicanti orphan before being plucked from the choir by Isidore Amato, the young organist who would become my father.

Tall and broad shouldered, my father met Felice's height and confronted him eye to eye. "You're not trying for a position at the opera? After the training you've received at San Remo?"

Stared down by Isidore Amato's unyielding brown eyes over his proud beak of a nose, Felice floundered defensively. "You must understand. My voice is really very good…it's just going through a rough patch. It's not up to solo work right now and I don't want to force it.…"

He would have stammered on if Annetta hadn't broken in. "Father, perhaps you could speak to Signor Viviani. He's on the Board of Governors at the Mendicanti and attends all the concerts there." She turned to Grisella. "Aren't you singing with the girls tomorrow afternoon?"

My younger sister nodded. "Father is playing the organ for us."

Annetta clapped her hands together. "That will do perfectly. Father can approach Signor Viviani while the music has him in a mellow mood. Maybe he has need of another musician for his theater or even his own household."

My father frowned. I gathered that he wasn't fond of being interrupted, or of taking orders from women. "I don't think so," he said. "Felice wouldn't want to get himself indebted to the Viviani. It would put him in a most uncomfortable position. That family is famous for exacting more than the expected compensation for favors given."

Felice inclined his head. "I'm sure you know best, Signor Amato."

Annetta was not so easily put off. She pushed up her sleeves, ready for an argument. My father regarded Felice with a jaundiced eye. I felt a bead of sweat roll down my forehead; the heat from the corner stove suddenly became oppressive.

I didn't fancy having my homecoming ruined by a family battle over Felice's prospects or lack thereof, so I jumped in with the first comment that came to mind. "The gondolier who took us off the boat told us that Domenico Viviani is enamored of the prima donna at the theater."

"Oh yes. He does have a well merited reputation with the ladies," Father hastened to agree. "That's part of the feud he has going with the Albrimani family. It seems Viviani is so obvious

in his liaisons with other women that his wife's family objects.
If only the man would show a bit of restraint!"

"I don't remember the Albrimani," I replied.

"An old family of impeccable lineage…very proud. The
Albrimani have been in the Golden Book since the founding
of Venice. They didn't buy their way into the nobility during
the Turkish Wars like the Viviani. I'm deuced if I can recall
the basis of the feud, but for years, the two families have been
at each other's throats. Gondolas are scuttled, trade routes
blocked, younger sons and cousins attacked in the streets. Your
new employer married a daughter of the Albrimani household
a few years ago. The alliance was supposed to heal the wounds,
but thanks to Viviani's indiscretions, it seems to have done more
harm than good."

Annetta spoke up excitedly. "Everyone knows about Domenico
Viviani's amorous exploits. The Albrimani are furious over his
open disrespect to their kinswoman. He's really courting danger
there."

"Anna-Maria! What do you know of such things?" My father's
face was livid.

Annetta raised her chin and shot back, "I can't live in Venice
and be entirely ignorant of what is said about such a prominent
nobleman."

As our father took Annetta to task for listening to gossip at
the market, I was struck by Grisella's pose by the harpsichord.
Her back arched at an odd angle, and her bright eyes blinked
rapidly while her lips pressed in a tight, straight line. I took a
step toward her.

"Grisella?"

Annetta whirled around, then called for Berta as she ran across
the room to Grisella. Suddenly, the girl exploded in a blurred
motion of flailing arms and swirling skirts. She struggled against
Annetta and emitted terrible growls punctuated by several words
for excrement that would have won me a caning at the *conser-
vatorio*. Father watched this amazing spectacle with a detached

shaking of his head, as if he were at a performance where the musicians were playing slightly off key.

Felice and I ran to help Annetta but were pushed out of the way by Berta hurrying past with a brown glass bottle. With practiced moves, Annetta pinned Grisella's arms while Berta tipped a small portion of the bottle's contents into her mouth. The girl calmed almost immediately. With glassy, unfocused eyes and squiggles of purplish brown liquid running down her chin, she allowed Annetta and Berta to lead her away.

Astonished and full of questions, I turned to Father. He gave me a cynical smile and said, "Not quite the homecoming you were expecting, eh Tito?" As he turned abruptly, we were left with the sight of his straight back and carefully powdered wig heading out the door.

Chapter 3

Later, back in my old room at the top of the stairs, I couldn't sleep for the thoughts flooding my mind. What ailed Grisella? Annetta had written of her willful temperament, but the scene we had witnessed was far more serious than a spoiled child's trick. According to Annetta, these spells had been going on about six months and seemed to be worsening. At first, the family physician had suggested cold baths and rest. When these methods failed to effect an improvement, he prescribed an elixir with the caution that it be used sparingly. It was the only thing that calmed the child. I tossed and twisted in my bedclothes. Now that I was home, I saw that Berta's advancing years had shifted the burden of caring for Grisella almost totally to Annetta. I resolved to help her as much as I could and, if possible, to find the cause of these mystifying fits.

As the clock in the dining room sent its eleven o'clock chimes bonging through the floorboards, my thoughts turned reluctantly to the reunion with my father. Isidore Amato held the key to the prevailing mystery of my life, but I judged him unlikely to discuss the matter. I wanted my father to answer just one question: why had he allowed the surgery that had changed the course of my life?

I had always been told the story of playing on a wooden bridge being built over the small canal near our square. The workmen chased me and my playmates away from the bridge many times, but the lure of scaffolding to climb and wood scraps

to chuck into the water provided too much temptation for an eleven-year-old boy. When the adults of our household were otherwise occupied, I sneaked back after the workmen had gone for the day. Always curious and agile, I climbed to the top of a tall supporting beam, then fell heavily. I struck another beam with my legs splayed out wide and hit my head on the stone walkway by the canal. My father told me that I had been lucky: lucky that I hadn't rolled into the canal and drowned.

I remembered the bridge—Felice and I had passed beneath it on our way home—but not the fall. When I had gradually awakened the night of the accident, a terrible pain throbbed between my legs and my mouth was filled with a bad, bitter taste. Concussion, the doctors said. With such a bad bump on the head, I might never be able to remember. Annetta sat by my bedside, trying to bathe my head with a cool cloth, but I pushed her hand away. My head was not where the pain was. My father kept pacing in and out of the room, his lean form casting a fitful shadow in the yellow candlelight.

"Just rest," he had said. "The doctors did what they had to do to save your life, now you must rest."

Within days, I had been put in a carriage with two strange gentlemen and several other bewildered boys. We were told we were headed for Naples, where we would be taught to sing like the angels. Now, eight years later, I was back in my old bed-chamber trying to make sense of it.

The fall from the bridge was a good story, quite logical and full of plausible detail, but a story nonetheless. At San Remo, I had discovered that most of the boys had been told some such story. Animal bites were plentiful, as were carriage and wagon accidents. Some boys remembered, however. They told of being lowered into a warm tub of water and being made to drink a bitter liquid that made them drowsy. Some had their necks squeezed until they lost consciousness. Like me, all had awakened with a vast pain where their scrotal sacs had been.

I realized that my father must have made a deal with the agents who scoured Italy and points beyond for talented boys

with beautiful voices. San Remo had been only one of several schools in Naples that provided the endless stream of mutilated singers that the opera houses and churches demanded. A poor family like Felice's might sell their boy and his manhood for a few ducats and be glad of one less mouth to feed, but why had I been delivered to the knife?

My father couldn't have needed the money. He had always made a good living as organist at the Mendicanti. This house belonged to him free and clear, inherited from his father, who had been a highly regarded organist before him. My father had given all his children musical instruction, and I could have followed right in his footsteps. My brother Alessandro was the only one of us who hadn't taken to music. If I had been the one who was practically tone deaf, instead of Alessandro, would he be here now? Would he be the one who would never know what it felt like to be a whole man, the one whose only hope for any crumb of the world's approval was to sing and strut on the stage proclaiming what a figure of distaste he was to one and all?

I longed to ask my father these questions but knew that I did not yet have the courage to do so. He had not taken supper with us. After Grisella's fit, he had called for his *bauta,* and Lupo had come running with the mask that confers equality on all the men of Venice. A *bauta* consists of a large, semi-opaque square of fabric that is draped over the head and a mask that covers the eyes and nose. A tricorne hat completes the disguise. In a *bauta* and long cloak a man is practically anonymous; he could be a commoner or a king. Not surprisingly, it was the favored costume of carnival revelers.

The longer I stayed in bed, the more tortuous my thoughts grew and the more insistent my qualms about reporting at the opera house became. I finally rolled out of my twisted bedclothes and padded across the cold floor to the window overlooking the *campo.* I laced my hands together and stretched my arms over my head. The newly risen moon was just past full; its light was bright enough to illuminate the square's single tree. Why not walk off my restless notions on the pavements of Venice?

I grabbed the breeches I'd left hanging from the bedpost, dressed hurriedly, then retrieved my cloak and hat from the hallway, where a key to the street door also hung on a peg. The outside air was cool but not uncomfortable. The bright moon in the dome of softly twinkling stars made the *campo* seem miles removed from my cramped, dusty bedroom. My head suddenly cleared of troublesome thoughts and I felt a tingle of excitement. I was alone in my city, the city of Carnival, and had all night to explore her wonders.

Keeping to the back *calli*, using bridges to cross the secondary canals, I moved quickly through the sleeping Cannaregio. Cramped family dwellings seemed to press against my shoulders. Here and there, cats skittered over tile roofs and forgotten laundry billowed from balcony rails like hovering phantoms. I was moving south, heading for the heart of Venice, the Piazza San Marco, where the carnival revelry would be at its peak. It wasn't long before I noticed that the houses grew larger and were separated by strips of garden protected by grilled gates. An occasional gondola swept by on the canal to my right, but I had no wish to be carried along. I wanted to move my legs and feel my heart pumping.

The grand houses gradually gave way to a string of shuttered shops, and a few dark figures passed me on the pavement. Rounding a corner, I came upon a brightly lit tavern with patrons spilling out of its open door. The smoky, yellow light surrounded a group of high-spirited Germans, all in costumes and masks. They staggered to the gondola mooring, a boatman offered his craft, and they immediately fell to arguing about the fare. Then, a young girl with the veil of an Arab princess drawn across the lower part of her face stepped out of the tavern and plucked at my cloak. She was peddling a tray of cheap, papier-mâché masks.

"You must have a mask, Signore. Carnival is no fun in your own face." Her slanting, dark eyes were bright and playful. I pictured the pretty mouth that must be smiling behind the veil.

The girl was right. I didn't want to be the only man on the piazza without a mask.

She helped me choose a small one, just a feather-tipped band of silver that covered my eyes, and tied it around the back of my head with a ribbon. At first I was sorry to see the girl disappear into the milling crowd as soon as she took my coin, then realized there were many other sights to see.

The traffic on the canal multiplied. A long gondola strung with colored lanterns passed by, then another. The bodies of the jet black boats blended so completely with the night it seemed as if the laughing passengers were borne magically along in a ring of fairy lights. The back of my neck tingled with excitement, and my ears picked up the sounds of a brass band. Almost running, I followed the blaring strains until I reached the piazza.

Bursting through the archway under the mammoth clock tower, I was instantly immersed in a swirling flood of masked merrymakers. A Harlequin in a conical hat and diamond patterned tunic was cavorting with his Columbine; they jostled me from behind and nearly pushed me down. A masked woman in gypsy dress and a tangled wig laughed and grabbed my arm. She smelled of stale sweat masked by flowery perfume. After whispering, "Careful, my pretty one," she surprised me by sticking her tongue in my ear. Her cloak was thrown back over her shoulders so I could look down the bodice that barely covered her breasts and see the rouge she had applied to her nipples. I pushed her away. A quick tumble with a prostitute was not how I wanted to spend my first night back in Venice.

Many assume that *castrati* lack sexuality or suppose that we are fit only to play the girl for those of our own sex who enjoy that kind of skirmish. The truth of it is more complex. Our sexual appetites are as varied as those of other men. At San Remo, there had been several soft, exceedingly corpulent maestros whom we couldn't imagine having amorous thoughts toward anyone. However, we had also heard many stories of the famous singers who managed to keep their noble patrons, male or female according to their tastes, as satisfied in the bedroom as they did in the opera house. Only a few years before, a popular Neapolitan *castrato* had nearly succumbed to pneumonia after being forced

to spend the night on a rain-drenched balcony. He had escaped through the window only seconds before his mistress' husband burst through her bedroom door with a cocked pistol.

I believe women feel safe with us. They have no fear of impregnation, and most of us have peaceful, equable temperaments. For myself, I had learned that I had to cultivate my desires very carefully if they were to become bold and insistent enough to complete the act of love. I couldn't squander my potency in the typical schoolboy method of assuaging these appetites, or I might find myself unable to pursue a romantic encounter should the opportunity arise. Thus I found myself continuously simmering with the first bubbles of desire, but rarely coming to the full boil. I was always looking for the woman who could turn up that flame, but fears of being mocked over my mutilation or not being able to satisfy held me back.

After warming my hands at a flaming brazier, I made a circuit of the huge piazza, trying to decide what to do first. Everywhere was the *bauta* in all its many forms. Some masks had wickedly curving, beaklike noses or grotesquely ridged eye sockets, but most were simple black or white molds of leather designed to keep the wearer's identity a secret. The women favored a plain velvet oval of a mask called a *moretta*, which covered their faces from forehead to chin and had slits for the eyes and nose. The wearer held the mask in place by gripping a small knob on the back of the mask with her teeth. I was pushing through a gaudy throng that displayed all these masks and more when I spied a strongman performing marvelous feats to the roll of a snare drum.

The muscular giant on the trestle stage wore a molting leopard skin, no doubt his humble homage to the legendary Hercules. I watched in awe as he tossed huge iron dumbbells around as if they were children's toys. Then, with many grunts and groans, he leaned over the edge of the stage and suspended a ship's anchor from a chain around his neck. His last miracle involved a number of his family members. He balanced two brothers on his wide shoulders, and a sister climbed up on those two. Before

a child was passed up to the terrifying height of the woman's shoulders, the rest of the family crossed themselves and fell to their knees. Many of the spectators followed suit. The drum beat out a furious rat-ta-tat and the crowd held its breath as the tiny child moved higher and higher. When it reached the pinnacle of the family pyramid and spread its arms in triumph, the cheering of the crowd was not diminished when we realized the figure was not a child but a youthfully dressed midget.

In search of other pleasures, I followed the tempting fragrance of fresh-baked pastry into a nearby café. Every seat was taken, so I joined the maskers hugging the walls to watch a handsome couple dance an impromptu *furlana*. The man was unmasked and had removed his coat. Although he had reached his middle years, he was vigorously built. The fine silk fabric of his breeches stretched over a lean, taut belly, and his white stockings covered muscular calves. Those nearest him expressed delight at his footwork and clapped the beat of the tune to encourage him on and on in the spinning dance. His partner was a tiny minx-like woman in a dress of gold satin that floated up around her knees as she whirled. Her face was covered by a *moretta*.

Thanks to my musical training, I possessed the wind of an athlete, but I wouldn't have been able to complete as many repetitions of the frantic dance as these two. The man finally stumbled to a stop with a good-natured laugh and motioned to one of his servants, who brought his master a cool drink and a cloth to wipe his brow. Now I had a good view of his full face. He was not a handsome man, but he had strong, regular features and a manner that bespoke strength and assurance if not outright audacity. His own brown hair was pulled into a pigtail and topped with a simple, unpowdered wig. Not surprising. I couldn't imagine a man with his obvious drive sitting still long enough to get a thorough powdering.

The man's bravos cleared a path to the door, but his dancing partner jumped playfully in his way. She removed the knob of the *moretta* from her mouth and flung her head back to be kissed. The gentleman obliged by cradling her chin in his strong

hands and thrusting his tongue where the mask's holder had so recently been. Then he swept her aside and, without a word, headed for the door. One of his men held the woman's wrists as she tried to follow.

My mouth was still watering for pastry, but I found myself pinned to the wall by a woman of obvious wealth who had slashed her gown of velvet and satin to pose as a beggar. She giggled with her male companion, who was disguised as a nun. "If La Belluna hears about her lover dancing with a ballerina from the Teatro San Moise, there will be hell to pay."

"Oh, he'll just buy her a diamond trinket and it will be forgotten," answered the sham nun. "Adelina Belluna knows the rules of the game."

"Well, if I were her I'd be getting everything out of Domenico Viviani that I possibly could. You never know when he's going to be ready for a new romance." The couple laughed as they darted toward a free table.

I barely had time to register the thought that the man who danced the exuberant *furlana* was my new employer when another, more malevolent conversation reached my ears.

"What outlandish thing do we have here? Is it a boy or a girl?" a deep voice asked in a lazy drawl.

"Perhaps it's a girl dressed in manly attire as a carnival disguise. There's no fuzz on those cheeks," an acid voice replied.

I turned slowly, as if to search for a waiter or an empty table. In the sea of chattering masks, how could I tell who had uttered those words?

"If it is female, the poor girl is to be pitied for possessing the flattest bosom in Venice." Now I saw. The speaker stood only a few paces from me. A white leather mask hid the upper part of his face, but his elaborately coifed wig was bare of any other covering. A pear-shaped pearl dangled from one earlobe and proclaimed his privileged status.

I started to edge through the crowd. I had not then faced the worst of society's prejudice against my kind, but I had been raised in a school for boys, and I knew a bully when I saw one.

The door was only a few steps away when another dandy in a gold-braided coat barred my way. His deep-voiced friend laid a heavy hand on my shoulder.

"Not so fast, my lovely." His wine-soaked breath washed over me. "We have a wager on your sex. Enlighten us. Are you a pretty boy or a girl with an unfortunate deformity?"

I shook his hand off and said quickly, "Excuse me, Signore, but my friends are waiting on the piazza."

"Ah, his voice. Hear it. He's one of those singing canaries, a *castrato*," said one of the pack of patrician youths who had closely surrounded me.

My chief tormentor set his pearl earring swinging with an evil laugh. "This is going to be even more fun than I thought. I've always wanted to get a close look at a man who's lost his stones. Bring him outside."

I twisted and squirmed as they laid hands on me from all sides. "Let me go. My friends are right by the door. They won't let you do this."

Their leader stuck his masked face close to mine. Spittle gleamed on his fleshy lips. "We followed you in here…alone. You have no waiting friends. But don't fret, we're going to be your friends for the rest of the night."

Getting desperate now, I started to call for help, but a sharp blow to my stomach knocked the wind from my lungs. Complaining loudly about a comrade who couldn't hold his wine, they dragged me out of the café and along an arcade leading to the nearest gondola mooring.

Heart pounding, I staggered to regain my footing. I pulled against their encircling arms, causing at least one of the tipsy fops to overbalance and lose his grasp. A covered gondola bobbed in the water just ahead. It was now or never.

The water in the Bay of Naples was a warm bath compared to the frigid canal. The maestros at San Remo had viewed swimming as a lung-developing exercise, and I had been one of the more agile fish in my class. Of course, my tormentors also knew how to swim. Every Venetian boy, rich or poor, is introduced

to the lagoon by his father or older brothers. I was counting on the element of surprise to even the score.

Two or three loosened their grasp and ran ahead to the gondola. The sturdiest of their number attempted to bundle me into the boat while their leader brought up the rear. Before my heels left the edge of the stone quay, I kicked backward with all my might and made a dive for the canal. The cold water took my breath away, but I came up flailing even as I gasped. I had managed to pull two of my attackers in with me. One was clawing at a mooring post, but its slick, mossy surface kept him from getting a firm hold. The rogues in the boat seemed more interested in staying dry and rescuing their friend than retrieving me.

Their leader was made of sterner fiber. He wasn't about to let his prize escape so easily. Kicking and splashing, he grabbed my waistcoat and dealt my chin a glancing blow with his other fist. I struck out furiously, trying to push his head under the surface. I made contact, but it was only his drenched wig that came away in my hand. He gave me a triumphant grin. With his longer reach and superior strength, he pressed me under the dark water and kept me there. Lungs bursting, I made a grab for the only thing I could think of. My hand followed his shirt ruffles to his chin, then slid toward his ear. I located the dangling pearl and gave it a violent tug.

He released me with a mighty yell. I didn't waste a second. Snatching one huge breath, I dived into blackness and swam up the canal, intent on gaining as much distance from the gondola as possible. The drumming of blood in my ears was the only sound as I cut through the frigid water. When I was finally forced to surface, I saw a bridge flanked by some steps leading to a small quay. I pulled myself up on the stone blocks and teetered to the top, grateful for the solid footing, but knowing it was too soon to rest. Angry shouts in the distance told me I had to keep moving.

I launched myself down a gloomy *calle* as fast as my trembling legs could carry me. The smartest strategy would have been to head for the piazza and lose myself in the crowd. But I wasn't

thinking; I was simply reacting. I ran blindly, not even sure of my direction. Every second or third turn, a canal or cul-de-sac would block my way. Then, with my heart pumping a staccato beat, I'd whirl wildly, certain that the marauding dandies would appear at any moment. Gradually I realized that the danger had passed and the fops probably hadn't chased me any farther than the first bridge.

I allowed my feet to slow. That's when I began to shiver.

Taking stock of my whereabouts, I found myself in a neighborhood unknown to me, surrounded by tightly shuttered houses. Ragged clouds obscured the moon, and lantern posts were few and far between. Dripping wet, my good cloak and one shoe lost to the canal, I trudged down dark *calli* and over deserted bridges, searching for one of the larger secondary canals that would dump into the Grand Canal. If I could find Venice's watery backbone, I knew I could find my way back to the Cannaregio.

The air was colder now and my teeth were chattering. I groaned as I ran a hand through my damp hair. I could bear being mishandled by ignorant fops, but a head cold or sore throat was death to a singer. If I couldn't find warmth or shelter soon, my engagement at the San Stefano might be over before it began.

I had nearly lost hope of finding my way when I stumbled onto a small, open square flanked by rambling structures. On the opposite side, a break in the clouds revealed a most welcome sight, the unmistakable, multicolored, polished-stone arch of the church of Santa Maria dei Miracoli. Now I knew where I was. I'd been to Mass at the Miracoli hundreds of times in the old days. My father's aunt—may the Lord rest that good lady's soul—had lived in this quarter. As Isidore Amato's last surviving relative besides his motherless children, Aunt Carlotta had taken it upon herself to guide our spiritual development. Happily, she had ended up indulging us with as many sweets and ices as prayers. My heart sang a silent hymn of thanksgiving to Our Lady and dear Aunt Carlotta as I located the wide pavement of the Strada Nova and trotted toward home, not sorry to be leaving Carnival far behind.

Chapter 4

The next morning, Felice and I took a late breakfast of oranges and toasted bread smeared with soft cheese. Annetta joined us, standing at the end of the table to fold some freshly washed linen into a basket. I'd already sounded a few scales in my room and was relieved that my throat seemed no worse for the wear. No one seemed to realize that I'd been out of the house half the night. I decided to keep the distressing incident to myself, at least for now.

Father had just set off for the Mendicanti with Grisella in tow. Annetta told us Father took the girl to work with him several times a week. She was included in the keyboard lessons that he taught, then joined the other girls for voice lessons.

"Although you wouldn't know it from the passages Grisella plays and sings for me." Annetta shook her head in perplexity as she left her folding to gather dirty dishes onto a tray. "She just doesn't seem to make any progress. Sometimes, I don't think she's even interested in music. If she would just work at it, she could have a very pretty voice. Maybe even better than her brother's." Annetta gave me a teasing smile, licked orange juice off her fingers, and headed toward the kitchen with the tray balanced on her hip.

At Annetta's insistence, Father planned to return home in the afternoon and collect Felice before going to his daily coffeehouse gathering. Throughout our meal, my friend vacillated between sunny anticipation and panicky foreboding at the thought of

meeting the Venetian musicians. I watched as he moodily chased bread crumbs around the tablecloth with a flicking forefinger. Felice's thick hair was still damp from his morning wash and fell in curls over his forehead. With his flushed cheeks, he would have looked the picture of health and happiness except for the strain evident in his eyes.

With a tight smile, he brushed the crumbs into his napkin and raised his chin to meet my gaze. "When will you leave for the theater, Tito?"

"Soon. I don't know what time the company usually gathers and I don't want to be late."

His shoulders drooped. "I'm happy for you, but I can't pretend I don't envy you, too. To have your opportunity, to sing on stage again, sure of my voice, that would be the answer to all my prayers."

I started to reassure him but couldn't make my tongue dance through the oft-repeated words of encouragement. With a sorrowful pang, I realized that even I had come to doubt whether his voice could return to its former glory. "Good luck with Father," I blurted awkwardly as I stood up and straightened my waistcoat. "I'll tell you all about the opera when I get back."

As I settled my second-best cloak on my shoulders, the house was caught up in a whirl of morning chores. Annetta had gone up to make the beds, Lupo had donned a leather apron to mend a loose tread on the stairs, and the yeasty smell from the kitchen told me Berta was baking bread. I opened the door and stepped out onto the square. Venice greeted me with a morning sky as hard and smooth as blue enamel, unsoftened by even a wisp of cloud. To get to the theater near the Rialto Bridge, I had to cover much the same route I had taken last night. This time I was in a hurry to reach my destination, so I boarded a gondola.

By the light of day, the buildings that had seemed so anonymous and threatening in the shadows of last night took on a more human air. Shutters were thrown open to entice the sun's warmth into autumn-cool rooms, and housewives were calling down to the water girls who bore shoulder yokes balanced with

jugs at either end. Everyone was astir. As my gondola made its way down the Canal Regio that gave the district its name, I saw shopkeepers sweeping their steps, setting out barrows, and building pyramids of everything from cabbages to boots.

I had asked my boatman to point out the Palazzo Viviani. He gave me the high sign as he propelled the gondola into the choppier waters of the Grand Canal. I gazed up at a wall of marble rising straight up from the water's edge. Along its front, at least ten freshly painted gondolas bobbed at their mooring posts. Pointed arches ascended in levels to a delicate rampart of marble tracery encircling the roof. I looked back as we swept down the canal and saw those gilded cupolas that my gondolier of the day before had told me cost the Viviani so many ducats. Of a distinctly Turkish style, they clashed with the gothic structures below. Just as in the palaces of Naples, I noted that wealth did not necessarily buy good taste.

A parade of other palaces lined the wide canal; many were not in as good repair as the Palazzo Viviani. It grieved me to see sadly faded façades, pitted marble, and foundations frayed by years of creeping tides. Finally, I settled back into the gondola's cushions, half closed my eye, and allowed the stately buildings to glide by in a blur of pomp and splendor. Then I saw my city as she had been in her glory years. Suddenly I felt every inch a Venetian despite my long stay in the south.

I disembarked near the Rialto Bridge, the span that presides over Venice's busiest commercial district. I hit the pavement with a bounce in my step, but my feet grew leaden as I neared the San Stefano. My moment of truth was at hand. In the blink of an eye, I would turn from student to employed singer in the service of a renowned opera company. There would be no more teachers to turn to if something went wrong, no more time to polish my skills. As a newcomer, I would be billed as *uomo secondo*, the second male singer. Soon every operagoer in Venice, which meant practically every living Venetian, would know me as a *castrato* singer. I couldn't help thinking of other paths my life might have taken, but I could harbor no illusions

about becoming anything other than what I was. What else was a eunuch to do but sing?

My reluctant steps finally reached the theater. The playbill outside announced an upcoming opera with music by a composer unknown to me, but the subject of the libretto was familiar mythological territory. It was the story of Juno's revenge on the wayward nymph Callisto. The queen of the gods was bent on punishing Callisto for catching the eye of her eternally amorous husband, Jupiter. Such exploits of pagan gods and ancient heroes were the popular themes of the day. As I entered the deserted lobby and crossed to the rear of the darkened theater, I discovered the company in the midst of rehearsal.

Two women and an elderly man stood on stage while workmen stacked pieces of scenery behind them. The younger of the women was arguing vehemently with a short, balding man in the orchestra pit. I took him to be the director. Another man, broad shouldered and handsome, sat at the harpsichord with his head in his hands. He suddenly burst out with whispered invectives seemingly directed at no one in particular. A medley of hammering, sawing, and clanging coming from the wings provided background noise for this little drama. I decided to keep to the shadows and wait for a pause in the action before making my presence known.

"She's doing it on purpose, calling attention to herself," screamed the younger woman with untidy blond hair escaping its pins in lank tendrils. She pointed a stabbing finger at the darker, older soprano.

"But what is she doing, Caterina? I don't see her doing anything except standing in her place," the director replied wearily.

"When I begin my aria, she starts smiling and swaying her hips toward the audience. She's taking their eyes off me, distracting them at my most dramatic moment." Caterina, whose family name I was to learn was Testi, thrust her sharply pointed chin in the air and crossed her arms decisively. "I won't sing with that mischief going on."

The director turned to the object of Caterina's spite and spread his arms in supplication. "Adelina, during this passage you and Crivelli simply stand at your places upstage. No movement is needed. You understand, my dear."

So this was Adelina Belluna, or La Belluna as the populace of Venice called her. We had heard of her exploits as far away as Naples. She was tall for an Italian woman and emphasized her height with a proud, straight back and a gracefully carried head topped with chestnut brown hair that was quite elaborately coifed for such an early hour. The color of her bottle green dress set off her creamy skin while the cut of the panniered skirt exactly balanced her wide shoulders and deep bosom. When she marched to the front of the stage, I found myself retreating a step.

Ignoring her rival, who was still glaring venomously, Adelina smiled sweetly. "I'm only being true to my character, Signor Torani. Juno has to be seductive. She is vying with Callisto for the affections of her husband Jupiter."

"And she is so good at being seductive," hissed the younger woman.

The composer at the harpsichord groaned.

"Caterina, please." The director audibly winced. Torani, Adelina had called him. He shifted nervously from foot to foot and adjusted his waistcoat and jacket. Beads of sweat appeared on his high, domed forehead ringed with frizzled, gray curls. I watched as he tried to placate first Caterina, then Adelina, and ended up driving both of them from the stage in twin rages of frustration. After a short, indecisive pause, he followed Adelina, voicing continuing pleas and protests.

Suddenly, I realized that I was being observed as well. Crivelli, the old *castrato* who was singing the role of Jupiter, stared at me from the back of the stage with a half smile.

He stretched a long arm toward me. "I think our young Arcas has finally arrived."

Puzzled, I stepped awkwardly from the shadows. "I'm Tito Amato, I was supposed to report here, but I wasn't sure of the time. I arrived from Naples yesterday."

Still smiling, the tall eunuch came off the stage to join me. "I know who you are. Arcas is the name of Callisto's son, the one Juno turns into a bear. It's the part you will be playing in the opera."

"Of course, I see what you mean now." I wondered if I looked as much a fool as I felt.

He shrugged. "I suggest that we take some refreshment. Torani will be more than a few minutes sorting things out with our good ladies."

Crivelli spoke with old-fashioned manners and moved with a slow, deliberate grace. As he guided me to a small doorway behind a draped curtain, he called to the composer, "Orlando, come meet our new colleague."

The three of us moved below stage level to an oddly shaped room that seemed to have too many corners. The room contained a table with a stained top and a few dilapidated chairs. Crivelli poured some weak wine from a bottle that stood on the window ledge. The glasses were chipped and smudged, but he served us as if we were in the grand salon of one of the finest palaces I had passed on my way to the theater. He made introductions with another flourish.

"Signor Amato, your reputation precedes you. They say you are a fine, intelligent young man, so you have no doubt guessed our identities, but allow me to make formal introductions. I am Anton Crivelli, one of your fellow singers, and this is Orlando Martello. Orlando hails from Rome but has graced Venice with his talents for several years now. He's the composer of the work you saw us rehearsing."

The handsome composer ground his teeth and muttered. "That wasn't a rehearsal. It was a shouting match."

Crivelli pursed his lips. "Perhaps the arrival of the new addition to our company will help rehearsals run smoothly again."

"Something had better help. My opera will be a disaster if these problems keep mounting up." Orlando turned to me with flushed cheeks. "It's been one thing after another. Last week a ream of scores that the copyist had just delivered went missing.

One minute the boxes were sitting in the orchestra pit, the next thing I knew they were gone and had to be recopied. That set rehearsals back two days."

Crivelli nodded. "I feared that trick would drive Torani into apoplexy."

Orlando's chest heaved in a great sigh. "And Caterina's bickering interrupts nearly every practice. The woman can't let anything pass. She cares more about where Adelina is standing or what she is wearing than my composition." He spread his hands. "My sublime composition! I ask you, isn't that why we are all here?"

"How long has the rivalry between Caterina and Adelina been going on?" I asked, surprised that the director was not more adept in handling squabbles between temperamental singers.

Crivelli lowered his voice. "Adelina Belluna has been the prima donna here for ten years or more, since before the Viviani family bought the theater. Other female singers have come and gone, but none captured the public's heart like Adelina."

"None has been able to sing like Adelina," put in the composer. "She's in a class by herself."

Crivelli continued with a shrug. "Most have realized they cannot hope to best Adelina either in talent or personal attractiveness and they have moved on without starting a major rivalry. But Caterina is different. Her voice can compete with Adelina's. And since she came here last year, she has shown herself to be incredibly tenacious about getting what she wants."

Orlando Martello worked his gracefully formed lips into an unattractive sneer and made a rude gesture while whispering Caterina's name.

"No, Orlando." The older man raised flowing white eyebrows. "As a musician, you must admit that Caterina has considerable talent. She certainly isn't beautiful and her manner isn't pleasing, but she can sing. Sometimes the tone of her voice and her phrasing sound just like Adelina's when she was younger."

"If so, that is only because she is copying the techniques of a singer greater than herself."

"No, these are instinctive abilities. Adelina has recognized this, too. Just as she recognizes that her voice is slipping bit by bit. The audience hasn't caught on, but her throat is showing its mortality. A singer knows when the hourglass is running out. I believe that's why Adelina has been so uncharacteristically difficult these days."

"Watch what you say, old man." The composer splashed more wine in his glass and drank a hurried, angry gulp. "You have little room to criticize, especially with this young voice fresh from the *conservatorio* ready to show what he can do." Orlando stood up and glared at both of us before swaggering from the room.

I took a sip of wine, trying to find some words to assure Crivelli that I had not come back to Venice to knock him out of his place. But before I could speak, he put a considerate hand on my arm and gazed at me with weary brown eyes. "Tito, I've been around a long time. I started as a chapel singer at the Basilica San Marco when I was just eight years old. We were still singing Monteverdi's music then…it seems a hundred years ago. I know my present limitations and, if the talk I have heard is true, I can guess at your great potential. I have always surrendered myself to what fate has offered me and tried to make the best of any situation. That is why I suffer the arrogance of that young pup." He jutted his chin toward the door Martello had just slammed shut. "I've tried to make a friend of him, hoping he will take pity on my poor old throat and write notes I can sing or, at least, ones that won't make me sound too bad."

As I marveled at his philosophical attitude, the old *castrato* went on. "I'm truly looking forward to hearing what you can do. My career is almost at an end, but yours is just beginning. I wouldn't be fair if I begrudged you that. It's the way of the world."

I smiled at the simple truth of Crivelli's words. His gracious manner put me at ease, and we drifted into a pleasant discussion about famous singers he had known and how much the opera had changed over the years. He was recounting tales about Adelina Belluna's great triumphs when one of the stage carpenters stuck his head around the door and told us we were wanted.

A short flight of creaky, winding stairs led up to the stage. The wings were filled with wooden planks, lengths of rope hanging from pulleys, and the towers of scaffolding that would be used to construct the machinery behind the magical stage illusions that audiences had come to expect from an evening at the opera. I knew the myth of Juno and Callisto ended with the nymph and her son ascending to heaven to become the starry constellations of a mother bear and her cub. I wondered how this effect would be accomplished and hoped I'd get a ride on a flying platform out of it. Crivelli ushered me past the domain of the carpenters and onto the stage where the small company had reassembled.

"Signor Tito Amato has arrived from Naples to play our Arcas," he announced grandly.

The director had thrown a woolen scarf around his neck to fight the draftiness of the large, open theater. He flipped one end of the scarf over his shoulder as he turned to greet me. His careless smile and quick, appraising glance suggested he was trying to determine just how much trouble I would eventually bring him.

"Good, we've been expecting you for days. I'm Rinaldo Torani, the director of this madhouse we call an opera company." He bent to gather some sheets of music from a pile at the front of the stage. "I'll let the others introduce themselves in good time."

He waved the courteous introductory words I had been planning to speak aside and shoved the music into my hands. "Time is short, study these arias and be ready to rehearse after the dinner break." He turned away abruptly and clapped his hands a few times. "Caterina, Crivelli. You're the ones I need now. Everyone else off stage please."

I stepped back into the wings and nearly tripped over a piece of lumber. One of the workmen rolled his eyes. The crooked room below stage seemed like a good place to read over my music. I was halfway down the stairs when a soft voice called my name.

"Signor Amato, wait a moment, please."

I turned to face a welcoming smile and lovely, compelling gray eyes.

"I'm Adelina Belluna. We're all so grateful you've arrived." She continued, explaining where my dressing room was and apologizing for Torani's abruptness, but her words did not speak to me as distinctly as her physical presence. She stood a stair or two above and leaned toward me on the banister. We were close enough for me to inhale the spicy, musky fragrance coming from her neck and bosom and to see the tiny web of lines at the corners of her eyes.

She slipped her arm under mine and led me past the stage and up two more flights of stairs to a wide hallway cluttered with old costume trunks and other castoffs from previous productions. A crudely painted chariot hung from the ceiling beams above our heads, and the long wall on our left was covered with the papier-mâché helmets and breastplates of a legion of mythical heroes and spear-carriers. The dressing rooms lay in a line on the opposite side of the hall.

Befitting her place as prima donna, Adelina's chamber was the largest and the first on the right at the top of the stairs. The door stood open and I glimpsed a comfortable sofa, dressing table, and mounds of petticoats and wig boxes. As senior man of the company, Crivelli should have had the second room, but true to his generous nature, he had given this more comfortable space to Caterina and taken the next room along the hall. His small dressing room connected to my even smaller one by an archway covered with a folding screen. The dancers and any other singers with small parts had to dress in communal rooms on the floor below.

After we had entered my room from the hallway, Adelina ran her fingers along the dusty dressing table in front of the mirror and looked up at the cobweb-covered window in disgust. "This room needs cleaning, it hasn't been used in a while. Look, somebody's even taken your chair."

"It will do for me. You've been very kind to help me get settled," I said, beset by muddled emotions. I dearly wanted her to stay and keep talking, but I knew I had to start learning my arias. I didn't want to risk disgrace on my first day.

She seemed as reluctant to leave as I was for her to go. As I shuffled the pages in my hand, she dallied around the room continuing to inspect what little there was to see. Finally, she took the scores from my hand and began humming one of the melodies as she laid the sheets of music out on the dressing table.

"Ah, I see Orlando is repeating himself," she said more to herself than to me. She ran a finger along the lines of black notes tumbling across the page. "He must be running out of ideas. This is very much like an aria he wrote for Angelino last year. I'm beginning to think we singers should give the composers a rest and just write our own music."

From down the hall, a booming voice suddenly broke the tranquil mood. "Adelina, Adelina, are you up here?"

Adelina's head jerked up, and color flooded the chest exposed by the low, square neckline of her gown. The soprano checked her reflection in the mirror. Smoothing her hair with one soft, white hand, she gave my arm a quick squeeze with the other. "I've got to go now, but welcome and good luck, Tito. I'm looking forward to singing with you."

She bustled out the door in a rush with a troubled expression on the beautiful face that had been so calm and self-assured only a moment before. Puzzled, I went to see who had caused such a reaction in the woman who I already felt was my friend, but the hallway was empty and all I heard was the click of the bolt on Adelina's dressing room door dropping into place.

Chapter 5

A long dinner has a way of soothing ruffled tempers and pacifying strained nerves. As afternoon rehearsal opened, the carpenters retired to their workroom to labor over some intricate detail of stage machinery, and the singers went to work in an almost mellow mood. Orlando accompanied Caterina through her opening aria without a breath of whispered criticism or even a scathing tone to his voice. She responded by concentrating on the music and together they worked out several clever embellishments. Prowling the main floor of the theater, Maestro Torani gradually lost a bit of his sour, harried look. He actually smiled a few times. While the others had been enjoying their dinners, I had been singing. With my music prepared, I was free to study the composer and the soprano while they rehearsed.

The first thing I had noticed about Orlando Martello was his exquisite features: darkly arched brows over deep-set brown eyes, a beautifully proportioned nose, and a mouth that wouldn't have looked out of place on one of Titian's paintings of Venus. But now I also saw the coarseness of his skin and the oily untidiness of his dark hair gathered back into a greasy bow. Hunched over the keyboard, the thick shoulders jacketed in brown wool seemed overly large for the small, flat hands moving swiftly through the music. His brown bulkiness made me think of a captive bear I had once seen in Naples. The bear's keeper had made it wear a funny hat and prodded it to beat on a toy harpsichord. The look in the harnessed beast's eyes had been pitiful to see.

Orlando turned to look my way several times. I could sense hostility, but since we had not met before that day, I was unsure of the cause. I finally decided his animosity must be the aversion a whole man often feels toward a eunuch. That sentiment has always puzzled me. We present no threat to them, and if jealousy lies beneath the hostility, we certainly have more reason to be jealous than they.

I turned my attention to Caterina. As she sang Callisto's aria declaring her infatuation with Jupiter, she lost the tense, preoccupied look I had noticed earlier. Her voice soared joyfully along the showy passages and managed to shade Orlando's music with a rich intensity it had not shown in the written score. Caterina would never be called beautiful or even pretty. Her hair was a dull yellow, and its hue did little to improve her equally sallow complexion. But her most unflattering feature by far was the sharp, jutting chin she used to emphasize points when she was correcting others. I found it unusual to see a female singer so careless of her appearance. Even her dress was plain, and ill-fitting besides. The costumers would have quite a time turning Caterina into a nymph lovely enough to seduce the king of the gods.

Torani called my name and motioned me to center stage. I looked around for Crivelli and found him just coming out of the wings with mussed hair, his coat over his arm and waistcoat unbuttoned.

Torani tapped his foot. "Was it a pleasant nap, old man?"

"Very refreshing," said the elderly singer, with a sweet smile.

"We wouldn't want to bother you," continued the director with heavy-handed sarcasm.

"You're not," said Crivelli, affable despite Torani's baiting. "Some workmen rousted me out of my comfortable place and now I'm ready to hear Tito sing."

I was surprised at how confident I felt. Orlando's compositions had been easy to follow and reminiscent of the operas of Handel that we had studied and performed at San Remo. With music in hand, I stepped forward and nodded to Orlando at the harpsichord. My first aria was a lusty hunting song, all flash and

bravura. There had been only a few lines to memorize. "Into the woods I go alone, trusty spear by my side" was repeated over and over and interspersed with references to Arcas' bravery and the general savageness of bears. Audiences of the day did not attend the opera for the poetry or the storyline. I sang with feeling and was delighted that my voice remained in good form.

Torani listened intently with half-closed eyelids but gave no sign of what he was thinking. Before I had come to the middle section, which slowed the tempo down a good deal, Crivelli was smiling broadly and I knew I had his approval. Caterina's thin face registered surprise. And did I detect a little jealousy? As I sang the repeat with my hastily worked up embellishments, Orlando looked surprised as well. He shouldn't have been. Singers were required to be the equal of any musician at composition. During the repeat of an aria, the audience expected the singer to build on the original melody with his own vocal ornamentation, the more ornate the better. The maestros at San Remo had excelled at teaching this skill and I was determined to do them proud.

As I sounded my final, extended trill and Orlando's hands fell silent on the keyboard, we all turned to the unexpected sound of one man's measured applause. I had no trouble recognizing the man who strode on stage with Adelina following behind him like a creeping shadow. It was Domenico Viviani, the noble dancer who had whirled through the exuberant *furlana* the night before. I also noted several of the same, sizable bravos waiting on their master in the shadows on the floor of the theater.

"I see my money has not been wasted. The impresarios were right about you, Amato." Viviani's rumbling voice filled the theater. What a *basso* he could have made if the circumstances of his birth had been different.

I saw I was expected to pay my respects. I began with a low bow. "Excellency, you honor me with your compliment and...."

With the heedless impatience of a man accustomed to dominating every social exchange, he cut my pleasantries short as he came to stand in front of me with his hands on his hips. "Forget

the pretty phrases, just put my opera house back on top. For too long, people have been favoring the San Moise or the Teatro Grimani. The Venetians are like a flock of geese. One sees a new bauble and they all gather around honking and chattering until a new spectacle catches their eye. You're the new bauble. Keep them dazzled and coming back night after night until the San Stefano is the only place that the fashionable nitwits even think of coming."

I gathered my shattered wits and gave another small bow. "Excellency, I will endeavor to be the diamond that makes the San Stefano the crowning glory of Venice."

Viviani snorted with laughter. "Pleasingly said." He stepped back and inspected me from head to toe with a leisurely, calculating gaze. I trembled inside like a young girl promenading on the piazza with her governess while a bunch of hot-blooded louts made insolent remarks.

"Your pretty face will bring them in," he said at last, "but remember, your pretty singing must keep them coming back. Maestro Torani, I think we have finally found a *castrato* who can complement our most beautiful jewel." He gestured toward Adelina, who preened unblushingly before the rest of the company.

The director wiped the sweat off his dome-shaped forehead with the end of his scarf, sour expression firmly back in place. Orlando beamed at the self-satisfied Adelina, while Caterina smoldered darkly in the background. Crivelli was also regarding Adelina. I searched his eyes and was puzzled to see only a look of muted, resigned compassion.

Viviani surveyed the wide, empty stage with a frown. In the wings, a few half-painted canvas scenes leaned against a side wall. The backstage area was filled with unfinished towers of machinery that would eventually accomplish miracles of stage magic. Besides my spectacular ascent to the stars, clouds would roll back and forth in the first act, and in the second, Juno would be transported down from the heights of Mt. Olympus to the mortal world represented on stage level.

"Torani, will this opera be ready to open in ten days' time?" asked the nobleman.

"Yes, Excellency, surely," said the director, taking another swipe at his damp forehead.

"It doesn't look like it."

"We've had problems from the very beginning, Excellency. Singers fall ill, carpenters don't show up for work, scenery is damaged. You don't know all the things I've had to cope with."

"Why have I not been told of this?"

Torani cleared his throat. "Well, each of the incidents has been fairly minor. Any one of them would be nothing, just the sort of inconvenience that always comes up during preparation for a major production." He continued in an aggrieved tone, "But this time our luck has been bad all along. I barely get one problem solved when another pops up."

"Are you sure it is only luck and not a human agent?" asked Viviani thoughtfully.

Torani shrugged and spread his hands.

"Whatever the cause, your job is to solve the problems, and solve them quickly. Work the cast and crew day and night if you have to. I will have a great success, an opera that Venice will talk about for years to come." Viviani towered implacably over the uneasy little director, but his eyes swept over every one of us.

"I've arranged an occasion that should whet Venice's appetite for this *Revenge of Juno*." Viviani's frown turned to an expansive smile. "A reception at the Palazzo Viviani two nights hence. Young Tito will be introduced as the next great *castrato* soprano. He will perform a duet from the opera, the one with the most memorable tune. I want the gondoliers singing it all over Venice by the next morning."

Torani scratched his chin. "Caterina and Tito have a very moving duet in the third act. They could have it ready by then."

Viviani's frown returned. "Not Caterina. This is to be a showcase for my two jewels, Tito and Adelina."

"But Excellency, their characters don't have a duet in this opera."

"What? Why?" thundered Viviani.

"I don't know. Orlando wrote it." The little director began to sputter. "Here, Martello, tell Signor Viviani why Juno and Arcas have no duet."

Orlando rose from the harpsichord and took a deep breath. "The libretto didn't call for one, Excellency. Those characters aren't on stage together that much, but there are many other arias and duets which would please your guests. Allow me to choose one."

"Are you a composer, Signor Martello?" asked Viviani in a soft, steely voice that made me think of the stilettos his men undoubtedly carried under their jackets.

"Of course, Excellency."

"Then *compose*. Write a new duet for Tito and Adelina. Make it brilliant, something the likes of which Venice has not heard before."

A stubborn look crept over Orlando's handsome features. For a moment, I wondered if he were actually going to refuse Viviani's request.

"Can you do it or not?" The nobleman strode to the edge of the stage and stared down at the composer in the orchestra pit.

"Yes, Excellency, yes, I can do it." Orlando was fuming, but he stood very still and looked Viviani in the eye.

"Splendid. Start at once. You will accompany the singers at the reception. Torani, I expect you there as well. Your job will be to describe the glories of this new opera to anyone you can buttonhole into listening to you." Viviani gestured for one of his men to bring his fur-lined cloak and regarded us all gravely. "Let not one of you fail me. You will be sorry if you do." With a parody of a bow to Adelina, he and his bodyguards swept off stage and out of the theater.

As soon as the nobleman was out of earshot, Orlando gave way to angry ravings. "Just compose a duet, just like that." Orlando snapped his fingers. "He thinks he can order a composition like he commands his footman to have his gondola brought around to the door."

Torani shushed the infuriated composer. "You fool! For the love of God, don't risk letting him hear you. You need Viviani as much as we all do. Where would you be without his patronage?"

Orlando stomped out of the orchestra pit. "Patricians like Viviani have no idea what is involved in creative inspiration. On opening night, he won't even realize what he is hearing. He will be holding court in his box and collecting compliments from a bunch of bootlickers. His triumph, but *my* music."

Torani shook his head. "That's the way things are. You must submit to the rules of society or starve."

"It won't be like this forever," Orlando said, setting his jaw and hunching his wide shoulders.

"Are you mad?" Adelina asked incredulously. "Do you think you can sell your compositions from a stall on the street like the roast chestnut man or the fish peddler?"

"I don't know, but society has to change. Artists are as sick as any man of having a nobleman's boot on their necks. Someday composers will be at liberty to write what they like and sell their music where they see fit."

I held my peace and regarded Orlando solemnly; he was spouting dangerous sentiments. We could all end up in trouble if the wrong ears were listening to his tirade.

Our director sighed. "Let's leave the future in God's hands. Right now, we need a duet for Tito and Adelina."

Orlando nodded curtly. With a short bow for Torani and a bitter glance for Adelina, he left us with a promise to produce the duet by tomorrow morning.

Not wasting any time, Torani dismissed Caterina and Crivelli and turned his attention to finding the foreman of the stage crew. If the opera was to be ready on time, there was as much to be done backstage as in rehearsal. Crivelli appeared grateful for the unexpected respite and gave us a friendly wave as he went out the door. Caterina gathered her things and left the theater with many peevish flounces and evil looks directed toward Adelina.

Adelina shook her head as she slipped her arm through mine. "It's really too bad. Caterina is so obvious in her ambition, in her likes and dislikes. If she could only learn to be more agreeable. There are times when you must hold your emotions in check and pretend affability to further your goals."

"Your concern for your rival is generous," I answered. "And a bit surprising. I thought there was bad blood between you."

"No, Tito, not bad blood. And I don't consider her a rival."

I had to admire Adelina's confidence but wondered if her assurance rested on faith in her theatrical abilities or on Viviani's obvious preference. Either way, I thought she might be underestimating the threat of Caterina's potential. Viviani was the type of man who would soon tire of his current favorite and move on to fresher pastures. Without his protection, Adelina would be just one more aging soprano fighting the years for her voice and her looks. Then Caterina's ability paired with the advantage of youth might carry more weight.

Torani soon put the pair of us to work in earnest. Adelina was to review her third act arias while the director accompanied me through a pastoral air from Act Two. He was objecting to what he called my sobbing Neapolitan intonation when the foreman of the stage crew stepped out of the wings and called to Adelina. "Signora, we've been working on the gears that raise and lower this platform. Could you go up and see if it does any better for you?"

Torani pounded a jangling chord on the harpsichord and jumped up. He ascended halfway up the stairs to the stage and addressed the foreman in a snappish tone. "Signora Belluna is busy and so am I. Can't you fix that thing without interrupting us?"

Adelina joined me and whispered, "We rehearsed my descent from Mt. Olympus at least ten times yesterday. That platform jerked so hard I thought I'd end up going over the side."

To create the illusion of the goddess Juno descending to earth, Adelina had to climb a ladder-like stair behind the backdrop painted with a distant prospect of Mt. Olympus. Above the view of the audience, she stepped onto a platform disguised as a fluffy

cloud, and the massive machinery floated her slowly down and forward as she sang.

The foreman disguised a sigh, attempting to maintain a respectful façade. "My men have been out in the workroom retooling the gears all afternoon. We've put them in place, but we can't complete the job until we see that the apparatus is balanced to Signora Belluna's height and weight."

Running a hand through his gray frizz, Torani mounted the last few steps to the stage. I followed his squinting gaze up into the shadowy heights above us, the hanging maze of catwalks, ropes, and pulleys that the audience never sees.

"Is that Beppo up there?" The director had spotted the carpenters' young apprentice. "Put him on the platform. He's about Signora Belluna's size."

The foreman on the stage looked doubtful, but Torani was insistent. "Use the boy to test the mechanism. All he has to do is stand there and hang on to the railing."

Adelina went back to her scores and Torani resumed his criticism of my style. "I know the maestros at San Remo favor this lamenting tone, but Venetian audiences demand a more cheerful…."

Torani stopped short, distracted by a triplet of grating creaks. "*Dio mio*," he grumbled. "What now?"

I looked up to see the fluff-covered platform suspended in the air thirty feet or so above center stage. Beppo's curly head popped over the railing; there was an anxious look on his round face. From the wings, the foreman glared up at the intricate machinery with his hands on his hips.

Without further warning, the front of the apparatus gave way. The apprentice grabbed frantically for a handhold but found only air. He screamed as he plummeted to the stage with a resounding thud.

Everyone in the theater hastened to Beppo's still form, but the boy was beyond help. His head was twisted back over his shoulder and a dribble of blood stained his chin. I remembered seeing him when I had first entered the theater. The workmen had been

shifting flats of scenery behind the rehearsing singers and, with youthful energy and a lively grin, Beppo had run to help. Now Torani was covering the apprentice with a sheet of canvas, and the stagehands were waiting to carry the body away.

Adelina clutched my sleeve, crying "Poor little Beppo" over and over. Still stunned, I put my arm around her waist and tried to find some soothing words, but the soprano refused to be comforted. She tore herself from my grasp and shook me by my shoulders. "Don't you see, Tito? That could have been me. I should have been the next one to step onto that platform."

The platform in question sailed slowly down to the stage floor. It landed with a dull clunk, raising a hail of dust. Torani coughed and flapped his shawl to clear the air. We knelt to examine the damage. The foreman twirled the rings that accommodated the ropes supporting the front of the platform. Each ring had been sliced through.

"Look. Someone's been very clever," the foreman observed. "These cuts are too thin to be noticed, and the strength of the rings allowed us to haul the platform up without it collapsing...."

I jumped in. "But Beppo's added weight caused the ropes to pull out of the rings on the way down."

The foreman nodded.

"Were any of your men working around this platform this morning?" Torani asked.

"No," said the foreman. "Everyone was on the other side of the stage, constructing the night sky scenery."

I thought back to earlier in the afternoon. "After dinner, Crivelli came out from the wings where this platform was sitting. I think he was using its fluff for a pillow. He said some workmen had awakened him."

"Not my men, we've all been out in the workroom since dinner."

Torani circled the platform like a worried terrier. He barked a list of orders at the foreman: no outsiders allowed around the theater, all equipment to be thoroughly inspected before each use, report any further problems at once, and so on and so on.

Adelina had recovered her composure. She was pale, but spoke firmly. "Signor Torani, who could have done this?"

Torani fingered the end of his scarf. "Probably the same person who made off with the scores and caused our other problems."

"And who could that be?" I cut in quickly.

"My best guess?" Torani frowned into the wings where the workman had laid the canvas-wrapped body. "I think Beppo was an innocent victim of the Albrimani-Viviani feud. Our patron clearly has his heart set on an operatic triumph. He's handed the Albrimani a perfect opportunity to try to discredit him."

"But Domenico's wife is from the Albrimani family. Their alliance was supposed to heal the rift and put an end to this senseless fighting," Adelina said ruefully.

Torani gave her a pointed look. "My dear, you should know better than anyone else how Domenico Viviani treats his wife. Instead of bringing peace, she has become just one more bone of contention in the ongoing dogfight."

Adelina had the good grace to blush and drop her gaze. "What are you going to do?" she asked in a shaky whisper.

"I will inform our patron what has happened and handle the matter as he directs." Torani grimaced. "Then I will make a very uncomfortable visit to Beppo's mother."

Adelina looked up with a strained frown. Torani patted one of her small, white hands and continued, "You know, I think our patron already suspects that the San Stefano's woes are more than simple bad luck. I'm sure he'll be amenable to posting some of his men on guard around the theater. No one will get inside except those who have a reason to be here." Torani smiled more kindly. "Don't worry, my dear, Domenico Viviani will make sure that we're all safe."

Chapter 6

The excitement that had buoyed me up over the past two days drained away as soon as Lupo let me in the door that night. The others had tired of waiting and had already gone in to supper. Annetta fetched a fresh plate from the sideboard as I sank into an empty chair. I watched dazedly as she served up a golden mound of Berta's polenta and topped it with savory bits of fried minnow. I dug in hungrily as both of my sisters peppered me with questions.

"But Tito, did you meet Adelina Belluna?" Grisella's high, whining voice cut through my exhaustion.

"I met all the principal singers, little one. La Belluna, Caterina Testi, Crivelli," I answered between mouthfuls of warm, hearty food, "and the patron of the theater, Domenico Viviani." I washed his name down with a generous swallow of wine. "He will be a hard man to please. He is anticipating a great success with this new opera, but not all his expectations are realistic, especially considering the problems plaguing the production."

I recounted the tragic incident of the dead apprentice. Annetta's mother hen instinct surfaced immediately. "Are you in any danger, Tito? Will you have to ride on one of those platforms?"

"Eventually, but don't worry. The theater will be guarded and we'll all be on the alert. None of the Albrimani henchmen will be able to get within twenty yards of the San Stefano."

Felice and Annetta jumped in with more questions, but my father silenced them by clearing his throat and calling for

a change of subject. "Caterina Testi," he said slowly, stroking his chin, "I know her. I didn't realize she was singing at the San Stefano."

"She sings the secondary female roles but obviously aspires to much more. She and Adelina have quite a rivalry going on. Crivelli says there's not a lot Caterina wouldn't do to push her career forward, but today all I saw was some petty squabbling over stage directions and the like. How do you know her, Father?"

"Oh, she grew up at the Mendicanti. Not much of a keyboard musician as I recall." My father wrinkled his nose in remembered disgust. Isidore Amato considered the keyboard to be the highest embodiment of musical expression, with his organ in the Mendicanti chapel having the status of a particularly hallowed shrine. For him, no other instrument, including the human voice, could compare.

Annetta passed me some more fish. "Caterina must be talented, though, or she wouldn't have made it to the opera stage."

"I suppose." My father shrugged. "Signor Conti put her on as soloist in a great many of the student concerts a few years ago. She had her admirers, but I thought she was overrated. And a bossy pest. She was always telling someone how a passage should be phrased or a note should be held."

"That sounds like Caterina, all right," I said, wondering if my father had been one of those on the receiving end of what Caterina thought was her superior knowledge.

"Yes. She was definitely not well liked and developed a reputation for being difficult to work with. I wonder how she came by the position at the San Stefano?" my father mused vaguely, his interest in Caterina waning.

Annetta had one more comment. "Maybe some of her people had some influence with Viviani to get her hired at the theater."

My father replied in blunt tones, "She has no people. Like so many of the girls, she was found in a basket outside the gate with a pitiful, begging note pinned to her blanket. 'I can't take care of my baby,' you know the sort of thing. It's possible the voice maestro, old Conti, spoke to Viviani about her. Conti

always seemed to have a tender spot for Caterina, but then, so many of the girls wheedle favors from him. The man's entirely too soft, no backbone at all. Now that I recall, Caterina still sees him for voice lessons…I wonder what he charges her?" He waved a hand dismissively. "But enough of theater gossip, I've had a letter that should interest you all."

My father waited until we had put our forks down and concentrated our gazes toward his end of the table. Then, breaking into an uncharacteristic grin, he drew a folded paper from his waistcoat pocket. Holding it at arm's length, he read, "Dearest and Most Beloved Papa." His grin widened. "I hope this letter finds you and my sisters in good health. Many of our ship's crew have been laid low by a fever, but I, by the grace of the good Lord, have been spared."

My father nodded. "Yes, Alessandro always had a good, strong constitution." He continued reading out loud, "I will be home a few weeks earlier than I expected. Our ship should dock no later than the tenth day of December. As you know, we were bound for the Turkish port of Smyrna, but when we stopped at Crete, we were advised to sell our cargo there as the current troubles in Smyrna would surely prevent us from realizing the best price for our goods."

Grisella bounced up and down in her chair. "That's only a week or two away. Will Alessandro bring us presents like he did last time, Papa?"

Over the top of the letter, my father gave Grisella one of his critical looks, the kind of look that had caused many a Mendicanti girl to run to her room sobbing into her handkerchief. "The most precious present you could wish for is your brother's safe return. Sea journeys can be quite perilous," he replied sanctimoniously.

Grisella's smile vanished and she poked glumly at the remnants of her polenta as Annetta cleared her throat. "What are the troubles in Smyrna?" my older sister asked. "Alessandro has traded there successfully many times in the past."

"He says he dares not write about them, but promises to tell us more when he arrives. I'll leave the letter here for you all to read." Father pushed back from the table, looking exasperated, as if we had failed to give Alessandro's letter the enthusiastic response he thought it deserved. He fired a parting shot on his way out. "Anna-Maria, you must get Alessandro's room ready for him. The current arrangements are not…suitable."

These last words had been aimed at Felice, who had slept in Alessandro's bed last night. My friend had been silent but attentive as I had described my first day at the opera company. Now he ran a hand through his black hair and said, "I never intended to be such a nuisance. Have you got somewhere else you can put me, just for a while?"

Annetta thought for a moment. "There's an old cot in the storage closet under the roof. We could put it in Tito's room. If that's all right with you," she directed at me. As I nodded, she sprang up to clear the table and said, "I'll send Lupo up there tomorrow and we'll get it down for you."

Felice stacked his dishes and slid them toward my ever busy sister. "Don't let me be any more trouble to anyone," he said. "Tell me where the cot is and I'll set it up in Tito's room."

"There's no need to do that now." Annetta gave him a quick smile. "Alessandro's ship won't arrive for days."

"Please, Annetta, let me do this one thing." He leaned over the table and touched her wrist to give special emphasis to his words. "I feel so useless here, let me fetch the cot."

"All right, Felice," my sister answered in a soft voice. "Grisella, take a candle to light the way and show him where the closet is. There's a trunk with extra blankets in there, too."

Grisella rolled her eyes and treated us to an irritated sigh of theatrical proportion. "But I want to talk to Tito about the opera."

Her words gave me a guilty pang. Upon coming home, I had resolved to reacquaint myself with my younger sister but so far I had barely talked with her.

Felice came around to stand behind Grisella and put his hands on her shoulders. With his lips to her ear and his eyes on me, he said in a stage whisper, "I want to hear more about the opera, too. Light my way upstairs and when we come down, I'll make Tito tell us everything he did today. I'll wrestle him to the floor and sit on him if I have to."

Felice's promise raised a giggle from Grisella. While Berta trundled in to finish clearing the table, the girl happily led Felice in search of the bedding.

<center>⌒⟶⟶⟶</center>

Annetta had created a snug retreat in her room on the second floor. The focal point was the narrow bed in the corner hung with lavish festoons of fawn-colored velvet and bolstered with pillows of faded tapestry and damask. I gratefully threw myself into a threadbare armchair that had been covered with a throw of the same velvet. Although the rest of the house was chilly, warmth pervaded this room. I soon saw the reason, a *scaldino*. Venetian women of all ranks are addicted to the *scaldino* during the winter months. Since our climate is mild eight months of the year, most houses are built without fireplaces and have only one or two stoves. Extra warmth is provided by a glazed ceramic pot filled with glowing charcoal that can be moved from room to room with an attached handle. Annetta's *scaldino* had been warming her room all during supper. I toasted my feet beside it while my sister sat at her dressing table and began to remove the pins from her hair. Long, silky strands tumbled down her back, which was turned toward me. I could see her face in the oval mirror.

"Recognize this, Tito?" She held up a small glass box filled with hairpins.

"Of course, I gave it to you on your tenth birthday. Aunt Carlotta took me down to the market stalls on the Rialto to pick out a present for you. I was so taken with that box. I thought it was made of jewels, not just cheap, colored glass."

"I did, too. We used to lie in the sun under my window and use that box to shoot rainbows of light all over the ceiling."

"You've remembered that all these years?"

Annetta's face became grave in the oval mirror. "After you left I had plenty of time to remember," she whispered softly.

I hung my head, reminded of the aching homesickness that had plagued me at the *conservatorio*, but I knew there was no use in recalling past sorrows. I changed the subject to the current state of the household. I was particularly interested in Father's activities.

"Father spends most evenings out," Annetta told me.

"Where does he go?"

My sister's hair crackled as she took an energetic brush to it. "I've always thought he had a woman somewhere. It's been well over ten years since Mother died and I wouldn't expect him to live like a monk. No other Venetian man would be so virtuous. Come to think of it, even the monks are not so virtuous these days."

She gave me a wisp of a smile from the mirror. I tried to return her gaze, but found myself looking down at my hands without anything to say. "Are you surprised that I talk of such things, Brother?" she asked in a low voice.

"Perhaps. I know that Venetian girls are usually closely sheltered until their marriage."

"I suppose I'm not the typical Venetian girl. I've been in charge of the household for many years now. After Mother died, Berta was supposed to manage things and chaperone both Grisella and me, but Grisella has been such a handful. She always demanded the lion's share of Berta's attention."

I was beginning to understand what the past few years must have been like for my sister: too much responsibility and very little amusement. While I had been feeling sorry for myself and struggling with my studies at the *conservatorio*, I had imagined everything at home staying exactly as I had left it. Now I saw how illogical that thinking had been. Despite the cheerful tone of her letters, my sister had been struggling too. I had a sudden inspiration. I told Annetta about the reception at the Palazzo Viviani.

"Would you like to go? I don't see why I can't get permission from Torani for you to come with us."

Annetta turned toward me, face alight. "I would love to see the inside of the *palazzo*. And hear you sing with Adelina, of course," she finished lamely.

We laughed at the same time and launched into gossipy speculation about the notable figures we might see at the reception. I recounted Viviani's afternoon visit to Adelina's dressing room, and we both wondered how Signora Viviani and her circle would receive the beautiful soprano.

A small cough announced the presence of Felice and Grisella at the doorway. The girl held a candlestick. Its flame picked out random highlights in the long, red hair tumbling over her shoulders and illuminated her smooth, peach-tinged cheeks. I was reminded, not for the first time since my return, of what a little beauty Grisella was becoming. She gave me a faint smile and began to move on down the hall.

Annetta stopped her by calling, "Grisella, come in here for a minute."

Grisella, expression now blank, glided into Annetta's room and sat down on the bed. Our older sister moved to her side. Felice perched on the low footstool by my chair. His legs were so long that it was easy for him to cross his arms over his bent knees and rest his chin on this pile of limbs.

Annetta pushed a few lustrous strands off Grisella's moist brow. "Are you all right, little one?"

"I think I need some of my medicine," she replied in a small, tight voice.

"I thought something was wrong when you came back from the Mendicanti this afternoon." Annetta nodded knowingly. "Was Father hard on you at the concert? Did he embarrass you in front of the other girls?"

"It wasn't Father. He said I did all right today."

"Then what is it, child?" Annetta gently raised Grisella's chin and studied her impassive face.

"Someone made a promise to me. Someone was supposed to be there and never showed up." The candle flame glinted off her hard, dark eyes. "I waited and waited."

I watched uneasily as Grisella's lips compressed and her grip on the candlestick tightened. Long familiar with our sister's moods, Annetta was a step ahead of me. She had already retrieved a key from the belt at her waist and was removing a bottle of elixir from a drawer in the table by her bed. Grisella had not yet been totally overtaken by whatever strange force caused her tormenting spells. She allowed Annetta to take the candle from her clenched hand and even helped our sister tip the elixir into her mouth.

"Not so much, dear," Annetta cautioned.

"I know. I'll be all right now," whispered Grisella as she laid her head in Annetta's lap.

Annetta relaxed back against her pillows and folded her legs under her skirt. Her brown eyes showed the relief of having averted another of Grisella's spells. Grisella lay motionless as Annetta stroked her hair and gave her some advice about how to get along with the other students.

"I know some of those girls must be very jealous of you. You have a nice home to come back to at the end of the day, and most of them are orphans. Not only do you have a family, but your father is one of the most important maestros at the school. I'm sure some of the girls do and say things to hurt your feelings, but you can't let them bother you. Tito and Felice know what I'm talking about." Annetta prompted us with a raised eyebrow.

"She's right, Grisella." Felice took the cue. "We were teased all the time at San Remo. When Tito started getting solo parts in our concerts, little *accidents* started happening." He grinned up at me. "Remember when that bunch from Genoa locked you in the latrine and old Norvello was going to whip you for being late to rehearsal?"

I could laugh about it years after the fact, but the incident had been no joke to me then. When hundreds of boys of different ages are housed together and kept on a rigid schedule of

study and practice, high spirits are bound to get out of hand. The popular maestros tolerated our pranks and tried to provide some play and recreation, but a few seemed to enjoy crushing any sign of misbehavior. Maestro Norvello had been a particularly mirthless stick of a man who had more than once drawn blood from my bottom with his hickory cane.

I finished Felice's tale. "And you scoured the compound and found me just in time. You even smoothed things over with that old...." I let the word I had been going to use to describe our most hated maestro hang in the air in deference to Grisella's young ears.

"And then there was the time you were almost poisoned to death," Felice continued, rocking back and forth on his stool.

"What happened?" cried Annetta as Grisella pulled her head from our sister's lap and sat up with a curious expression.

"It wasn't really that bad," I explained. "Someone doctored my wine before I went on stage. He wasn't trying to murder me, just interfere with my singing. He succeeded in that. My throat turned to cotton and my breathing was ragged. I got through the opera somehow, but it definitely wasn't my best night."

"Who did that to you?" asked Annetta in shocked tones. She had never competed with another singer for a coveted role and had no idea how cutthroat the process could be. It was no wonder ambition was rampant with the stakes so high. A *castrato* who achieved the highest order of fame could retire a wealthy man in just a few years.

Felice and I glanced at each other. I said, "We never found out for sure."

In the same breath, Felice replied forcefully, "It had to be that pig of a Calabrian, Bruno Cambiatti. He always hated you."

"But we never really knew."

"It never happened again after I dealt with him, did it?" Felice closed his eyes and smiled slyly, like the fox relishing the bunch of grapes in the old fable.

I shook my head as he put his hand over his heart in a mockingly plaintive gesture, and said, "Just a few well placed punches in the fat belly of his."

Annetta's eyes widened and I could almost see her readjusting her mental assessment of Felice's character.

"Oh Tito, you're far too kind. Bruno's curls weren't even ruffled," Felice finished defensively.

We were each lost in memories for a moment, then Annetta rose and pulled Grisella up after her. "It's time someone was in her own bed." Grisella's dark eyes had turned misty. She allowed herself to be led away, too sleepy or dazed from her elixir to protest.

Felice stretched his long legs and jumped up from the stool to pace the room. Reminiscing about our adventures at San Remo had energized him, while the cozy warmth of Annetta's armchair was making my eyelids as heavy as Grisella's.

"So, our gondolier was right about Adelina Belluna and Viviani. Were they really that obvious?" he asked as he paced.

"Oh, you heard that, did you?"

"Most of it, yes."

"There's no doubt they are lovers, but she would still be prima donna without that advantage. She couldn't be anything else. I've never met a woman like her...so beautiful and so strong. No wonder half of Venice is at her feet." Felice's inquiring look encouraged me to continue. "You must hear her sing, Felice. What skill she brings to that trite score we have to work with. She can shade a note with a hundred different emotions. She infuses the music with such passion."

I paused on hearing Annetta's footsteps and husky laugh. She threw herself across her bed with hair and skirts flying and propped her chin up on one hand.

"Is the music the only thing she infuses with passion?" she teased.

"You don't understand," I said wearily. "Adelina was so kind to me today, and she certainly didn't have to be. She was even gracious in the face of Caterina's malicious remarks. I wish I had just half her composure."

"Oh, we understand." Annetta chuckled again. "Is he always this easily infatuated, Felice?"

My friend had stopped pacing and was leaning glumly against a bedpost. The lines of strain I had noticed around his eyes at the beginning of this long day had returned. He kept his gaze on me while he answered Annetta. "Not at all. I'm afraid your brother has never given his affection easily."

Chapter 7

The day of the reception at the Palazzo Viviani began wet and overcast but ended with a blazing sunset that reflected off the canals in fiery oranges and pinks. Maestro Torani had ended rehearsal early and sent us home on a wave of last-minute instructions and exhortations. As a gondola bore me toward the Campo dei Polli, I wondered if Annetta had started getting ready. Torani had easily secured Viviani's permission for me to bring my sister to the reception, and Annetta had talked of nothing else for the past two days.

I had originally thought that our group of singers would set out from the theater, but Adelina had announced other plans. To perform at the *palazzo*, she had demanded plenty of time in her own boudoir with the services of her maid and hairdresser at hand. Torani and Orlando had sparred over who would collect Adelina and escort her to the reception. Torani, being the director, won that battle hands down.

I had hardly closed the door of the house behind me before Berta trotted clumsily down the hall.

"Oh, it's you, Signor Tito," she said in a worried tone.

"Who were you expecting, Berta?"

"My baby…and your Papa. I have their supper ready, but they don't come. Every night they are later and later and my little lamb looks so tired."

After a moment's puzzlement I realized that she meant Grisella. "I'm sure they will be here soon. Lessons at the Mendicanti must have ended an hour or two ago."

Berta's lined face remained full of concern, and she continued to twist the corner of her apron. Before heading back to the kitchen, she gave me a sidelong glance that plainly expressed her lack of confidence in my attempt to reassure her.

I started up the stairs but stopped halfway when Annetta appeared at the top. The golden brown hair which was usually held back from her face in some utilitarian knot was arranged in soft curls piled high on her head. She had left one shiny ringlet loose to flow down her right shoulder. Two combs ornamented with silver butterflies that seemed to tremble on her curls completed the effect. Her gown worried me a bit. It was French brocade the color of a ripe persimmon, but unadorned by any frill other than a row of matching bows that marched from the low bodice to her slim waist. I hadn't expected to see Annetta in a powdered wig or weighed down by jewels, but I was afraid she would feel out of place among the sumptuously dressed patricians.

In that intuitive way of hers, my sister had read my mind. "I know what you're thinking," she said. "Annetta looks very ordinary. Will she even be admitted to the *palazzo* in that old dress?"

"No, no. I think you look beautiful," I answered on reflex, then realized I meant every word.

Annetta descended holding her skirts out to each side and swaying to a tune played by invisible musicians. Her brown eyes sparkled with a look far removed from her accustomed, tranquil gaze. It was good to see her happy and excited.

She reached the stair above me. "I know my wardrobe can't begin to compete with what most of the women will be wearing, but I don't care. This is my best dress and it will just have to do." She poked me in the chest with her forefinger for emphasis.

"It will do, beautifully," I agreed.

"Besides, I'm not going to this reception to impress anyone. I just want to be there, to see what it feels like to be a guest at the fabulous Palazzo Viviani."

"But we won't ever get there if I don't start getting dressed. Where's Felice?" I asked as I dashed around her and up the stairs.

"He went out to talk to someone about some work, one of Father's friends. He didn't know when he'd get back. Don't take too long, Tito."

❧

The arched entrance to the Palazzo Viviani was ablaze with lantern light and crawling with pink-coated footmen. Gondolas were lined up three abreast waiting for an opening to dart up to the moorings topped with the Viviani crest so they could deliver their passengers. As we disembarked, a footman ran up to ascertain our identities. He passed our names to another pink coat and, before we had begun to mount the stairs to the richly sculpted bronze doors, an austere man with sunken cheeks and flinty eyes sailed down to direct us through one of the smaller archways.

"The musicians will gather in a room down this corridor. Signor Viviani does not want anyone to see you before the entertainment. Afterward you may mingle with the guests as you please."

Annetta and I quickened our pace to match our guide's long, smooth strides. His pink livery denoted the status of a servant, but the deferential attitude of the footmen who sprang to open doors and the sudden quieting and lowered eyes of a trio of chattering maids proved that our guide was a man of some authority in the household. As he led us deeply into the sprawling residence, my curious nature prodded me to peer into the rooms with open doors.

Crates were piled high in cavernous chambers while smaller rooms were filled with slanted writing desks and shelves groaning with ledgers. Even at this time of the evening, with a large party going on upstairs, men in canvas aprons were hard at work moving boxes and checking stock. Our somber escort

was directing us through the ground-floor business area of the great house to avoid the guests pouring into the reception salon on the second level. According to Venetian custom, the *palazzo* served not only as living space for several generations of the noble family and its servants, but also as the warehouse and headquarters of the family business. Based on the huge amount of goods, it seemed the Viviani business dealings must be quite successful indeed.

We finally stopped before a door attended by a very young footman. Muffled strains of music from a string ensemble floated down a nearby staircase.

Our escort put his hand on the doorknob. "The others have already arrived. Leave your cloaks in here. Someone will call for you shortly." He opened the door and gave Annetta the smallest of bows, really just a barely perceptible inclination of his head, before he whisked up the stairs.

"Who was our friendly escort?" I asked of the assembled company as we stepped into a small room that was furnished like the antechamber of an advocate's office.

Torani cleared his throat, his expression more irritated than usual. "That's Bondini. If he has a first name, I've never heard it. Crivelli would probably know it. They both hail from Bolzano, over on the mainland. Bondini is Viviani's major-domo."

"And foremost pompous ass," Orlando broke in.

Torani held up a cautionary hand. "Bondini has day to day charge over all his master's dealings. He organizes the household staff, decides who will be admitted to Viviani's suite and takes care of…some of his more personal errands. You don't want to cross him. I've been told he can break an occasional arm if he has to."

"Well, I say it's just not right." Orlando could not keep silent. "He shoves us away from the main entrance and treats us like lepers, as if we are somehow unclean because we perform before an audience."

Adelina was slumped in a straight-backed armchair with her hand on her forehead. She sighed. "Orlando, please don't start that again. Domenico, I mean Signor Viviani, is merely

trying to whet the crowd's appetite for our duet. He wants us to make a grand entrance to get everyone's attention. It makes good sense."

Torani nodded. "Adelina is right. I've been up there. The room is buzzing with talk about *The Revenge of Juno* and our new *castrato*." He inclined his head to me and seemed to notice Annetta for the first time. "Is this pretty lady your sister?"

"Oh, yes." I belatedly presented Annetta to each of my colleagues.

Orlando swallowed his resentment and made some pleasant welcoming remarks. Adelina seemed glad of the diversion. She rose and took both Annetta's hands in hers. "We're so glad to have Tito with us at the San Stefano. You must come and hear a rehearsal. The opera is finally beginning to come together."

We were all standing in the middle of the small room, rejoicing over getting through two unhampered days of rehearsing *Juno*, as we had come to call the production. In cheerily decisive tones, Adelina proclaimed that delay and misfortune were finally behind us. I watched Torani's face. If there had been a brief flicker of unease in his eyes, it vanished almost immediately. He was wallowing in the general self-congratulation when the young footman entered. In a quavering voice, the boy announced, "Signora Maria Grazia Albrimani."

A rotund stump of a woman in a somber widow's gown marched through the door. I put her age at less than forty, although her severe dress and heavy facial hair gave her the aura of a more advanced age. Her broad bosom, which supported an ornate crucifix as her only jewelry, rose as she drew herself up and prepared to speak.

"Some of you may know me. I am Signora Viviani's sister. I have come to view the...." Her lip curled in a particularly dramatic expression of disgust. "The actress who is bent on embarrassing us all and bringing dishonor to this house."

I dropped my jaws in mute surprise, unsure of what to do or say until Torani took the lead.

Our director swallowed hard and bowed obsequiously. "Signora, we are simple musicians, here to entertain, not offend." As he spoke he sidled in front of our little group, perhaps trying to shield Adelina from Signora Albrimani's wrathful glare.

"The presence of a courtesan is always offensive to ladies of quality and refinement, Signore. When the courtesan parades herself before a good wife that she has wronged, the offense is doubled. No, tripled."

"Oh dear," whispered Adelina. Annetta drew close and reached for her hand.

"I have heard all about this La Belluna," the little woman continued in scathing tones. "Her mother was a common servant in the house of a Turkish trader. Only God himself knows who her father was. She may even have the blood of an infidel in her veins. They say she has had so many lovers that no one in Venice can remember how many men have kept her. And still she makes a brazen display of herself on the stage and uses her whore's wiles to ensnare more good Christian men. It's appalling! Venice should follow the example of Rome and forbid women to appear on the stage."

"Please, Signora." Beads of sweat were popping out on Torani's domed forehead. He spread his arms wide, palms facing backward, in a protective gesture that included us all.

"Out of the way, fool. You're no better than she is, bringing such a wanton woman into this house." Signora Albrimani pranced deftly around Torani and placed herself squarely in front of Adelina. "Why don't you take yourself away from here instead of flaunting your shame before everyone?"

Adelina's cheeks were flushed, and she clutched my sister's hand so tightly that their arms were trembling in the folds of their skirts, but she kept her voice soft and steady. "I have been invited here to sing by the master of the house and sing I will."

"Then this is what I think of your singing and this is what the Albrimani family thinks of you." The undersized virago suddenly bounced onto her tiptoes and slapped Adelina hard across the cheek.

Orlando was the first to move. Cursing and sputtering, he sprang at Signora Albrimani as she stepped back with an unrepentant smirk on her round face. Torani wisely restrained him. Adelina stood as still as a statue, her hand to her cheek, her eyes staring into the middle distance. What was she thinking as Annetta murmured in her ear and tried to draw her away?

As I stood listening to the blood drumming in my ears, the door burst open to admit Bondini and the young footman. The major-domo seized the meaning of our stricken tableau in an instant. In a whispered growl toward the miserable footman, he said, "You should have called for me at once."

Then, with a bow to the still smirking noblewoman, he said, "Signora Albrimani, your sister is asking for you. She would like you at her side when the entertainment begins."

Bondini swept a pink-coated arm toward the door. His posture was all deference, but his severe gray eyes gave his words the weight of a command. Signora Albrimani drew a black-lace fan from a pocket in her voluminous skirts and flicked it open with a rebellious snap. She gave each of us a long, challenging look before leaving the room with the small, petulant steps of a child ordered away from a favorite game.

Torani exhaled with an audible rush of air, then grabbed the major-domo's sleeve. "This is abominable. What right has that loathsome woman to insult Signora Belluna?"

Bondini brushed Torani's hand off his arm, straightened his sleeve, and directed his answer to Adelina. "Signora, you have my most sincere apology. The master's sister-in-law has seriously overstepped her bounds. She resides in this household as Signora Viviani's companion and is charged with helping her sister with a multitude of domestic duties. Unfortunately, the companion casts herself in the role of champion and protector. The lady invents troubles, takes offense at trifles, and is determined to create a crisis at least once a day. I say this in explanation, not to excuse her behavior."

Adelina listened gravely, her face a lovely, unsmiling mask with a fading splotch of red on one cheek. She broke her stillness with a shudder and nodded at Bondini.

"Can I get you something, Signora? A glass of wine? Brandy?" He kept his eyes on Adelina but snapped his fingers at the footman, who had been hovering anxiously.

"No, Bondini. I don't need anything. I'll be fine." The soprano smoothed her hair, adjusted her glittering necklace, and continued in a firm voice. "Isn't it about time for the duet?"

Bondini's expression barely flickered, but I thought I detected relief in Viviani's right-hand man. It would surely not have gone well for him if he had been forced to report that one of his master's jewels couldn't sing because of Signora Albrimani's outrageous conduct.

Adelina swept through the door and started up the stairs, her head held as regally as the queen of the gods she was to portray. If she had qualms about performing after what had happened, she gave no outward sign. We followed in single file, even the temperamental Orlando humbled and quieted by the soprano's full measure of grace and dignity.

Chapter 8

Looking back on that night, the performance and its aftermath seem like a blurred jumble of events. The preliminaries flashed by in the space of one nervous heartbeat. As the rest of us waited outside the high, crimson and gold salon, Torani crossed the marble floor to the harpsichord that nearly filled a bay at one end of the long room. He introduced our duet with an icy calm. Then, a bearish Orlando plowed through the salon and took his seat at the keyboard. Adelina and I followed to the fluttering of polite applause. Mild interest registered on the faces of the brilliantly clad patricians seated on the spindly chairs that had been brought forward by the footmen. The less important guests had to make do with standing in small groups or hugging the wall behind the seated nobility.

A few faces amid the crowd leapt out at me as we made our way across the room. Here, a comically tall wig crowned a man who must be struggling with drowsiness brought on by an overgenerous dinner. He could barely keep his heavy-lidded eyes open. And there, an enticing pair of feminine eyes the color of emeralds was peering at me over a skillfully manipulated fan. Domenico Viviani sat directly in front of the harpsichord. His face could have been chiseled from the same marble that graced so many of the surfaces in his *palazzo*. His piercing, brown eyes sent us the message that he was expecting nothing less than perfection. Finally, I caught sight of Annetta's proudly beaming

face over the sea of powdered curls: a steadying sight if there ever was one.

Adelina and I began with a piece of fluff designed to put our listeners in a receptive mood. Then we sang a lengthy duet that Orlando had originally written for Crivelli and Caterina. With less than two days to produce a finished, well-rehearsed piece, Orlando had taken some liberties with the poetry of the libretto and reworked the duet for my character to sing with Adelina. I had been given a generous allowance of vocal leaps and flourishes, even some passages that stretched the flexibility and stamina of my voice to its limit. I realized Orlando must have added these at the last minute, as I knew Crivelli couldn't sing them anymore. Adelina also had plenty of material to showcase her talents, and she plunged into the music with a spirited gusto that kept the audience enthralled.

I kept trying to figure out how she did it. Her voice was still good, no doubt of that, but I and every other regular operagoer in the room had heard better. Was it the depth of feeling she brought to the character of Juno? On paper the vengeful matriarch of the gods had seemed such a dusty stereotype. But in Adelina's experienced hands, Juno displayed unexpected dimensions. There was pathos behind the anger. Adelina let the audience experience Juno's sorrow as she remembered the days when her mighty husband had loved and desired only her. In subtle nuances, she communicated the shame of being rejected for a younger woman time and time again. Her sweet, yet forceful voice and her graceful gestures touched a receptive chord in every listener. The after-dinner napper opened his eyes and sat up straight in his chair with a bemused expression on his face. Ladies who had been busily comparing clothing, jewelry, and seating arrangements gradually fixed their wandering attentions on Adelina. As my singing partner wrung every bit of emotion from our dramatic duet, I saw private sorrows exposed on carefully powdered and rouged faces.

It was not only the faces of our listeners that betrayed. When the course of the duet allowed me a chance to observe Orlando

Martello, I was astonished at the transformation of his face. His hands flew over the keyboard, but his eyes were glued to Adelina. As he watched her bring his notes to life, his entire demeanor softened. I saw no sign of the irritation that so often turned his smiles into sneers. Orlando's finely shaped lips were parted in a graceful curve that spoke of admiring delight. Even his skin seemed finer, actually glowing. How could one man appear in two such different guises? The coarse-grained hothead that Torani had been forced to restrain just a few moments ago had become a gentle, love-struck swain.

As I turned my attention back to the audience in time for our final refrain, I noticed that the emerald-green eyes atop the fan had found a new focus. I was surprised to follow their appraising gaze straight to Annetta. As they turned slowly back to me, their owner finally lowered her fan. I had a glimpse of a white, fresh face and a delightful crooked smile before another feminine head topped by a huge round wig bobbed into my line of sight. I was also perplexed to see several glum faces on the front row. Two men who wore silk coats but lacked the sashes, medals, and other trappings of Venetian nobility were whispering to each other and shaking their heads. They both gave me long and particularly pensive looks.

The duet concluded to great applause, and we were called upon for several encores. When our patron judged our performance to have reached its maximum impact, Domenico Viviani strode forward and kissed Adelina's hands, then called for a last round of applause for the both of us. Before I knew it, our noble host grasped my elbow and steered me into the crowd to meet those individuals he must have fancied were critical to the success of his operatic endeavor.

Everywhere I heard myself introduced as "Tito Amato, the immensely talented *castrato*, newly arrived from Naples." My discomfort grew with each introduction. Why couldn't he just describe me as a talented *singer?*

I exchanged bows with a dizzying parade of Venetian patricians, churchmen, senators, and foreign princes. At one point I

spotted Annetta in the crush of brocade and velvet shoulders. I stretched one long arm, grabbed a handful of skirt, and dragged her into our charmed circle. Before Viviani could make another introduction, I made one of my own.

"Excellency, allow me to present my sister."

"But of course." He smiled jovially, a sign I took as further proof that he considered the evening a success. Then he directed a questioning gaze right and left.

Annetta had the look of a startled doe, but I gave her arm a quick, reassuring squeeze. "Your Excellency, my sister, Anna-Maria Amato." She stepped forward and dropped into a shallow curtsy.

Viviani's smile collapsed and was replaced with a puzzled expression. I wondered anxiously if our patron had forgotten that he had given Torani permission for my sister to attend the reception. But after that instant of hesitation, his gaze roved appraisingly over Annetta's face and form. Running the back of one hand along her jaw, he said, "A pleasure, my dear. Another pretty face is always welcome at the Palazzo Viviani." Annetta and I traded amused glances as Viviani hustled me along.

Our last stop was Signora Viviani and her entourage. One of these I had already encountered. The formidable Maria Grazia Albrimani hovered at her sister's side like an observant watchdog. With her round face and ferocious expression, she reminded me of the temple dogs embroidered on Chinese tapestries that were said to defend their holy masters to their dying breaths. She gave me a stiff smile as we approached. Viviani presented me to his wife, then melted into the crowd after Bondini came up and whispered a few words in his ear.

Elisabetta Viviani was ensconced in a high-backed armchair of figured velvet, one of the few comfortable chairs in the salon. She rested her head on the back of the chair as if her elaborately coifed wig weighed too heavily on her long, fragile neck. Her pale hands, one clutching a lace fan, lay motionless on her lap. The Signora was not a great beauty, but she possessed the polished appearance and haughty indolence that unmistakably marked

her as one of the privileged class. In addition to her sister, Signora Viviani was attended by several other ladies of varying ages and by one young man. Or was he? His cheeks were smooth but, on closer inspection, I saw that the youthful blush on those cheeks was cosmetic and that there were fine lines at the corners of his eyes. Signora Viviani made a languid motion for him to bend close to her and her mouth grazed his ear in a whisper. He responded with a high, delicate laugh that confirmed my suspicion that he was a *castrato*.

"Signor Amato, you have a charming voice," she said, fixing me with a glassy stare. "You will certainly enliven our opera this winter."

"You are too kind, Signora," I replied with a low bow.

"We were getting so tired of it all. Going to the opera every night to see old Crivelli wheeze and totter around the stage. Every new *evirato* that Domenico brings in is always reported to be the brightest and the best, but none of them has had your gift. That one last year!" She turned to her gentleman-in-waiting. "*Caro*, what was his name? You know the one."

"He called himself Angelino. He liked to boast that his vocal talents could rival the angel choirs of heaven." Her elegant companion rolled his eyes.

"Oh yes, what conceit he had. I made a joke about him, didn't I? What was it? I can't recall."

"My sweet lady, I'll never forget it. Instead of the heavenly host, you compared his singing with the screeches of the damned." Again the high, lilting laugh.

"So I did, so I did." Signora Viviani tittered behind her fan and her ladies followed suit.

She turned back to me. "But Signor Amato has the voice to the match the praises that are heaped on his name." Her eyes lost their glassy look and assessed me more keenly. "I predict that the opera will no longer be boring." She leaned forward and tapped me on the chest with her fan. "And I predict that our passion for good singing will finally be satisfied."

One of the younger ladies burst into a giggle but quieted abruptly when the old watchdog, Signora Albrimani, shot her a stern glance. The *castrato* on the other side of his lady's chair began to eye me warily.

Signora Viviani sat back wearily and continued in a vague tone, "You must take a name for the stage. All the singers that aspire to fame come up with something memorable, something that describes their talents."

"I confess that taking a stage name hasn't occurred to me," I replied, considering quickly. "Since the opera hasn't even opened yet, I think I'd better wait and see what Venice thinks of me."

As I received only a vacuous stare and a dismissive nod in return, I let myself be displaced by others who were crowding in to pay their respects. I made my way around the perimeter of the salon, looking for Annetta or Adelina. I saw no sign of either. When a footman presented a silver tray laden with glasses, I realized that my throat was bone dry and gratefully took a deep gulp of Viviani's excellent wine. To escape the crush of the over-heated salon, I turned this way and that in search of the supper room. In my haste, I bumped into the owner of the green eyes that had so closely observed my performance.

She raised a delicate eyebrow. "Where are you off to in such a rush, Signore?"

"Please excuse me, Signora. I didn't mean to run over you. I was looking for the supper room."

"Does singing give you an appetite then?"

Not knowing quite what to say, I'm afraid I only stared and smiled foolishly.

She continued to regard me inquisitively. I thought she was absolutely extraordinary. Up close, her skin was as pale and perfect as it had seemed from a distance. Her green eyes shone with a lively intelligence that aroused mischievous, incongruous thoughts within me. Unfortunately my tongue remained leaden and mute.

She spoke again, fluttering her open fan on her ivory bosom. "What's this? Has your beautiful voice deserted you? Are we to

come to a standstill so early in our conversation? Surely you know whether singing makes you hungry or not."

I had an overwhelming desire to impress her, to say something tremendously humorous or charming, but all I could manage was a weak, "Sometimes it does."

She smiled her crooked smile. "Then I had better leave you to your supper."

She melted into the crowd as I silently cursed my towering stupidity. I clearly had a lot to learn where the ladies of society were concerned. Directing my unhappy feet to the periphery of the vast salon, I soon found Torani in an adjacent room enjoying a plate of delicacies from a long table laden with silver trays and platters. He clapped me on the shoulder and dabbed his greasy lips with a napkin.

"You and Adelina made quite an impression, Tito. Viviani is well pleased."

"Yes, we sang well," I said indifferently, my mind still on the disappointing exchange with the alluring, green-eyed woman.

"You are too modest." He chuckled and reached toward an epergne filled with chilled quail eggs and spiced olives. "Did you see Bragadin and Steffani? They looked positively worried."

I could only shake my head in puzzlement.

"Of course, you don't know who they are. The manager and musical director of the Teatro San Moise, our most serious rival. You have them shaking in their boots."

I remembered the two thoughtful gentlemen in the front row. Viviani had been showing me off to the competition. "Does this mean that *Juno* will be a success?" I asked.

"It's a good start. On opening night, the boxes are sure to be filled with the guests who heard you sing tonight. And Viviani's connections will ensure that word of tonight's triumph will spread around town throughout the coming week. The cafés and coffeehouses will be buzzing about the new *castrato* at San Stefano. That means the cheap seats in the pit will be sold out, too. No one will want to miss *Juno*."

"I don't know if I like the idea of being the talk of Venice."

"Why?" Torani raised an eyebrow as he sucked on an olive pit. "That's how a singer's reputation is made. If you have a successful season here, you can go anywhere you want...Rome, Florence, even London."

I shook my head. How could a whole man understand what it felt like to be a eunuch, especially with everyone in the Republic of Venice discussing my merits like I was a prize racehorse? I wanted to walk the streets, go into a shop, or have an ice at a café with no one knowing that there was anything remarkable about me. But from now on, everywhere I went, I would always be known as Tito Amato, *castrato* soprano. Since the surgery had been forced on me, my love for music and the joy of using my voice had been shadowed by the knowledge that I had been mutilated for the very thing I loved. Mutilated for the sake of the music. Once I had been master of my voice. Now my voice controlled my life, my very destiny. I had become a slave to the music.

Suddenly I was no longer hungry. I only wanted to find Annetta and go home. I bade Torani goodnight and stepped back into the salon. Most of the guests had departed, and I noticed that many of those remaining had overindulged on Viviani's good wine. I glanced toward the corner where I had talked with Signora Viviani but saw only a tableau of empty chairs. She and her hangers-on had withdrawn to a private area of the sprawling *palazzo*. I wondered if the *castrato* who waited on her so devotedly was still at her side and what more personal services she might be requiring of him. Was that what happened to those of us whose voices failed? Somehow I couldn't see Felice taking that role.

I found Annetta waiting near the hallway where we had gathered before the duet. "Have you had enough?" I asked with a tight smile.

She grinned ruefully. "I think so. I've had wine spilled on my dress, been quizzed about my lineage by every dowager in the room, and had my bottom fondled by an archbishop."

We descended to the little room where we had left our cloaks. There was no sign of the young footman, and the long corridor lay in semi-darkness. Only a few wall lamps threw weak rings of light at wide intervals. The commercial floor of the great house had finally been put to rest for the night.

The door to the room was standing ajar, and we hesitated when we heard quarrelling voices.

"Just come to England with me, everything will be different there." This was a man's voice, deep and insistent. Surely it belonged to Orlando Martello.

A feminine voice responded, "Why should I do that? What makes you think I want to leave Venice?"

"You're not being treated as you deserve. Your talent is monumental, yet you are forced to put up with Viviani's insatiable demands. Don't you see? Just because he owns the theater doesn't mean he owns us."

We heard a heavy sigh. "Orlando, don't do this."

"But Adelina, think of it. A new wind is blowing and it will knock princelings like Viviani down in the dirt. Someday artists like us will be masters of our fate. England is the place to go now." He paused, then continued with mounting excitement. "Londoners are mad for Italian opera. Handel can't produce scores fast enough to satisfy them. The theaters there are scrambling to hire Italian singers and composers, offering huge salaries for just one production."

"Yes, yes. I've heard all of that, but I must stay here. My plans require that I stay in Venice."

Orlando's voice softened. "If you won't go to London for your profession, then do it for me."

"You?" Adelina's voice held an incredulous note.

"You must know that I adore you. I've loved you for ages. Marry me, Adelina. Marry me and come to England. I promise you will never want for anything."

A long silence followed. Annetta made a questioning face and pointed down the corridor to the outside door. We were both in a haste to leave, but I didn't intend to break in on this unlikely

tête-à-tête. Neither could I afford to abandon my second-best, and now only, cloak. Annetta needed her things, too.

Then we heard Adelina speak in a resolute tone. "Orlando, I'm flattered. I truly am. But I don't feel the same way and I can't think of anything I've done to give you the impression that I do."

"But we could make a brilliant partnership. My music and your voice. Give me a chance. Let me persuade you to change your mind." Orlando's voice fell to a murmur.

Annetta and I still hadn't moved when Adelina burst from the room, eyes filled with angry tears and mouth set in a look of grim determination. I spoke her name and reached for her arm, but she shook her head and pulled away. We watched her gather her skirts and speed up the stairs in a huff of indignation.

Orlando stepped into the hallway a second later. His handsome face was a glowering mask of hurt and anger. When he saw Annetta and me standing outside the door, he bowed his head and let his shoulders slump like a great weight had been put on him. Annetta took a step toward him and opened her mouth to speak, but the composer lifted his head and practically scorched us with his gaze. "Vile *castrato*," were the only words he spoke before he ran down the long corridor and out into the night.

Chapter 9

"At least give it a try, Felice," I urged my friend over a steaming cup of chocolate. "You would be paid weekly wages for the run of the opera, and you would still be using your musical skills."

We were breakfasting at a café on the Piazza San Marco. In summer, we would have been sitting under the arcade, but with winter nudging autumn aside, we were having our chocolate behind glass doors fogged by the breath of shouting waiters and hungry patrons. We were discussing an opportunity at the theater. With opening night only one week away, Torani was scrambling to find musicians for the orchestra.

"What has happened to the regular violinists?" a reluctant Felice asked.

"One left for Florence unexpectedly and several others are pleading illness."

"That's an odd coincidence. What do you think is going on?"

"Torani thinks the Albrimani are behind it. Since Viviani posted guards around the theater, there have been no further incidents of sabotage, but...."

"That wouldn't stop someone from getting to the musicians with bribes or threats once they left the building," Felice finished for me.

I nodded, toying with my spoon. "Are you afraid for your safety? Is that why you don't want to join the orchestra?"

"No. That's not the reason. You know I've always been able to take care of myself." Felice took a sip of the fragrant chocolate,

then confided, "You see, if I take a position as a violinist, I might as well admit I'm giving up on my voice, and I'm not ready to do that. Sometimes my throat surprises me and I can sing like I always did. I start to feel confident again, then my voice breaks without warning. If I could only learn to control it."

"Do you still think that is possible, after all the remedies that you have tried?"

He smiled in a conspiratorial way and leaned over the table. "Someone has let me in on a secret. One of your father's friends, a much respected teacher at the Ospedale Pieta, an associate of the great Vivaldi himself."

I sighed inwardly. The last thing Felice needed was another piece of worthless advice arousing false hopes.

"It's so simple, Tito. He thinks my larynx must be congested from straining too hard. It's the swelling that is causing my voice to break. He recommends belladonna."

"What? A poison?"

"It's true, Tito. Gargling a small portion every day can shrink the swollen veins around my vocal cords and put my voice on the mend." My friend nodded emphatically.

I shook my head. "Felice, you astonish me. Who is talking about danger now? Belladonna can be lethal."

"It is toxic—yes—in larger quantities. But I'm talking about a tiny amount. I'm supposed to gargle two drops in a glass of water every day for three weeks and not sing at all during that time."

Felice sat back with a triumphant smile on his plain face. I lowered my gaze and frowned at the stains on the tablecloth. We both jumped when a waiter dropped a tray loaded with dishes. I watched a saucer that remained miraculously unbroken careen on its side and come to rest with a clatter by our table.

"Don't listen to this man, Felice. Just because he works alongside Vivaldi doesn't mean he knows what he's talking about. Don't start this regimen," I begged.

"I started yesterday," he replied flatly.

I wanted to argue, to convince my friend it was ridiculous, a folly to continue this risky cure. But just as I started to speak,

the hopeful spark in his gentle brown eyes changed my mind. Who was I to ridicule his misplaced confidence? Perhaps Felice needed to make one more attempt to save his career before he could face the sorrow of losing the voice that was his whole life. If I were in his place, I might be clutching at the same slender straw.

At least I could advise caution. "Promise me that you will be careful. If you start to feel strange, in any way, you must stop taking the drug right away."

He nodded slowly. "I will, Tito, I promise."

I threw my napkin down and pushed back from the table. "Well, if you are not going to be singing, you might as well be scraping away on a violin. Let's go tell Maestro Torani he has a new violinist."

My lanky friend tore at the remnants of a roll and seemed deep in thought. Then, with a sudden nod of his head, he decided. "All right, I'll do it. Let's go."

We stood to gather our tricornes and cloaks, and I felt something crunch under my right foot. I looked down. It was the errant saucer. I had ground it to bits.

⁂

Torani seemed pleased with my addition to the orchestra, but Orlando refused to be impressed. In the days since the reception, the composer had avoided both Adelina and me. He had arrived just in time for rehearsal, attacked the harpsichord with a brooding expression, and hurried off as soon as Torani gave us leave. This morning, he muttered contemptuously as he flung musical scores at the newly hired string and brass players. I left Felice tuning a borrowed instrument and mounted the steps to the stage.

The San Stefano stage had undergone a wondrous transformation. The painted flats that had been drying in the scene painters' studio had been moved into place. On my left was a wooded dell with leafy green trees receding into the distance; to the right stretched rolling meadows studded with wildflowers. Center stage, serene and majestic on the backdrop, stood the distant peak of Mt. Olympus. Only a slight gaudy tone to its

purple sides spoiled the pastoral landscape. Even now, one of the scenery artists was fetching a ladder and a pot of paint to soften the mountain's bright hues.

Crivelli came up behind me. "It's amazing what they can do with a bit of paint and canvas."

I agreed. "This space seems so much larger than it did yesterday."

"I think it's the use of perspective," the old *castrato* reflected offhandedly. "These artists have quite a clever bag of tricks. They are masters at illusion." Then in a very different tone, "Uh oh. Here comes our prima donna-in-waiting."

Crivelli tried to duck between the nearest pair of flats, but Caterina was too quick for him. She planted herself directly in his path, ready for battle. Her thin lips were set in a firm line, and a sheen of perspiration covered her forehead despite the coolness of the theater. She shook a sheaf of music in Crivelli's face.

"I have to talk to you about our duet from Act One." Caterina stabbed a finger in the middle of a page. "Here, this measure. You keep coming in too early. You are rushing the music and putting me off tempo."

Crivelli took the pages in his pale, blue-veined hands. While he studied the music, the soprano tucked some unruly strands of blond hair behind her ears and tapped her foot impatiently. I puzzled over her exasperating behavior. Why couldn't she relax? Why couldn't she discuss a problem without becoming shrill and argumentative? To some extent, I could understand her drive for perfection. In my own work, I had never been satisfied with second rate. Not long after I had realized that music would, by necessity, be my life's work, I decided that I would never waste my voice. My suffering on its account had made it too precious to give it less than my best. Caterina must have her own reasons which drove her relentless ambition. I was contemplating what these might be when she whirled to face me.

"And another thing," she said, eyes blazing. "Tito, when you tried on your costume for Act Three, I could see that the plumes on your helmet were much too long. They'll be hitting

me on the face when we're on the platform. I can't sing with your feathers in my mouth."

I took a deep breath and made myself reply in the firmly controlled tones I had heard Crivelli use. "I'll have Madame Dumas take a look at them."

"She had better do more than look. That helmet needs fixing. If she were any kind of a seamstress she would have made it right in the first place."

Caterina was casting her scorn at the company's chief costumer, a straight-backed, gray-haired Frenchwoman who insisted on the title of Madame despite her many years in Italy. A more dignified and competent needlewoman could seldom be found. I gave my fellow singer a clumsy pat on the shoulder. "Don't worry over it, Caterina. I'll see that the helmet is taken care of."

The soprano drew away from me as if I had touched her with a red-hot iron. Crivelli and I watched in baffled silence as she tossed her head and hurried across the stage to upbraid Torani for some conjectured misdeed.

Finally, my old friend shook his head and whispered, more to himself than to me, "What a poor frightened thing she is."

An opera nearing opening night takes on a life of its own. Like a river at floodtide, it overflows the boundaries set by written notes, costumes, scenery, and whatever fancy stage effects the carpenters have devised. As a performer, you are either buoyed by swelling waves that are sure to crest in a stunning achievement or trapped in eddies and currents that will just as surely dash the production on the rocks of dismal failure. Either way, the process becomes inevitable. Despite the pressure from Viviani, the many delays and attempts at intimidation, and the internal tensions within the company, I sensed that *Juno* had the momentum of a great success.

Adelina seemed to share my hope. She started that day's rehearsal in high spirits. Torani had decided that the myth of Juno's revenge called for a goddess that was one part queen and one part warrior. Madame Dumas had outdone herself creating

a costume that presented Adelina in just that way. The skirt and panniers resembled a court dress but the bodice was constructed of thin, overlapping metal discs that gave the impression of armor and also happened to show off Adelina's generous bosom to excellent effect. The headdress was a flattering composite of wig and battle helmet. The finishing touch was a tall spear that Adelina brandished when Juno whipped up a windstorm or turned mortals into bears. She delighted in her role as warrior goddess, and spent her time between arias teasing the stage crew with her spear and challenging Crivelli to mock battles.

Even Orlando absorbed some of the floating optimism.

He continued to ignore Adelina as much as possible but spoke to the rest of us in less malevolent tones. By dinner, he had coaxed an animated performance from the small orchestra that had begun the morning with a barely meshing, lackluster display. It was when Torani called for a dinner break that an unfortunate incident occurred.

Over the years, Felice had accustomed himself to his tall height, but he had not yet become master of his lengthening arms and legs. In fact, the movements of these loose, ungainly append-ages sometimes gave him the look of a giant marionette. In the general rush to seek food and relaxation, Felice's legs became tangled with Juno's spear, Adelina had carelessly abandoned in the orchestra pit. My friend tried to catch himself by grabbing a music stand, but that went flying with sheets of music, more chairs, and Felice himself.

The crash was tremendous. Every eye in the theater focused on Felice, helpless and ridiculous, his long legs sticking up in the air from the demolished orchestra pit. The worst part was the laughter. Adelina broke the surprised hush with a loud fit of giggles and set the vast, empty theater echoing with laughter. Mine included, I'm ashamed to admit. Felice's fellow musicians scurried to pick him up and right the chairs and music stands. My poor friend shook his head like a wet dog and looked around in bewilderment. His gaze settled on Adelina, who promptly put her hands over her mouth but failed to stifle her giggles. Felice was still giving her a stony

stare as Orlando threw a surprisingly considerate arm around his shoulders and led the musicians off to dinner while making light of the fall and promising that everyone would be on their knees sorting music in time for the afternoon session.

The other singers and stagehands drifted away, leaving me alone with the now embarrassed soprano. "Oh Tito, I'm so sorry. Your friend must think I'm terrible. He must feel so bad." Adelina had finally composed herself.

"He'll be all right," I said more confidently than I felt.

"I didn't mean to start laughing. He just looked so funny knocking down first one thing and then another. Please tell him I'm sorry."

I promised to carry her apologies to Felice and started to suggest that we follow the rest of the company to dinner when she laid a hand on my arm. "Tito, I'm too tired to go out. Stay and talk with me. I'll send my maid out to the cookshop to get us something to eat."

I followed Adelina down the narrow stairs to the crooked room where we went to rest when we weren't needed on stage. Her demeanor showed a marked change from the playful antics of the morning. Her normally straight back was slumped and her steps were leaden. I poured us both some wine from the bottle that always sat on the ledge and waited to hear what Adelina had on her mind.

She regarded me steadily, the lines in her face emphasized by the harsh sunlight streaming in through the window. "I think Caterina truly hates me."

"Why?"

"I heard her complaining to Torani this morning. She accused me of trying to ruin her performance, of criticizing her unfairly and turning the other performers against her."

"Don't let that bother you. Caterina has been on one of her rampages today. She's given each of us a tongue lashing."

"This is different." The unhappy soprano let the corners of her mouth droop. "Her words were so vicious, so full of hate. She has misunderstood every piece of advice I tried to give her."

"You have been more than generous, Adelina. Especially considering the jealous scenes. Caterina resents your skill, the way an audience responds to you. But what can she do besides complain? And who will pay any attention to her charges?"

"That's just it. She meant for me to overhear. Maestro Torani tried to calm her down and draw her farther away from where I was standing, but she wouldn't budge. She kept saying that I would be sorry, that I would soon get my due. It was almost a threat."

I poured more wine for both of us and said, "Surely you have faced this kind of thing before. Every opera company I've ever heard of is seething with politics and intrigue. Someone is always trying to oust the lead singer."

Adelina raised a feeble smile. "Ah, yes. The hoof beats, the whizzing arrows." She continued in response to my questioning look. "Since finding success as a singer, I have been an object of constant pursuit. Sometimes I feel like a poor doe desperately running through the forest, trying to elude the hunters. You will doubtless learn how this feels at first hand, Tito." She pondered for a moment, then went on. "This deer is becoming very tired and the hoof beats grow louder. I can't keep this up much longer. I have to leave the opera, but first, things must be set right."

She took a sudden gulp and put her head on arms, weeping profusely. Stunned, I moved to her side and stroked her hair. "Adelina, you can't leave. You are a marvelous performer. You can't let some overly ambitious youngster force you out."

Adelina fought back tears. "It's not Caterina. It's me. Listen to my shaky high notes, my weak vibrato. Listen with your trained ears, not with your heart, and you will see what I mean. I've been hiding my imperfections with tricks for months, but it's getting harder all the time. I want to stop singing while I'm still admired, before the public realizes that my voice is going."

I shook my head, unsure of how to comfort her. She put a soft hand on my cheek. "Don't worry for me. This is just part of life. A singer's voice doesn't last forever, especially a woman's voice. I have been planning for the day when I would have to leave the

stage for a long time." Her eyes grew misty again. "That day is not far off, but first, I have plans I must see through."

I searched my coat pockets for a handkerchief. "Adelina, I had no idea you were feeling this way. Just this morning, you seemed so happy."

She dabbed at her eyes with the square of linen I had found. "I've learned to make a mask of my face. You may look at me and see a smile, but it is no less a disguise than you see on the carnival maskers."

"Why, Adelina?"

"We all have our reasons, Tito, but don't do as I have done. Let your mask down before it freezes on your face and you find you can't ever take it off."

I must have looked puzzled. "Yes, you wear a mask," she replied. "I've seen how you cringe when you are introduced as a *castrato*. You wear the mask of a normal man. You cover your disgrace and pretend, even to yourself, that you are whole. But I've watched you drop the mask when you sing. Then your face is exalted by the beautiful sounds coming from your throat. Drop your mask for good, Tito. Embrace what you are. Fate has made a very special place for you. Revel in being a *castrato* and ignore those who would have you do otherwise."

I sat dumbfounded at her words. Before I could gather my wits to reply, a deep voice, now familiar to both of us, echoed down the stairs. "Adelina, where are you?"

I sprang up. "This is too much. I'll tell him you are unwell."

She restrained me. "No, Tito, I must go to him. This is part of my plan." Then she smiled, and her eyes glittered with the hardness of diamonds. "This very day, things will begin to be set right."

I watched Adelina hurry out, her back once again straight and proud, and listened as her heels tapped up the steps and Viviani's voice boomed out to greet her. I was left alone in that sunny, little room with the dirty walls to finish my wine and reflect on the ultimate frailty of our voices and the mysterious caves behind the masks that cover the faces of our friends.

Chapter 10

Later that evening, as Felice and I headed home, my friend was quiet and his face was as long as the fiddle he had played that day. He didn't cheer up until we found Grisella waiting for us at the entrance to our square. She had thrown a soft cloak of dark green wool over her shoulders; stray wisps of her lustrous, golden red hair were escaping from the hood. Her face held a look of simmering excitement.

"Father and I got home early today. He said I could come out and wait for you," she said as she ran to greet us.

The girl slid between us and locked elbows with Felice on one side and me on the other. "What happened at the theater today, Tito?"

"Just more rehearsal, Grisella. There's so much to do with only six more days until *Juno* opens. Our Felice is going to be part of the show. Torani gave him a job playing violin in the orchestra."

My friend inclined his head toward my sister. "I put on my own show today, you should have seen it."

Grisella took a few skipping steps between us. "What do you mean? What happened?"

"My big, clumsy feet got the better of me." He rolled his eyes in a self-mocking way. "I tripped and managed to take practically everything in the orchestra pit down with me. It's a wonder the harpsichord is still standing."

"He's exaggerating as usual. It wasn't really that bad," I put in.

Felice smiled dolefully. "I'm just glad Viviani arrived in the afternoon instead of the morning. If he had been there to see my stupendous fall, he probably would have had Torani fire me on the spot."

"Signor Viviani? What was he doing there?" Grisella asked quickly.

"He owns the theater, little one," I replied. "He can do anything he wants there."

Felice snorted. "Do anything he wants in Adelina's dressing room, you mean."

I shook my head and gave Felice a warning glance over Grisella's head. My little sister didn't need to be hearing theater gossip that was far beyond her years.

We had almost reached the door when Grisella dropped our arms and ran the few remaining steps. She gave the bell a hearty pull. Lupo must have been waiting for us in the hall; the door opened immediately. Grisella's hood slipped down, freeing a tumult of red-gold locks as she jumped up and down before our genial, stoop-backed servant.

"I didn't tell them, Lupo. You said I couldn't keep a secret, but I did, I did."

Lupo raised his bushy eyebrows in mock surprise. "Very good, Signorina. I will remember to tell Berta how clever you are."

She threw her cloak toward him and ran into the sitting room. "Do we have a surprise in store?" I asked, piling my cloak on his outstretched arms.

Lupo wiggled his eyebrows. "Step in the sitting room and find out, Signor Tito."

I went straight in with Felice at my heels. Annetta was in the corner, warming herself by the stove. Seated at the round table littered with remnants of coffee and cakes, my father was in deep conversation with a man dressed in traveling clothes. The newcomer's coat of heavy, corded fabric was well-made but rumpled and stained. His long, sturdy legs stretching out to catch

some warmth from the stove ended in worn boots of expensive Spanish leather. He laughed and looked up at Grisella as she began to shower the back of his head with kisses. I suddenly recognized the face of my brother Alessandro hiding behind a neatly trimmed beard and mustache.

"Tito," he began, looking me carefully up and down, "so you've returned. It's been a long time. If I had seen you on the piazza, I would hardly have recognized you."

"Yes, time has worked on both of us," I said, remembering my brother as the fearless, athletic boy I'd tried so hard to emulate in the old days. "I've been home several weeks. I'm singing at the opera, now."

He lowered his eyes. "So Father has been telling me."

An awkward silence fell. For a brief span, each of us addressed private thoughts as the coal in the grate hissed and popped. Annetta's voice broke the quiet with a trace of shrillness.

"Alessandro, you should have heard Tito sing at the Palazzo Viviani the other night. He was wonderful. Everyone says he will be a great success."

My brother looked up sharply, his dark eyes lined with fatigue but still penetrating. "Viviani? You sang for Domenico Viviani?"

"He is my employer," I answered. "The Viviani family owns the theater. His agents hired me away from the *conservatorio* in Naples. Why? Do you know him?"

His shoulders moved in an exasperated shrug. "I have encountered some of his men. It seems the Viviani clan has interests almost everywhere. They are tough competitors, to say the least, but surely they treat their singers more gently than their business rivals," he ended with a smile.

Alessandro drew his legs in and slowly unfolded from his chair. He approached me uncertainly, as if he could hardly believe that the beardless eunuch in front of him was really his little brother. Finally, he embraced me and kissed both my cheeks. I smiled tentatively. I knew my brother's practical merchant soul was revolted by the idea of sacrificing a body's manhood for the

sake of a beautiful voice. Whatever sum was paid to acquire my golden throat, Alessandro would have considered it a very bad bargain indeed.

My father clapped his hands to summon Berta and Lupo.

The last traces of daylight were fading and shadows had crept over the room. Lupo lit the lamps with a long taper while Berta cleared the small table of cups and crumbs. Grisella was hanging on Alessandro's arm while he made small talk with Felice. Annetta conferred with Berta about supper and started to follow her to the kitchen, but Alessandro intervened.

"Don't go, Annetta, I want to give you your present."

He untangled himself from Grisella's adoring grasp and knelt to unpack a canvas bag. First Alessandro brought out a small bundle wrapped in white cloth and handed it to our father with the king's share of respectful deference that Isidore Amato always demanded from his children. The cloth fell away to reveal a handsome snuffbox of gold filigree. The gift must have pleased Father immensely as he thanked Alessandro with uncharacteristic warmth and complimented him on his taste in choosing the gift. Father slipped the box directly into his waistcoat pocket, exclaiming about the envy it would arouse in Conti and his other Mendicanti colleagues.

Annetta's gift came next. Alessandro began pulling what looked like a rope of bright azure blue from the depths of the bag. He held the rope over his head with hands spread wide apart and gave the length of blue a good shake. A gauzy, delicately woven shawl unfurled before our eyes. He arranged the fabric over Annetta's head and let the ends fall over her shoulders.

"Thank you, Alessandro." She stroked the soft fabric, eyes shining. "It's so light. I can hardly feel it on my head."

Alessandro fingered one end of the shawl. "It came from India, brought by overland caravan. They say the silk is so finely woven that you could pass the entire shawl through a wedding ring." He cocked his head to admire the bright fabric against our sister's chestnut hair and creamy skin. "Wear this over your hair at church and you may find yourself with a wedding ring."

Annetta laughed and gave Alessandro a playful push. "Stop trying to marry me off. You are older than I am and I don't see a wife at your side." My father grimaced. I knew he didn't like to contemplate losing his unpaid housekeeper or seeing Alessandro's resources flow away from our household to support a wife and children.

Grisella could contain herself no longer. "What about my present?" she asked, jumping up and down.

Alessandro knelt by the bag again and carefully unwrapped a box of thin, light wood. He set the box on the table and put his hand on the latch. "This came all the way from China, little one. It followed the same route as our famous countryman Marco Polo did hundreds of years ago."

He opened the box to reveal writing paper of a delicate, exotic manufacture. Each sheet of crisp white had decoratively torn edges and was hand inked at the top with a sinuous, oriental motif of fighting dragons.

"How lovely," Annetta exclaimed. Grisella remained silent and unsmiling.

Alessandro took a sheet from the box and held it before a lamp. "Look Grisella, you can almost see through it. It's made of rice and decorated by Chinese artists. Every box contains paper of a different design. No other girl in Venice has anything like this."

Grisella's face settled into a cross expression. "I don't want paper," she said fretfully. "I want the shawl. It's the best present." She made a move to grab the azure fabric off Annetta's head and for once my older sister lost her composure. She struck Grisella's arm away roughly and clasped the shawl firmly as the younger girl struggled to pull it away.

Father jumped up, but before he could reach the girls, Grisella had gone rigid and was shouting horrible curses at Annetta. In an instant, the girl was in the throes of the worst convulsion we had yet witnessed. Her curses turned to grunts. She shook and twisted, striking her fists out at random. Father fought to grab her flailing arms as Annetta yelled for Berta. This time it took

all three of them to get some elixir down her throat and carry her upstairs to her room.

Alessandro turned to me in alarm. "This sickness, these spells. They're getting worse all the time. Something must be done."

"I agree," I answered. "Her physician has made the elixir as strong as he dares, but she seems to need more and more of it to calm her. The other measures he recommends don't seem to be helping at all."

"What does he think is causing her fits?"

"I get the impression he hardly knows what to think."

"Could she be play-acting?" My brother stroked his beard. "Grisella was always one to want everyone's attention focused on her."

Felice spoke up hesitantly. "I don't mean to meddle in family business, but I've been spending a lot of time with Grisella while Tito is at the theater and Annetta is busy with her chores. The girl is terribly embarrassed by her spells. And frightened. She's terrified that she will end up as a madwoman chained to the wall of a lunatic asylum. I'm convinced that the spells are genuine, not under her control at all."

Alessandro nodded thoughtfully, then amazed us by offering another theory. "What if she is possessed?"

I stifled an astonished laugh and traded uneasy glances with Felice. "Surely you are not serious, Alessandro?"

"You cannot imagine the things I have seen in the East, Tito." My brother regarded me with a serious expression. "I have watched infidels possessed by demons spin around for hours until they either lose their wits or die. Indian fakirs who climb ropes suspended in thin air. Holy men from Persia who put themselves in a trance and allow spirits of the dead to talk through their mouths. So many strange things exist in this world."

"But this is Venice. We are civilized men, not savages. And this is the eighteenth century, not the Dark Ages."

"Besides, poor Grisella is just an innocent young girl," Felice added. "How could she have fallen into the grip of demonic symptoms?"

My brother shook his head. "I don't have the answers, but this illness strikes me as most strange and unnatural. Maybe we should talk to Father about getting a priest instead of a doctor."

Alessandro broached that subject at supper. Grisella had finally quieted down and was sleeping peacefully upstairs. The rest of us were at the table plying Alessandro with questions about his travels. After complaining about the Turkish unrest and the resulting decline in profits, he brought up his theories about demons and evil spirits. Father reacted as skeptically as I thought he would. Our father was full of cautionary tales about the perils and temptations of this world, but he had never had any use for superstition. A ghost would have to cause quite a commotion to get a rise out of Isidore Amato.

Annetta was also doubtful. She believed that Grisella's fits sprang from emotional turmoil and pointed out that they occurred more frequently when our sister was upset. This observation only inspired Father to grumble about Grisella's fickle moods and to blame Berta's coddling and overindulgence. We debated until bedtime, finally agreeing that we should all do our utmost to promote tranquility in the household and particularly try to avoid provoking Grisella's temper. She should also get as much rest as possible. Over Father's objections, it was decided to limit her activities at the Mendicanti. He, of course, considered her musical instruction of paramount importance, but the rest of us persuaded him that Grisella's health should come first. Consulting a priest was left as the option of last resort.

One more incident, painful but necessary to mention, occurred that night. Felice and I had gone up to bed and were in my room discussing the events of the day. I was still in my shirt and breeches, sitting cross-legged on my bed, polishing a shoebuckle with a dab of spit and the corner of my bed sheet. Felice had already changed into his nightshirt; his dark hair was loose and flowing onto his shoulders. He was reclining on his cot, propped up on one elbow.

Like so many nights at the *conservatorio*, we had shared our opinions on matters great and small and had fallen into

a companionable silence. Then Felice abandoned his cot and crossed the floor to climb onto my bed. He reached out and gave my chest a tentative caress.

I stopped my polishing but didn't look up right away. Finally I said, "I thought we had settled that back in Naples."

"Loving you will never be settled for me." He slid his fingers inside my shirt.

"I only agreed for you to come home with me because you promised that my friendship would be enough." I caught his wrist and gently forced his questing fingers away. "Felice, you know how I feel. You may have been born for the pleasures of your own sex, but I wasn't."

"But Tito," he said, his face full of longing. "Everything in my life is falling apart. My love for you is all I have left. Please, let me show you. Please, just for tonight."

I sprang from the bed and paced the floor. "I can't. I won't pretend something I don't feel."

Felice frowned and his eyes hardened. "It's that woman, isn't it."

"*What?*"

"It's Adelina. Ever since your first day at the theater you've talked of no one else. You praise her looks, her gestures, her singing. You act as if her every word is a precious treasure. She is the only one you want to spend time with. I've hardly seen you since we got off the boat."

"This has nothing to do with Adelina. I've been at the theater night and day because Torani has been driving us like galley slaves. Besides, you and I had this discussion many times while we were still in Naples, before I ever met Adelina. Dismiss any thought of love between you and me from your mind because *that* is not going to happen. You need to find someone who feels the same way you do."

"No, no." He was almost crying now. "You could love me if only you would let yourself. You would if she weren't in the way."

I shook my head violently, heartily annoyed with Felice for reopening this old quarrel.

From the bed, he stretched a pleading hand toward me. "Tito, please. The only person Adelina really cares about is herself. I've loved you for eight years. Forget that cow of a soprano and let me show you."

My anger flared at his description of Adelina. I grabbed a brush off my dressing table and threw it at him.

Felice dodged the brush and grabbed a shoe to hurl at me. We yelled at each other while he pulled on his breeches, stuffed his naked feet in some boots, and threw his few possessions in a bag.

With a last miserable look, he barged out of my room and ran down the stairs. I went out to the landing in time to hear the street door slam. Damn Felice, anyway. Why couldn't he understand? I lingered at the top of the stairs, freezing and shivering, for a full quarter of an hour. I almost started after him several times, but finally decided to let time work its calming effect on both of us. I went back to my bed and blew out the candle.

I was poised uneasily between sleep and wakefulness when my bedroom door opened with a soft creak. Felice padded across the floor and sat down on his cot with a ponderous sigh.

"Are you awake, Tito?" The question overflowed with timorous hope.

I rolled over in the darkness. My friend was only a vague shadow.

"Yes," I breathed.

"I'm so sorry," he said, the words tumbling out in a rush. "I don't know what made me bring that up again. I know how you feel. You have made it plain in the past. I shouldn't have pushed you."

"Let's just forget it," I sighed, mustering a thin, unseen smile. "Get to bed, my friend. We both need some rest. Tomorrow will be another long day."

Despite my intention, I lay awake for a long time that night. Strong emotions vied with each other in the arena of my weary mind. Anger, disappointment, regret, and frustration clashed and retreated, then regrouped to skirmish again. But none was so strong as the feeling of nameless, floating apprehension. Every

time I willed my mind to grasp this foreboding and give it form, I came up with only shreds of guilt as if I had, by returning to Venice, loosened a chain of events that was sure to end in disaster.

Chapter 11

Juno's opening night finally arrived. Torani had managed to shepherd the disorganized production I'd found on my arrival into a polished opera. When left to his own devices, our little director could find a carpenter's lost hammer as readily as he could coax a good performance from a hesitant singer. Viviani must have been busy with other matters during the past week; he had made only a few perfunctory visits to the theater. Thus Torani had been free to concentrate his creative energies on refining the opera instead of placating our patron. *Juno* had flourished as a result.

Felice fulfilled his duties on the violin in an offhand manner. He had taken to frequenting taverns with the other musicians and coming home long after midnight to throw himself onto his cot in a drunken haze. When we found ourselves alone together, he apologized profusely and went out of his way to show me that there would be no repeat of the scene of our last fight.

Adelina had made some friendly overtures toward him, but Felice did not respond in kind. He avoided her company, and I thought I detected a simmering resentment from his place in the orchestra pit when she was on stage. Of all the singers, Felice seemed to get along best with Caterina. Perhaps their mutual dislike of Adelina made them kindred spirits.

Caterina remained a mystery to the rest of us. Her quarrelsome demands had continued unabated until the evening of dress

rehearsal, but during that final run-through, she was subdued, even pensive. When Torani directed Madame Dumas to lower the neckline on one of Caterina's gowns, we all held our breath, then stood amazed as the soprano quietly assisted Madame in making the adjustment. What had happened to our resident gadfly? She sang in the same fresh, spirited voice but regarded the cast and crew with a searching expression as if seeing us for the first time. She reminded me of a plough horse that had worn blinders for years and had them suddenly removed.

Now, the crew was readying the stage for the first act. Already in costume and make-up, I peered through a slit in the heavy curtain that smelled of smoke and mildew and watched Venetians of all ranks pour into the auditorium. The huge chandeliers with three tiers of candles had already been lit and raised above the floor of the pit. There were no seats in this area. The public gave a small coin to stand or mill about. They drank wine or anise-flavored water and argued about the performances until a particularly melodic aria or a favorite singer pulled their attention back to the stage.

The more fortunate patrons enjoyed the opera from boxes that were arranged around the main floor in a vast horseshoe that climbed to five levels. Noble families held keys to their boxes for a season's time. The finest ones served as miniature salons suitable for card parties, suppers, love trysts, and a myriad of other social activities. Tickets for the more modest boxes could be obtained for individual performances, at the box office. I knew my family had secured a box to watch my debut. By necessity of our finances, it would be one of those that were the highest and furthermost from the stage. I strained my eyes toward the back of the theater but could not make out any familiar faces.

We had argued over bringing Grisella. Father thought she was too young and directed Annetta to bring her to watch part of the dress rehearsal instead. I had shown my sisters around backstage and tried to answer Grisella's flood of questions. The little minx seemed to be everywhere at once. She poked into costume trunks, peered into dressing rooms, and lost herself

behind flats of scenery. Torani reprimanded her more than once, but Crivelli found her excitement charming. The old *castrato* took her by the hand and explained the workings of the huge cloud machines and even persuaded the stage crew to give her a ride on one of the flying platforms.

Grisella had been so thrilled with her visit that she begged to accompany the others to opening night. At first Father refused, but the girl had pouted vehemently and cajoled Annetta into taking her part. In the interests of avoiding another of her violent spells, Father finally agreed that Grisella could watch the opera, with the understanding that he would bring her home early if she became overly tired.

I turned my gaze to the boxes that overlooked the stage. The most ornate was decorated with bas-relief cherubs bearing a cartouche of the Viviani crest. Pink-coated footmen were lighting wall lamps and arranging chairs and tables. A hollow-eyed wraith in a pink coat glided to the rail and turned inward to make a final inspection. He waved the footmen away with an imperious gesture. It was Bondini, of course, making sure everything was in readiness for his master's pleasure.

I felt someone come up close behind me. "What is so interesting out there?" asked Adelina, costumed in her Juno regalia. "What do you see?"

"My future, I think."

"You are wondering what they will think of you."

"Yes," I said, eyeing the noisy crowd. "Will they like me? Or run me off the stage with booing and hissing?"

"You have to believe in yourself, Tito. The stage leaves no room for doubt. You cannot go out there with an attitude that begs the audience to spare you an ear. You must force them to listen, drag them away from their gossip or their supper."

"And what if I can't do that?" I whispered, feeling a sudden ripple of tightness across my chest.

"You can and you will. Trust your voice, my friend. It hasn't failed you yet." She gave a soft, throaty laugh. "I know great

things await you. I just hope that I'm still around to hear the famous singer you will be in five or ten years."

Her words lifted my heart from the pit of my stomach. As usual, Adelina's advice was sound. I just had to find the confidence to carry it off.

Behind me, Adelina moved her head to see through the curtain. "It looks like Domenico has brought his full entourage. At least our patron feels sure of a triumph." She clucked her tongue. "If Venice only knew the real man, no one would give so much as a *soldo* to see his opera."

"What are you talking about?"

She curled her lip. "Domenico ordered Torani to convince Beppo's mother that her son's death was an accident. An accident that Beppo caused by his own high spirits. She's a widow who takes in laundry to feed her children. Domenico authorized Torani to give her twenty *zecchini.*"

"That's a pitiful sum to keep a family. It won't last a month."

"I know. I'm instituting a fund for her. Crivelli has agreed to take charge of the money. Would you care to contribute?"

"Of course," I replied, glancing back toward our patron's box. Viviani had arrived. He stood at the railing, a commanding figure surveying the interior of the San Stefano like a general reviewing his troops. Two other men with an obvious family resemblance stood at his side.

"His brothers, Carlo and Claudio," Adelina informed me. "You hardly ever see them together. Domenico usually has them off tending to his business interests in the East."

Elisabetta was just entering the box; the jewels at her ears and neck glittered across the width of the stage. The clamor in the pit diminished as all eyes turned to watch Signora Viviani take her seat. She looked tiny and lost in yards of heavy, russet damask. Close behind her were her constant companions: her protective sister, Signora Albrimani; and her deferential *castrato*. They appeared to spar over who would help the lady arrange her skirts. The *castrato* finally bumped the sister out of the way and completed the task with fluttering hand movements.

I knew that Adelina had also seen Signora Albrimani when she tightened her grip on my shoulder and hissed, "Insufferable woman."

"Don't let her bother you." I placed my hand on hers. "Surely, she is no threat. She wouldn't dare make a scene in front of Viviani."

"It's not that. It's her wrongheaded arrogance that infuriates me. She thinks she is protecting her sister. She has no idea."

I was about to ask her what she meant when my attention was diverted to a party entering one of the second-tier boxes near the stage. Lamplight bounced off golden buttons and epaulets as officers of the Venetian navy held seats for a group of brilliantly dressed women. The women were masked, but something about the neck and shoulders of one in a bright blue gown reminded me of someone.

Adelina saw where I was looking and regarded the box with avid curiosity. Just then, the blue gown removed her mask and cast her inquisitive gaze over the neighboring boxes. I could almost see her green eyes sparkle from where I stood.

"That woman, the one who just unmasked, who is she?" I breathed.

Adelina gave me a sideways smile. "That is Signora Veniero. Her husband is a patrician, and *capo di scala* of Venice's naval yard on Cyprus."

I must have looked blank for she said, "You know, the port commander."

"Is he there in the box?"

"I don't see him. He is probably with his fleet. I'm told the Signora prefers to stay in Venice rather than go out to Cyprus on her husband's tours of duty."

I responded to Adelina's amused, questioning look. "I just wondered. I saw her at the Viviani reception." I was saved from having to elaborate by Torani calling the cast to center stage for last-minute instructions.

It is difficult to describe my performance in *Juno*; singers are always their own severest critics. My character, Arcas, had only two arias in Act One. The first was rather short and came after one of Adelina's long bravura pieces, the kind that audiences relish. When her solo was over, the box holders threw flowers and bits of paper with sonnets written on them, and the pit whistled and stomped until she agreed to repeat the aria from the beginning. By the time she had collected her favors and swept offstage, the audience was drifting back to visiting their neighbors and enjoying their suppers. There was only so much attention I could expect from a Venetian audience for whom a night at the opera meant so much more than simply following the music.

My second aria was my chance to shine. It came near the end of the act, after a particularly long and tiresome recitative. By then people were asking each other about the new singer and were ready to listen.

With Adelina's advice in mind, I struggled to quell my misgivings about my identity as a *castrato* and concentrated on making Orlando's music as beautiful as I could. I began with an elegant passage of extended notes followed by several bars of rapid trills. One by one heads turned toward the stage. The hum of activity in the auditorium dwindled and I became aware of an expectant silence. I took a few steps forward and struck a regal pose as I allowed my voice to reach maximum volume. I stole a glance at Viviani; he was nodding approvingly.

The other face I wished to read was easy to find. The lady I now knew as Signora Veniero was leaning forward in her seat, one hand on the box railing and the other on her white bosom. At the emotional peak of the aria, I turned toward her box and made my song an arrow directed to where I judged her heart must lie. As the swelling notes washed over her, she locked her eyes on mine. For one throbbing moment, we were the only ones in the theater, connected by the sensual bond of my ethereal music resonating within her heart. The cadenza came to an

end. As I let the last note die away, she touched her fingers to her lips and extended her arm toward me.

I came offstage in a daze. A grinning Torani immediately pushed me back on, and I collected my own share of flowers and sonnets. When I got back to the wings, Adelina was waiting to kiss my cheek. She said, "You felt it, I could tell."

I knew exactly what she meant: the power of hearing my voice resound throughout the vast theater, knowing every person there was hanging on my every note. The memories of most of my later performances have run together in my mind, but I will never forget that night in Venice.

Adelina and I stayed in the wings to watch Caterina and Crivelli finish the act. As Jupiter, the old *castrato* had rid himself of his meddlesome wife and was singing the joys of a frolic with the lovely wood nymph. Orlando had written a playful piece that focused more on melodic line than vocal acrobatics, and Crivelli sang it well. Using every bit of stagecraft he had absorbed in his forty-year career, he managed to create the impression of a lusty monarch, though his obviously advanced age gave the scene an ironic twist that went beyond the intention of the poet.

Crivelli was winded when he came offstage. He made a majestic exit, striding tall and proud with two pages carrying his train, but as soon as my friend was out of sight of the audience, he crumpled like a withering flower. He handed the heavy royal robe to Madame Dumas and collapsed in the nearest chair. He put his hands on his knees and leaned forward to breathe more easily.

Orlando rushed backstage at the fall of the curtain. Full of high spirits, he was carrying a bottle of French brandy and offering a pull to everyone he encountered. He slapped Crivelli on the back and said, "Congratulations, old man. You pulled off another one."

Crivelli nodded with a rueful smile as Orlando eyed me appraisingly. The composer finally said, "I have to tell you, Amato, I've always considered you *castrati* an abomination, but you certainly did justice to my music out there." He gave me an

awkward cuff on the shoulder and stuck the bottle in my face. "Not too soon to celebrate. We have a triumph on our hands." I shook my head at the brandy.

Torani appeared through the forest of ballet dancers who were adjusting costumes and shoe ribbons as they waited for their entr'acte. He took the bottle from the composer's grasp. "Better slow down on that, Orlando. You are needed out front for the ballet, and we still have two acts of the opera to get through."

Crivelli soon recovered his breath and was ready to go up. We mounted the stairs slowly and were surprised to meet Felice on the way down. There was no reason for an orchestra musician to be on the upper floors.

He responded to my questioning look as he squeezed past us. "Just wishing Caterina good luck. Her big scene is in the next act."

When we reached the third floor, we found the door to Adelina's dressing room standing open but no one inside. Her make-up table was piled high with sticks of grease paint and jars of powder. Bottles of amber scent and a decanter of red wine were illuminated by the oil lamps on both sides of her mirror. No rustle of fabric came from behind the folding screen.

"More rouge I think, right under the cheekbone." Adelina's voice floated down the hall from the last place we would expect her to be.

Crivelli and I moved down the hallway to Caterina's door. The young singer was seated before her dressing table with Susannah, Adelina's maid, carefully applying color to her face. Adelina stood behind the pair, watching in the mirror and making suggestions.

"This is a surprise," I said to Crivelli in a whisper.

"But a very welcome sight," he responded, fingering his chin thoughtfully.

We had barely gone into our own dressing rooms before Grisella burst in my door. "Did you see me, Tito? I clapped and clapped for you. I wanted to buy some flowers to throw but Father wouldn't let me."

She gave me an exuberant hug as the rest of my family followed at a more restrained pace. Alessandro put his arm around Grisella's shoulders and shook his head. "She was leaning so far over the railing we thought she would fall. We had to grab her by the waist and make her sit down at least ten times."

"I just wanted to see everything," Grisella said excitedly.

"You won't be able to see anything lying in the pit with a broken neck," my father said sourly. He spoke to me in a lighter tone. "You have made quite an impression, Tito. The audience went mad for you. Can you keep it up?"

"I don't see why not."

He took a pinch of snuff from the filigreed box that Alessandro had given him, inhaled deeply, then closed the lid with a decisive snap. "You should ask Viviani for more money. If you keep his theater full, you should be properly compensated."

"I think that might be premature," I answered, not surprised that Father went right to the financial heart of the matter.

Crivelli provided a welcome interruption to this discussion by sticking his head around the screen that divided our dressing rooms. "Do I hear my little friend Grisella?"

My sister made the old man a pretty curtsy. "Your Jupiter is wonderful, Signore. Next to Tito, you are my favorite singer."

"If you like worn-out windpipes," my father said, not quite sotto voce.

Annetta spoke up quickly, "Grisella, if you would work on your lessons and practice more, you could be in the opera some day."

Grisella was working up a petulant sigh when we heard a commotion in the hallway. Signor Viviani and his brothers, with a nervous Torani and an inscrutable Bondini bringing up the rear, were coming up to congratulate the cast. We came out of our dressing rooms and made an impromptu receiving line in the hallway. My family was pushed to the end of the hall, wedged in between a dusty costume trunk and a discarded throne. Viviani had a good word for each of us but, true to form, he lingered over the women. He stood appraisingly before Caterina and at last pronounced himself pleased with her performance and her

newly polished appearance. Her cheeks flushed with color. She dropped a small curtsy but kept her mouth shut.

He saved the most lavish praise for Adelina. At the end of his speech to her, he ran his fingers over her hair and down her powdered cheek to take her chin in his powerful grasp. Adelina's eyes widened as he pulled her face close to his and whispered a few words next to her ear. Every eye in the hallway was on our patron and his leading female singer as he gave her mouth a rough, deep kiss. If any of us had been unsure about the relationship that existed between them, that kiss, and the intimate, probing caress that accompanied it, left no room for doubt.

Viviani finally released Adelina and looked around the hallway with a lofty smile. There was an uneasy shuffling of feet and several bowed heads. Muffled strains of ballet music wafted up the stairwell and underscored the embarrassed silence.

Bondini was the first to speak. "Excellency, we should be getting back to the box. The ballet is almost over."

"Ah, yes." The nobleman rubbed his hands together and gave us a parting command. "Keep it up, my singers. Make the second act even better than the first. We don't want to lose any of our audience to the San Moise."

As our patron turned to descend the stairs with his brothers and Bondini hovering in his wake, Torani emerged from his deferential silence. His frizzled wreath of gray hair stood on end and he paced the crowded hallway, barking instructions. "Crivelli, why have you not changed? Get into your next costume at once. Tito, you need to change, too. Why are all these people up here?"

"My family, Signor Torani." I gave Annetta and Alessandro a pointed look. "They are just leaving."

The director nodded brusquely. He stepped to the door of Caterina's room and spoke to the women who had retreated there. I could see that Caterina's cheeks were still red and Adelina had a firm, angry set to her mouth. Susannah was fussing nervously with the pleats in her mistress' costume. Torani softened his manner and, by the time he had hurried in pursuit of the

Viviani retinue, our Juno and Callisto had calmed down and were conversing in low tones.

Crivelli shut himself into his dressing room as Annetta took both of my hands in hers. Alessandro stood behind her, smiling but anxious to be off. She chuckled. "Don't worry, we're going. Father didn't want to come backstage but I had to tell you how wonderful you were in the first act."

Father had his head in my door, searching from side to side. "Grisella? Where has the girl got to?" He called more loudly, "Grisella!"

Our little sister stepped from behind a pile of trunks near the top of the stairs. Father may have been right about the opera making her overly tired. The bluish smudges under her eyes had deepened into her pale face. "I'm here, Papa," she said in a small voice.

With my family headed back to their box, I hurried to change from Arcas' tunic into his hunting garb. Over the top of the screen I could hear Crivelli whistling the melody to one of Jupiter's arias. I smiled to myself. Nothing could shake his pleasant disposition. He would remain an optimist to the end.

Fully costumed, the singers gathered in the hallway by our dressing rooms. Thanks to Susannah's art, Caterina's lips and cheeks had a lush glow, but I noticed something else about her. Her eyes had lost their worried look. This was the first time Caterina had appeared truly relaxed and happy since I had met her.

Our other female singer was not at her best. Adelina was leaning against the doorframe, fanning herself with one hand and rubbing her armored midriff with the other. Her face and neck were flushed. Susannah hovered behind her with the wine decanter. "Have another swallow, my lady, it's nice and cool."

The maid emptied the decanter into a glass and handed it to Adelina. The soprano drained the glass, then made a face. "That one was bitter at the dregs. Susannah, get me a cool cloth. It's so hot in here."

One of Torani's lackeys was puffing up the stairs. "You are wanted. All of you. Places in five minutes."

Adelina waved her hand at the three of us. "Go on. You are all on before me. I'll be down in a minute."

"Are you all right, my dear?" That was Crivelli.

"Yes, just very warm all of a sudden. It happens sometimes. Go on, go on."

I followed Caterina and Crivelli down to stage level, and Torani signaled Orlando to start playing the prologue to Act Two. My fellow singers took their places with their attendant nymphs and trainbearers while a muscular stagehand turned the winch that raised the heavy curtain. I watched Jupiter and Callisto romp through their flirtatious duet but didn't hear a note. I was focusing on my next aria, repeating the phrases and embellishments over and over in my head. My concentration was so intense that I didn't hear the first screams.

Susannah's piercing voice finally got through to me.

"Help! Someone help. My mistress is poisoned."

The backstage area exploded into chaos. I pushed through bodies running hysterically back and forth and took the stairs two at a time. When I reached the first landing, I saw Adelina clutching the banister and swaying at the top of the next set of stairs. Her face was a horrible bluish white and a line of brown liquid dribbled down from the corner of her mouth.

Susannah was trying to pull her mistress away from the stairs. Adelina collapsed into her arms, but the little maid couldn't hold her. The unconscious singer tumbled halfway down the staircase. Her golden helmet bounced away and got tangled with my feet as I struggled to reach her.

With a pit of dread where my stomach should have been, I cradled Adelina's head in my lap. Susannah cried in great, gulping sobs on the stair above us. My friend's skin was moist and cold. I patted her cheek. Her eyelids fluttered just once, giving me a glimpse of pupils that were tiny dots in a huge circle of gray. I bent my ear to her nose, but could detect no breath.

Torani was bending over us, shielding us from the curious crowd on the stairs. I looked up into his pop-eyed face and gave a wordless, questioning cry. He shook his head. Together, we

carried the soprano down the stairs and reverently laid her on Jupiter's royal robes, which Crivelli and Madame Dumas had spread at the foot of the stairs. Torani and I tried again to rouse her, but there was no doubt that Adelina had slipped beyond our reach.

The rest of the company circled the body in stunned silence. Then I heard a smothered scream. Caterina pushed through the performers and stagehands and threw herself to her knees at Adelina's feet. The young soprano's face was a study in stricken surprise.

Torani jumped up and spoke to the weeping maid, who was slowly descending the stairs. "What happened?" he asked.

Susannah's shoulders shook and her mouth worked convulsively before she was able to reply. "It was poison. She took ill right after she had her wine."

"But...how? Who?" Torani exclaimed.

Susannah pointed a quivering finger straight at me. "It was Signor Amato's friend. That tall one that plays the violin."

Part Two—*Abellimenti*

Chapter 12

I had retreated to the spot I was beginning to call my thinking place. It was a round tower at the corner of an ancient Benedictine monastery that was tucked between a sluggish canal and a maze of shops and courtyards. The monastery was only a short walk from the Teatro San Stefano. I had found it by accident—if such a thing as chance occurrence truly exists—while shambling over the pavements of Venice during the dark days after Adelina's death. The Father Superior assured me the tower was open to everyone and invited me to visit anytime I liked. An open staircase wound around the structure's central core. At the top, the warmth of the stone blocks baking in the afternoon sun made my retreat a pleasant place to linger, even in the month of December.

I had been standing at the railing an hour or more, watching the traffic on the lazy canal and soaking up the peace of an ordinary Venetian day, before I could make myself think about yesterday. That was the day we had taken Adelina across the lagoon to the cemetery island of San Michele. The funeral procession contained only two gondolas besides the one that carried her red-draped coffin. The Venetians had adored my friend from their theater seats, but few were willing to interrupt their carnival fun with a depressing trip to the graveyard. Adelina had no living family, so her fellow musicians served as her pallbearers. Torani, Crivelli, Orlando, and I bore the pitch-covered coffin to the nave of the little church on the island and

stood with a stony-faced Caterina and a weeping Susannah as the priest commended Adelina's soul to eternal life and her body to the grave.

Viviani had not deigned to attend the funeral. He had closed the theater for only two days, then reopened with the same opera. To sing the role of Juno, the nobleman had hired a mediocre soprano better known for her performances in patrician bedrooms than on the stage. The company was at odds over the decision. For the first and only time of his life, Orlando agreed with our patron. The composer didn't want to see *The Revenge of Juno* consigned to the scrap bin without a proper hearing. Torani reluctantly agreed. He recognized a shrewd business decision: nothing entices an audience like a mysterious scandal.

The loudest protests had come from Caterina. Adelina's terrible death had shocked her into an initial silence, but she found her voice when summoned to rehearse with Marguerite, the new Juno. Caterina's protests echoed my own, but I thought her anger sprang from a different source. She was angry because she had not been moved into the prima donna position, while I could hardly sing for the double grief of losing one adored friend to death and another to unjust accusation.

Felice was in the guardhouse near the Rialto Bridge. On that disastrous opening night, the *sbirri* had run backstage as soon as the pause in the music and the commotion in the wings had signaled trouble. These constables enforced domestic tranquility and were always on hand at the theaters, mainly to break up fights in the pits. The *sbirri* were rough men, more given to swift action than intelligent consideration. When confronted with a dead body and an accusation of poison, they did their duty as they saw it. It hadn't helped Felice that a physician had appeared and, after a cursory examination of Adelina's body, seconded Susannah's diagnosis of poison.

And Felice had not helped himself. When the death on the staircase halted the production, Torani sent the ballet dancers back on stage to fill the void. Wondering what had caused the backstage ruckus, Orlando and his musicians worked uncertainly

at their instruments. The pit grew restless. A few shouts went up over an undercurrent of inquisitive murmurs and grumbles. The scrape of chairs and slamming of doors came from the boxes. Backstage, Susannah led the four constables around the curtain and pointed down into the orchestra. As soon as he saw her accusing finger, Felice dropped his violin and scrambled over the railing into the pit. It was a futile flight. The crowd was dense, and many hands instantly reached out to grab him. I watched helplessly as the *sbirri* carried him off with the populace cursing and spitting at him.

The sound of dragging feet and heavy breathing interrupted my doleful thoughts. I knew who it must be; I had told only two people about my thinking tower, and those were not Annetta's steps. Crivelli's white head emerged from the darkness of the spiral stairs.

"I thought I might find you up here." The old *castrato* joined me at the railing. "Quite a view. It makes everything seem so distant."

"Only an illusion. Nothing can make this misery retreat."

"Have you been able to see Felice?"

"No, Annetta and I have been to the guardhouse several times. They let us leave a basket of food, but Messer Grande, the chief of police, has ordered no visitors." I stared down at the market stalls in the next courtyard, but Felice's sad face filled my mind's eye. "What will happen to him, Crivelli?"

"Messer Grande is making inquiries. He was at the theater talking to Susannah again today. When he gets enough evidence he will take Felice before the Tribunal."

"The Tribunal of State Inquisitors." I gulped hard.

Crivelli nodded, his kindly old face filled with concern.

"But why the Tribunal?" I asked. "Why not the Criminal Court?"

"Your friend is not a citizen of the Republic. Any crime committed by a foreigner is considered a treasonable act and comes under the jurisdiction of the State Inquisitors."

"What will they do?" I asked in a hushed voice.

"The Tribunal's standard of justice is swift and harsh. Visitors are always astonished at the barbarity of the process. The evidence, if any, is presented in secret. The accused may not even be told the details of the charge. When the Inquisitors proceed against a man, they are already sure of his guilt. Why waste time hearing his side of the story when the result is a foregone conclusion?"

"And their punishment for murder?"

"Death, by strangulation."

I threw myself down by the railing and raised my face to Venice's clear blue sky. "He didn't do it," I cried. "He couldn't have murdered Adelina."

Crivelli knelt beside me. "Tito," he asked in a low, earnest voice, "why was Felice up in Adelina's dressing room?"

"I don't know, but I do know Felice Ravello. We've been together day and night for the past eight years. He's closer to me than a brother. I know he didn't do it."

"Susannah is sure he put something in Adelina's wine decanter. The chief seems to think she is to be believed. The talk on the piazza is that the authorities have their man and will deal with him shortly."

"If Messer Grande wants to find who meant Adelina harm, he should look to the rest of the company."

Crivelli cocked his head.

I stretched my legs out on the warm stones and leaned my back against the railing. "Who has been besetting Adelina with persistent harassment? Who covets her position at the theater? Who would do anything to be the prima donna?"

Crivelli regarded me with a silent, enigmatic expression.

"You know who I mean." I grabbed his coat collar. "Go on, say her name."

"Caterina," he whispered.

"It had to be that greedy serpent of a soprano. She couldn't wait for leading roles to come her way fairly. She had to destroy Adelina and snatch them away." I gave a mad laugh that made Crivelli's jaw drop. "How frustrating for her to see Viviani

hire someone else to sing Juno. Marguerite better watch what she drinks if she doesn't want to end up on San Michele with Adelina."

"You don't know that Caterina is responsible. We don't even know exactly what happened." He laid a cautionary hand on my shoulder. "Surely you noticed that Caterina had changed her manner toward Adelina. On opening night they were quite friendly."

"That was Caterina playing the ingénue grateful for the older singer's attention. A clever strategy. It allowed her to get in Adelina's room without arousing suspicion."

"You must not rush to these conclusions, Tito. There could be another explanation for Caterina's sudden change in attitude."

"I'd like to hear what that could possibly be."

"Then why don't you ask her?"

His question surprised me, but a moment's reflection told me it made good sense. My one thought was to get Felice out of this terrible mess. Messer Grande would not be interested in airy theories about a theatrical rivalry turned deadly. He would demand good, hard evidence. To free Felice I would have to show the chief exactly what happened that night and hand him the real killer. I turned my face toward Crivelli.

"You are right. I must talk to Caterina. And Susannah as well. Only the truth will save Felice. I have to discover as much as I possibly can about that night."

Crivelli nodded sagely. "There may be others who wanted Adelina dead for reasons that you know nothing about. Have you forgotten Beppo's death?"

"No, of course not. How could I? Do you think the collapsing platform was meant to kill Adelina? That it wasn't the Albrimani after all?"

"Or perhaps the Albrimani are even more vicious than we think. We have to acknowledge all possibilities."

"This is not going to be easy," I sighed, foreseeing the difficulties that lay ahead.

"If it helps, I'll be with you every step of the way."

"You believe in Felice's innocence, then?"

"I believe the matter is more complicated than Messer Grande would like it to be." He stood up creakily, one hand to his back. "And, over the years, I have become very fond of truth."

Back at the theater, I was eager to start asking questions. I spied Susannah in what was now Marguerite's dressing room. She was clearing out the last of Adelina's things under the haughty eye of the new soprano. The little maid was sorting corsets and petticoats into large wicker baskets while Marguerite arranged her own cosmetics and trifles on the dressing table. The suspicious wine decanter was nowhere in sight. Marguerite opened drawers with an air of peevish disgust and shoved the contents in Susannah's direction.

"Take these things away, Signorina…whatever you are called. Be quick about it. I need to start getting dressed. My public expects perfection."

Susannah interrupted her packing long enough to put her hands on her hips and aim a disgruntled look at the new prima donna's back. Then she resumed dragging a heavy basket toward the door. I saw my chance.

"I'll carry that, Susannah. Where do you want me to take it?"

"I have a gondola waiting out front, Signor Amato," she said, giving me a look just a few degrees warmer than the one she had sent Marguerite.

We struggled down the stairs with our burdens and settled the baskets and boxes of Adelina's belongings in the gondola. The maid started to embark, but I laid a hand on her arm.

"Wait a moment, Susannah. I'd be greatly obliged if we could talk about what happened that night."

The maid pulled her chin into her chest and fixed her resentful black eyes on mine. "You mean the night my mistress was murdered by *your friend*."

"Please. There are just a few little things I'd like to know."

"Little things are they? Since when is poison a little thing? Since when is the death of a great lady and a singer known

throughout Italy a little...." Here she choked and tears streamed down her cheeks.

I sent the gondola on to Adelina's apartment in the Calle Stretta and led Susannah to a stone bench by the entrance to the theater. It was still early; two Viviani guards patrolling the theater's perimeter were the only people around. I searched my pockets for a handkerchief and handed it to the sobbing maid.

"Why are you so sure that Felice poisoned Adelina?"

"I believe my own eyes, that's why."

"Tell me what you saw."

She dabbed her cheeks with the crumpled ball of cloth. "I've already told Messer Grande."

"Tell me as well. I have to know what happened. Adelina was the closest friend I had in the company."

Susannah nodded slowly. "She was very fond of you and often spoke of you. She wondered what you would make of your career."

"Well, then?"

The maid sighed and began her tale. "My mistress came up near the end of the first act. She was in good spirits so I knew she must have been pleased with her singing. It was easy to tell how things had gone down on the stage. If she didn't think she'd done well, she wouldn't speak to nobody, just throw her wig on the sofa and start brushing her hair with a vengeance. But that night she was all smiles and in a hurry. She had me get her out of one dress and into the next one right away. She said 'Signorina Testi wants our help, she needs to look her best for her important aria.' So my mistress took me next door to work on that mouthy one. What sallow skin she has, and that sharp chin. A person could cut themselves on it."

As Susannah shook her head over Caterina's facial imperfections, I put in a few questions. "Your mistress showed no sign of illness or distress?"

"No, none."

"When had she last eaten?"

"She'd had some roast chicken and fruit at midday, before we came to the theater. She always waited until after the opera to eat anything more. She said she couldn't sing and digest at the same time."

"Perhaps the chicken was off," I said in a hopeful tone.

She gave me an aggrieved look. "Impossible. I baked it myself that morning and ate my own dinner from the same bird."

"You were with her all day?"

"Yes, except when she went down to sing."

"What happened in Caterina's dressing room?"

"I did what I could, but the Signorina didn't have many face paints to work with. My mistress sent me back to her room to get a certain shade of rouge. That's when I saw him."

"Felice Ravello?"

"I know the name now, but I didn't then. I thought, 'What's that fellow doing up here?' I must have startled him. He was standing at my mistress' dressing table with her wine decanter in his hand. He almost broke it, he set it down so fast."

"Did you see him put something in it?"

"Not exactly."

"What do you mean?"

"I didn't really think much of it at the time. If only I had said something." The gulping sobs began again and I forced myself to remain silent until she was ready to go on. "I thought he'd come up to see you and, when he saw the wine standing there, he'd decided to get himself a free drink. I said, 'Your friend isn't here. This is Signora Belluna's room.' He skittered out fast, full of apologies. He was slipping something in his waistcoat pocket as he left."

I thought I detected a ray of hope. "So you didn't actually see him put anything in the decanter?"

"I know what he did well enough," she retorted. "Messer Grande told me. They found a glass vial in his pocket. Dark amber glass like the apothecaries use for poisons and acids and such."

"But you still don't know that he poisoned the wine, not really. Maybe the wine was bad. Maybe someone else put something in it," I sputtered, letting my fears for Felice take over and provoke Susannah's ire.

She jumped up and threw my handkerchief in my face. "You don't care what he did to my mistress. You are just trying to get your friend out of trouble, but it won't work. I pulled the cork on the wine and put it in the empty decanter as soon as we got to the theater. She'd had a glass while I pressed her first costume and another before she went down for Act One. She was fine, fine as she ever was until that *Felice* put his poison in the decanter. She took a glass before Act Two and it wasn't five minutes until she started feeling queer. I thought she was just overheated. That bodice with all those metal circles was so heavy. I gave her another glass....God save me, I wouldn't have hurt her for anything."

I tried to calm her distress, but the maid was determined to vent her anger. "You saw how she suffered. You held her as she died. How can you defend that murderer?"

"I hate what happened to Adelina as much as you do. I know it looks bad, but I don't believe that Felice is responsible."

"Bah!" She made a gesture that could have been a curse or an obscenity. "He did it, all right. I just hope the executioner tightens the wire around his throat with a slow hand. I want him to suffer...to suffer as badly as my mistress."

With a last venomous look, Susannah turned and hailed a passing gondola. I wondered what would happen to her; there were more ladies' maids in Venice than ladies. I hoped she had family who could take her in until she could find another position. Or perhaps Adelina had provided for her. There was a thought. Had Adelina made a will?

Chapter 13

With the sun rapidly sinking behind the rooftops, I ascended the steps leading to the theater's entrance and pushed through the heavy doors into the dark foyer. An elongated triangle of light stretched from the half-open door of the box office. Muffled voices came from inside.

"...won't hurt the take. We had to turn people away last night. Too bad we can't extend the run."

"Impossible." This was Torani's voice. He must be going over the receipts with the business manager. "All theaters must shut down on December 16 and remain so until the day after Christmas. That's the law of the Republic and even Signor Viviani cannot bend that rule."

"Has His Excellency chosen an opera for the new year?"

"He will go along with my suggestion. The man is a cretin where music is concerned and he knows it. He concentrates on the marketplace where his true talent resides and lets me run the show here."

"Same cast?"

"Tito will stay, of course. He's our big draw. Viviani wants him in the lead. It's time to put Crivelli out to pasture. And Caterina is out."

"Not a crowd favorite, is she?"

"No. She warbles well enough but they just don't like her. Too serious, no spark."

"And not much here either." The low rumble of male laughter hinted at the descriptive gesture that must have accompanied the words.

I shivered, but not from the chill of the dark theater. How lightly they discussed our futures, as if we singers were no more than pieces on a game board. I had my hand on the door to the auditorium when a murmured name stopped me.

"...Ravello, the violinist. His Excellency wants the matter cleared up swiftly. He doesn't want Messer Grande and his thugs poking around the theater any longer."

"But what made the fellow do Adelina in?"

"Who knows?" Torani's voice held a shrug. "Maybe she rejected his offers of love. She has refused many a man, and none too gently either."

"But he is a *castrato*."

"That doesn't always stop them. Remember that capon we had several years ago? He couldn't keep his hands out from under the dancers' skirts."

"Still, it's odd. So senseless."

"It will all be forgotten after the holiday. Tito and La Grande Marguerite will be the talk of Venice, and La Belluna's demise will fade into a barely remembered scandal."

"Marguerite is not La Belluna."

"No, but she'll have to do." Torani groaned like a convict sentenced to ten years at the oars of a state galley. "I'll coax a good performance out of her somehow."

The creak of a chair and the slamming of a drawer told me it was time to move. I tapped the door to the auditorium to make it swing back and forth and turned on my heel as if I had just come from the pit. The ticket manager came out of the office and began to light the wall lamps with a long taper. Plaster cherubs holding garlands sprang out from the shadowed walls of the richly ornamented foyer.

Torani greeted me. "Tito, how is the voice tonight?"

"It's fine, Maestro, but my mind is troubled. The police have arrested the wrong man. It grieves me to think of Felice being held in the guardhouse unjustly."

Torani cast his eyes upward as if beseeching the plaster angels to smite this latest source of irritation. "I've already lost one of my best singers. I've got ballet girls having hysterics if someone merely taps one of them on the shoulder. I've got seamstresses ready to walk out at the slightest hint that a murderer is still at large." He stopped to wipe his brow. "I beg you, Tito, don't stir up trouble. It's a tragedy that Adelina was taken from us, but *Juno* must go on without further disturbance."

We were walking across the pit. Soft yellow light shone from under the half-raised curtain. On the stage, disembodied legs moved this way and that in a seemingly aimless dance. It was getting late. Several servants were already dusting chairs and lighting candles in their masters' boxes.

"Signor Torani, you have also lost a violinist, a man who helped you out when you were short of musicians."

"Felice Ravello was easily replaced. There are scores of mediocre violinists looking for work. Whenever I go in a tavern, they cluster around me like flies on an uncovered dish of *gelato*."

I bit my lip. "Isn't it possible that Adelina's death is related to the other problems that have plagued this production? Felice could not have had anything to do with the falling platform that killed Beppo. Just think. It would be the ultimate act of sabotage...murdering the prima donna on opening night."

Torani frowned and looked behind us. "That would place the blame on the Albrimani family."

"Perhaps. Why not?"

"To start with, the difficulties ceased when Signor Viviani posted his bravos at every door and throughout the theater."

"What about scaring the original orchestra musicians away?"

"I'm not so sure that wasn't simply a few vagabond violinists looking for better wages elsewhere. If it was the Albrimani, it was done from outside. To poison Adelina, one of them would have had to get inside the theater and up to her dressing room.

Messer Grande has questioned everyone on that point. There were no strangers backstage that night."

We had reached the stage door. Torani put his hands on my shoulders. He was smiling, showing his yellow teeth, and nodding encouragingly. "Just let it be, Tito. You were meant to sing, not to do Messer Grande's work for him. Put all this unfortunate business out of your mind. Just go out there and give me the best Arcas I have ever heard."

As I headed for the stairs to the dressing rooms, a lonely figure caught my attention. Caterina was perched on part of the set for Act One, a low stone wall fashioned of canvas and wood. Her feet were planted on the floor and her back slumped in a dejected curve. She stared at the activity on the stage, but made no reaction until one of the scene shifters practically pushed her from her seat so he could maneuver the bulky set piece onto the stage.

Madame Dumas bustled past with her scissors and thread. "Monsieur Amato, you should be dressed. They will call for places in a few minutes."

I glanced back toward Caterina, but the soprano had disappeared. I ended up chasing her all evening. If I stationed myself where she was supposed to exit, she ignored the staging and darted around a different flat of scenery. If I tried to corner her in her dressing room, the door was slammed in my face. My only chance to have Caterina to myself without a handy escape route was at the end of the opera when we made our ascent on the starry chariot that carried Arcas and Callisto up to their final destination among the whirling constellations.

Caterina wouldn't look at me as we sang our last duet. When the song called for us to face each other, she stared fixedly at a spot somewhere above my right shoulder. As I took her arm to escort her onto our flying chariot, she discreetly shook me off and settled herself at the very edge of our platform.

I slipped one arm around her waist and made my choreographed gesture to salute the singing nymphs and courtiers on the stage.

Smiling, I whispered between my teeth, "Get over to the center of the platform. You are going to make this thing tip over."

She refused to move, except to grip the silver-painted railing more tightly. Only when the chariot began to rise with the floor at a definite angle did she shuffle a few steps toward the center.

"Why are you avoiding me?" I asked in an attempt at a soothing tone. "I need to talk to you."

"Why should I talk with you?" she shot back.

"Why should you not?"

She glared at me and flared her nostrils. If the audience was paying any attention to the actors in this spectacular ascent, they must be wondering what Arcas had done to make his mother so angry. Caterina said, "I know what you want to say, but I don't have to listen to it."

I paused to choose my words carefully. "I'm only asking for your help...help that could save an innocent man from a gruesome death."

"And put me right in his place," she replied in a harsh whisper. "That young face of yours hides nothing, Tito. When Susannah declared that Adelina had been poisoned, your eyes snapped right to me. You have been following me with that brooding, accusing look ever since."

"No, Caterina, you misunderstand. I don't suspect you. I just want to ask you a few questions about the time you spent with Adelina on opening night."

"Liar! You want to throw me to the wolves and rescue Felice. You are just like everyone else. You think I am a throwaway orphan of no account. Wouldn't you be surprised to learn the truth about me."

"Oh? What truth is that?"

Her mouth softened, but the smiling form it took was as unpleasant as her words. "Why should I help you? You *castrati* are everyone's darlings. You have no idea how hard the rest of us have to work to gain the audience's attention. I think I'll make you work hard for once."

"Adelina didn't seem to have any trouble holding the public's attention." The words were out before I could stop them. Wonderful, I thought, another inquiry halted by my careless tongue.

The result was not what I expected. Instead of more angry words, the bitter mask dropped from Caterina's face to reveal honest, deeply felt pain. With a sudden, sweet vulnerability, she twisted around to face me and said, "You have never spoken truer words, Tito."

After the curtain calls, I climbed the stairs with an armful of flowers and a heavy heart. I had looked for Crivelli backstage, but he was nowhere to be seen. I had found Torani and Bondini huddled in a quiet recess by the stage door. The director gave me a nod and a quick word complimenting my performance, then resumed his conversation with the ubiquitous Bondini. Viviani's chief steward must be getting the latest business report. His master would no doubt be pleased. The crowd that night had been as plentiful and as enthusiastic as ever.

When I threw myself down before my dressing table, my mirror mocked me. It didn't show the acclaimed singer who had just been cheered into three encores, but a discouraged wretch pulling off his wig and slowly removing his greasepaint.

Crivelli called from his dressing room, voice brimming with curiosity. "Tito, have you come up? Did you talk to Caterina?"

"I wouldn't call it a talk," I answered. "It was more like the sport of the English 'milords.' I pursued her as they do the fox. When I had her cornered, she bared her teeth and slipped away."

A disgusted sigh floated over the partition.

"She hinted at a secret she is keeping," I continued, "something about her background. She brought it up on her own and almost dared me to discover what it is."

"Why don't you let me try to tame our little fox. She doesn't envy my voice as she does yours, so I can sidestep all the jealousy that you arouse in her ambitious breast."

"Good idea. If Caterina did poison Adelina she would never admit it, but she would be less guarded with you. She might disclose a bit of information that could help us."

"Ah, you used the word *if*."

I grunted at my reflection in the mirror. My own hair was flat and damp from the wig I wore on stage, and my face still bore smudges of paint. "I confess that I'm finding it difficult to picture Caterina as a cold-blooded murderer. She seems genuinely shocked by Adelina's death. But you can't blame me for leaping to the obvious conclusion."

"You're speaking of the rivalry between the two sopranos?"

"Of course. Nearly half my life has been spent competing with other singers. I've known many a *castrato* that would practically kill to get a certain role. I don't see why our female counterparts should be any different."

"*Practically*, that's the important word. I, too, have witnessed bitter rivalries. Even been the object of some in my younger days. But there is a fathom of difference between wishing your fellow singer would drop dead in the middle of his cadenza and poisoning his wine."

"Yes. The risk is great and the rewards fleeting after all." I splashed cool water over my face and chest and pushed the dividing screen aside as I toweled off.

Crivelli sat at his dressing table in his shirtsleeves. "Besides," he said, "I don't see Caterina as that devious. Her emotions are clearly readable in her face. I have watched her struggle to conceal them, but she is unable to mask her feelings. Anger makes her cheeks flush and her lips compress. Frustration makes her move her shoulders in tight little shrugs. Have you not noticed?"

"I know that when she dislikes you, you can feel it across the room."

"We've all felt that at one time or another."

"What if she is in love?" I asked. "What does she do then?"

He considered the question as he rose and pulled on his breeches and finally said, "Now that's an emotion I have never witnessed in Caterina."

Crivelli looked around for his neckband. Without it, his old throat resembled a thick drape of wrinkled cloth. I found the cravat on a pile of white stockings. His hands shook as he

fastened the hooks. Perhaps Torani was right. My fellow *castrato* had enjoyed a long, successful career. He should be ready for a more restful existence.

I helped him on with his coat of faded blue silk. "I talked with Susannah, also."

"Yes?"

"When Felice was arrested, he did have a vial that could have contained poison in his pocket, but I think he could explain that."

Crivelli cocked an inquisitive eyebrow.

"Felice was taking small amounts of belladonna for his throat," I told him. "Someone gave him the idea that it could help him regain his voice."

The old *castrato* clucked his tongue. "A dangerous and useless practice. A drop of belladonna might help a singer with a sore throat get through a performance but not someone with Felice's problem. I'm afraid his vocal cords have toughened and there's no way to reverse that."

"Right now I'm more worried about the lifespan of his neck than the noises it makes."

"Naturally," he said, reaching for his silver-knobbed walking stick. "But do try to get some rest, Tito. You look quite done in. I'm going to see if I can catch our foxy soprano. We'll compare notes tomorrow."

Chapter 14

For the remainder of the evening, I can only blame callow infatuation and poor judgment.

After I had put on my street clothes and dressed my hair in a simple plait confined by a black ribbon, I noticed an envelope lying on my floor near the door. The outside was addressed to Signor Amato, and inside were two sheets of fine writing paper. One sheet contained a sonnet written in a delicate, flowery hand. Its playful theme was the sweet release of unrestrained lust. The other sheet contained only two lines:

> *I must see you. Meet me by the statue of*
> *Bartolomeo Colleoni at a quarter past midnight.*

The signature was blurred as if by too hasty blotting, but I thought I could just make out a Sig. V.

Signora Veniero! She had not been in the audience that night, but I had spotted her in a second-tier box the evening before. Her brilliant green eyes had connected with mine more than once. I had been longing to have another chance to talk to her but hadn't known how to arrange a meeting. Now she was contacting me!

I tore down the stairs and through the darkened theater. A crew of sweepers was clearing the pit of its litter of papers and discarded odds and ends. Torani stood at the door of the box office. He extended a hand toward me as I rushed by. I shouted that I was in a hurry and would talk with him the next day. It was

nearly midnight and the Colleoni statue was in the easternmost quarter of the city. I would have to take a gondola and promise the boatman a *zecchino* if he got me there in time.

Bartolomeo Colleoni had been one of Venice's great heroes several centuries back. A *condottiere* who led mercenary armies against both the Turks and our old enemies of Milan, he left his considerable fortune to the Republic on the condition that a prominent statue of him astride his favorite steed be erected on the Piazza San Marco. At the valiant general's demise, his gold was eagerly accepted, but the Senate decided that a monument to a private citizen in the spiritual and political heart of Venice was intolerable. It would represent a dangerous level of individualism in a city-republic that demanded her citizens put the interests of the state above all else. With typical Venetian cunning, the Senate ordered the statue be raised in an out-of-the-way square in front of the Scuola San Marco instead of on the piazza of the great basilica. Thus the letter of the bargain was kept, but the old soldier was denied his cherished tribute.

With my gondolier pushing the oar as fast as possible, I was at the edge of the city in under a quarter of an hour. I had him set me down under cover of a small bridge at the corner of the square. The night was cold but clear with a magnificent canopy of stars. Lantern posts set at intervals before the shadowy mass of the church of Santi Giovanni e Paolo flickered over the smooth paving stones. I was overjoyed to see the deserted *campo* inhabited only by the fiercely scowling Colleoni on his bronze stallion. I stationed myself by the pedestal of the huge monument and willed myself to enjoy the pins and needles of anticipation that were coursing through my body.

Exactly on the appointed hour, I saw a gondola with two rowers draw near the quay. A tall, masked woman disembarked and approached the statue with a striding gait. I strained my eyes. Could this bulky woman who walks like a man truly be the object of my infatuation? I asked myself the question a moment too late.

Behind me, I heard the clatter of boots running on hard paving stones. In front of me, the tall woman threw her cloak off with an impatient gesture and also broke into a run. I ducked around the corner of Colleoni's pedestal and sprinted for the bridge. My gondola had passed a crowded wineshop on the opposite side of the canal. If I could reach the bridge and yell to attract attention, I might yet have a chance.

They brought me down before I had got halfway. Tackled from behind, I struck the stones with my forehead and, suddenly, the stars were dancing all around me.

I must have been in a stupor for only a few minutes, but that was long enough to have been blindfolded, gagged, and had my arms bound tightly behind my back. Through a splitting pain in my head, I judged I was in the bottom of a swift gondola on one of the narrower canals. My captors were silent, but the scrape of their boots and rustle of their garments made me think there were three men besides the boatmen. After a few minutes, our progress slowed and I heard one of the gondoliers give the hoarse cry that warns other traffic that a boat is poised to turn into a wider canal. We shot forward. Now the craft tossed and rocked on the choppier water of a larger channel.

My head swam and bile rose in my throat, but I willed my stomach to settle and tried to analyze my situation. Was this a kidnapping? A robbery? My small purse was still in my waistcoat pocket; I felt it digging uncomfortably into my lower ribs. I moved slightly to ease my position and instantly received a sharp kick in the back. A rough voice warned me to be still and stay quiet. A heavy cloak descended around me, muffling all sound and concentrating my attention on simply getting enough air to stay conscious.

Finally the gondola bobbed to a halt and, somewhere very close, iron scraped against stone. Rough hands grabbed me. I was lifted bodily and half dragged, half carried out of the night air. Their message was brief and pointed. I was flung into a hard chair and a voice rasped close to my ear, "You've been asking too many questions, *castrato*. La Belluna's death is no business

of yours. You are to stick to your singing and leave the dead in peace. Understand?"

Before I could signal a response, I was kicked in the side and grabbed around the throat.

"Not his neck, you fool. You were warned." The raspy voice rose in intensity.

An expletive followed and my head was jerked back by some-one yanking my plait.

"No more questions about La Belluna. Understand?"

This time I was allowed to nod before a second set of hands forced my chin down. Steel slithered from a scabbard and pressed against the back of my neck. Were they going to kill me after all?

No, the blade was sawing through my hair, and soon I had lost my plait. The gag was jerked from my mouth and my life-less hank of hair was stuffed in its place. Strangely gentle hands stroked my thighs and took a firm grasp on the crotch of my breeches.

"Whatever you have left here, my friend—that's what you will find in your mouth the next time we meet."

Chapter 15

I awoke the next morning with a knot the size of a walnut on my forehead and bitter anger churning my spirit. I had been dumped, weak and shivering, at the bottom of the *calle* that led to the Campo dei Polli. As soon as I hit the pavement, I snatched the blindfold from my eyes but glimpsed only an anonymous gondola filled with hulking shapes slipping down the misty canal. Somehow I directed my heavy feet up the *calle* and fit my key into the front door. Head throbbing and heart still pounding, I climbed the stairs and shut the door of my room against the violence of the night. Without removing so much as my coat, I stretched out on the cool linen sheets and Morpheus, the ancient god of sleep, dealt with me more gently than anyone else had that day.

The appropriate target for my anger lay in a building with an iron water gate somewhere on one of Venice's major canals. Lacking the means to narrow my target further, I sat at the breakfast table glumly swirling my coffee and watching the creamy clouds form and billow in my cup. Annetta hovered over my bruised forehead with a bottle of arnica and one of Father's old handkerchiefs that she was trying unsuccessfully to make into a bandage. After she and Alessandro had absorbed the gist of my midnight adventure, they both pressed me with anxious questions but were getting only curt grunts in response.

Annetta finally assumed the big sister's no-nonsense tone that demanded a response. "Are you going to do as the men ordered—drop your efforts to free Felice?"

I had turned that dilemma over in my mind since winter's gray dawn had begun poking at my bedroom window. In the weak light, Felice's empty cot appeared as an indistinct, shadowy mass. By the time it had solidified into a wooden frame topped with a mattress and pillow neatly wrapped in bed linen, I had made up my mind.

"Would you want me to give it up, Annetta?" I asked. "Could you stand by and simply let cruel Venetian justice take its course?"

"You know I could not." Her jaw was firmly set, but she twisted the cloth with worried hands. "Especially since last night's attack virtually proves Felice's innocence."

"Yes, I thought of that," I responded. "If Felice murdered Adelina, why would anyone else be interested in stopping my questions?"

Alessandro had been pacing the room. His long legs, accustomed to ships' decks and wide-open marketplaces, were uncomfortably confined by our tiny dining room crammed with furniture. He straddled a chair across from me. "You can't go on blindly asking questions of first one and then another, Tito. That won't get you anywhere and could be dangerous besides. We need to plan this out, make it an organized investigation." He gnawed at a callused knuckle. "The main thing is time. How much do we have?"

"I'm not sure. It has been four days since Adelina's death."

Alessandro considered. "I'm surprised that Messer Grande has held off this long. If he accepts Susannah's version of her mistress' death, there should be nothing holding him back from hauling Felice before the State Inquisitors."

Annetta brightened. "Maybe Messer Grande is not as convinced of Felice's guilt as rumor would have it."

I saw what my next step would have to be, but didn't relish the prospect. Venice's chief of police, one Ludovico Cello by name

and Messer Grande by title, was the king spider in a dense web of official peacekeepers, minor authorities, and a cadre of hidden agents dedicated to preserving the interests of Venice's ruling elite by whatever means necessary. The ruthless determination of his informers was legendary. Any sensible citizen would keep far away from Messer Grande and his agents, but to learn the details of Felice's situation, I would have to confront this spider.

"I'll go down to the piazza and see him later today."

The words came reluctantly, but I felt better for having said them.

Alessandro shook his head. If he had meant to oppose my plan, he was interrupted by Berta entering the room with all the officious importance of the Doge's chief chamberlain.

"Look what my baby has made," she said with a beaming smile, "all by herself. Well, with only a *little* help."

Grisella bore a steaming basket. My nose recognized a childhood treat: *frittelle*, hunks of fried dough sprinkled with cinnamon and sugar. But the pastries were not meant for us. With a sober expression on her little face, Grisella set the basket on the table, crossed to the linen cupboard, and retrieved a fresh white napkin. With great ceremony, she unfurled the cloth and tucked it around the contents of the basket. Only then did she observe her sister and brothers.

"Oh, Tito," she squealed. "What happened to your hair?"

I gave her a modified version of the night's activities, but didn't leave out the essential objective of the attack, which was, of course, to induce me to abandon Felice.

Grisella's dark eyes widened. She came close and ran a hand through what was left of my hair. Then she gave my forehead a gentle kiss, no more than the touch of a lark's wing. As Annetta and Alessandro shared a look of concern, Grisella's behavior grew more agitated. She grabbed my sleeve and moaned, "This is terrible. This shouldn't have happened."

I tried to downplay my condition and turn her attention to lighter matters. "I don't mind the short hair, little one. I think

I'll turn Lupo into a fashionable *friseur* and have him dress my hair in curls every morning."

"No, no. That doesn't matter." She was near tears now. "You must get Felice out of jail. He's my friend. He doesn't belong there."

Annetta shot Berta a pleading look. Alessandro patted Grisella's shoulder, saying, "Tito is trying. We'll all help him. You mustn't worry yourself about this."

Berta forestalled further hysterics from the youngest Amato by placing the *frittelle* basket firmly in her hands. "You can do something for Signor Felice now. Take these pastries to the guardhouse before they get cold. Try giving some to the guard, he might let you see your friend."

Annetta wasted no time in untying her apron and accompanying Grisella on her errand. Berta began gathering the breakfast crockery onto a tray, taking her time to brush every last crumb from the tablecloth. Finally she crossed her arms and pursed her lips.

"What is it, Berta?" This was Alessandro.

"Last night was my lamb's worst spell yet. Your Papa was out. There was only Signorina Annetta and I to manage. It was a frightful fit. We could hardly hold her still. And the curses she yelled at us, *Dio mio*." She made a quick sign of the cross. "I thought she would never come out of it."

"What set this one off, Berta?" I asked.

She spread her arms. "Who knows? It seems to take less and less. She had begged to go to work with your Papa so he took her with him for the first time in a week or more. She came back tired and out of sorts, but he said she'd had a good day." The old servant thought for a moment and continued in a challenging tone. "The doctor came and said more cold baths would be the cure. The man is a fool, learned or not. Something else must be done. I tried to talk to Signor Isidore about it this morning, but he just put me off as he always does."

Alessandro stroked his beard. "I have recently heard of a Dominican friar, a very holy man who is said to work wonders

in these cases. He lives in a monastery out on one of the lagoon islands. I say it's time to see what he can do for Grisella."

Berta nodded enthusiastically and then gave me a reproachful glare as I raised skeptical protests against what I considered to be absurd superstition. Try as I might, I could not picture a devil residing in my sister's body.

But my brother was adamant. "What is the harm in trying an exorcism? This monk is an intelligent, educated man, not some wild-eyed fanatic. Before he entered the monastery, he studied at the University of Padua. If Grisella is bedeviled by some spirit, this worthy man may bring her peace. If not, what harm will have been done?"

I had to agree with Alessandro's logic and ended up wishing him luck in finding this monk. After all, what could be lost in trying?

I was nearly ready to set out for the Procuratie, the vast building that held the offices of Messer Grande and a hundred other Venetian officials, when Lupo brought a note up to my room. This time I had the good sense to send Lupo running after the messenger to confirm that the sender was who he purported to be. At least I could let the events of last night teach me a little caution. The note was from Crivelli, bidding me to meet him at the Mendicanti as soon as possible. He promised someone would be waiting at the orphan asylum to impart information that would be of much interest.

Chapter 16

"When I was a girl, all my dreams were centered here in Maestro Conti's studio. In the other rooms, I scrubbed and mended as I was told to do. Sister Viola taught me to read and write in the schoolroom just down the hall and rapped my knuckles when I couldn't form the letters to please her. The other girls thought I was just a little drudge who wasn't pretty or clever enough to be included in their circle. Most of the teachers despaired of my future, if they bothered to think of me at all. But not Maestro Conti." Caterina put a hand on her old teacher's shoulder and gave it a squeeze.

Conti was sitting at his harpsichord with his back to the instrument, wrapped in his black academic gown. He gave Caterina's hand a responding squeeze. His unhappy, pink face sank into his fleshy chin as Caterina continued. "Everything was different in this room. Maestro Conti believed in me. He helped me uncover my voice like miners dig gold nuggets out of the earth. How many hours I spent daydreaming of singing at the opera and thrilling all of Venice with my voice. Then everyone would be sorry for how they treated me." She finished with a self-deprecating snort.

Caterina crossed to the lead-latticed window. Morning light streamed through the panes of wavy glass and fell in buttery pools on the flagstone floor. The soprano's face was illuminated in every detail. I had never seen her look so pensive and detached.

"Of course, time has a way of rolling on and outwitting our most cherished plans. Now I sing at the opera every night, but it holds no happiness for me." Caterina's eyes grew watery. "I know I'm a competent singer, but I can't convince myself that I belong there. Don't you see how frightened I am before I go on stage?"

She directed the question toward me but continued before I could answer. "The public is waiting out there, beyond the foot lamps. Waiting to sit in judgment. I see their critical eyes stare up at me from the pit and loom over the railings of their boxes. One wrong note, one weak trill and they'll condemn me. If I'm lucky they'll be merciful and simply go back to their gambling or romancing; if not, they'll run me off the stage."

Crivelli's even voice came from the corner where he had found a padded bench. "We all know the pit is full of puny critics who fancy themselves music connoisseurs. We learn to ignore them and concentrate on singing the best we can."

Her bony shoulders began to shake. "I can't do that. I dread their boos and catcalls. It's practically all I think about."

"Why do you go on singing if it makes you so miserable?" I asked.

"I have to be sensible," she answered with a sniffle. "I must earn my living, and the opera is the only thing I know. After all, I grew up as an orphan. Who else would support me? I used to wonder if my mother was somewhere in Venice. Every night, before I slept, I'd imagine a beautiful woman in a fur-lined cloak coming to get me and telling me that my being at the Mendicanti was all a horrible mistake. A common fantasy, isn't it, Maestro?"

Conti nodded into his chins as Caterina went on. "When I'd grown up a bit and learned more about the ways of the world, I thought it more likely that my mother was a prostitute. Not the sort our noble patron would frequent, but one of the scraggly women you see in doorways, hiding from the *sbirri*. Now, whenever I go to the basilica and pass a poor crone with her palm out, I think, is she my mother?"

"You are afraid that will be your fate," Crivelli commented from the corner.

Caterina flashed him a relieved smile. "You understand. Yes, I feel compelled to make the audience like me. I have to succeed at all costs. If I don't, what will become of me?" Her voice wavered. "I'll end up another toothless beggar asking for alms on the piazza."

"Caterina, Caterina," Conti murmured as he scurried to her side. His black robe billowing behind him made him look like a pink-faced beetle going to rub his student's hands as tears started down her cheeks.

I saw where this was leading. Caterina seemed genuinely sorrowful, but I was horrified at where her compulsion to succeed had driven her. "How dare you try to excuse your conduct?" I said viciously.

She raised her sharp chin and wiped the back of her hand across her cheeks. "Say what you mean, Tito. Please, don't spare my feelings. I'm not used to that kind of consideration."

"As you wish, then. You poisoned Adelina because she stood in your way. You thought that if she were gone, Viviani would give you the leading roles and your future would be assured."

My words fell like chimney ash on wet paving stones; they had no effect at all. Conti continued to regard me sadly as he rubbed Caterina's shoulder. I turned to Crivelli. For once he was silent and inscrutable. Caterina's disgusted expression deepened, and she finally broke into a bitter chuckle.

"It's best you stick to singing, Tito," she said in a brittle voice. "You make a poor detective."

"What do you mean?"

"Just this…I would hardly have killed Adelina. She was my mother."

I dropped onto one of Maestro Conti's hard chairs. My accusatory outrage drained away like wine from an overturned glass.

"So, Caterina," I said at last, "how is this possible?"

"I only know what Adelina told me." She pushed a straggling lock of hair back from her face. "She had me meet her here in

Maestro Conti's studio on the day of *Juno's* dress rehearsal and told me she had left me here as a baby. I suppose she didn't think I would believe her without Maestro's confirmation. I asked you to meet me here for the same reason."

Stone-faced, Caterina drifted over to the harpsichord. She sat down and rested her forehead on one hand as if she were still overcome by the circumstances of her birth. Maestro Conti came to her aid by taking up the tale in his rapid, high-pitched voice.

"Venice remembers La Belluna as a grand diva, but that was not always the case. Once, she was just a frightened, penniless young girl. With not a mouthful of bread to feed either of them, she consigned her daughter to the nuns of the Mendicanti."

"I wonder how easily that decision was made?" Caterina said without raising her head.

Conti shook his head until his chins quivered. "She never forgot you. When your mother acquired a little money of her own, she sought me out and charged me to look out for you. I was to make sure you had everything you needed and, most importantly, train your voice so that you would never be without a way to make your own living. We met in secret so that I could report on your development."

He crossed to the harpsichord and began to stroke Caterina's hair. "Adelina never missed an opportunity to hear you sing. Once she was established in Venice, she was in the audience for every one of your public performances. We used to have such fond talks about how quickly you progressed."

"She paid you to be my friend," the soprano said, shaking his hand off her head.

"It started that way." Conti's voice broke into a squeak. "But, my dear, you became the daughter I knew I could never have. Watching you grow up became one of my greatest joys."

As tears rolled down his pink cheeks, I realized that Maestro Conti was a *castrato*. Another soul mutilated for music, he had managed to find his niche in life turning orphan girls into piping nightingales.

Caterina nodded sadly, only partially mollified. She waved a hand to tell him to go on with the story.

"Adelina was only fifteen when her mother died. The Turkish trader who had sheltered them both turned the daughter out when she refused to take her mother's place in his bed. Her pretty face and pleasing voice were the only assets she possessed. To keep from starving, she learned to earn a few *soldi* singing popular airs at festival times. Fortunate for such waifs that Venice has so many holidays!" Conti sighed glumly, eyes still on Caterina. "Adelina was finally taken up by a troupe of entertainers. You all know the type. They throw up a stage of planks and barrels on the piazza, mix some music with some funny business, and pass a hat around for coins."

Crivelli rose painfully from his corner bench. "I remember her then. I first saw our unfortunate prima donna at a regatta on the Grand Canal. Her troupe was set up in the Campo San Bartolomeo, not far from the finish line. The crowd was greatly taken with her. Many of the spectators missed the boat races just to hear her sing. Even then, without any formal training, she was magnificent. I knew I would see her at the opera eventually."

I tried to picture Adelina as a struggling singer, a young woman about my present age. How hard she must have worked to perfect her craft. In a short space of time, she had somehow mastered the gradual and systematic training that took me eight years to complete. Then I remembered how I last saw her, the lovely face a ghastly blue mask, the vibrant body limp and lifeless, horrible brown liquid dribbling from the lips that had shared so many confidences and given me such heartfelt advice. I shook the gruesome picture from my mind.

"Adelina told me much of this," I said impatiently. "Where does Caterina come in?"

Old Conti wrung his hands nervously. "Adelina attracted a benefactor, a young Hessian count fleeing his duties at a stodgy, northern court. He set her up in comfort and paid for the voice lessons that fashioned her natural talent into a formidable instrument. She was just beginning to be noticed in the opera houses

when she became pregnant. Suddenly her lover wanted nothing to do with her or the baby."

Caterina spoke through clenched teeth. "Adelina's handsome count couldn't get out of Venice fast enough. He went home to an arranged marriage with a moon-faced German princess and was never heard from again. Meanwhile, Adelina's expanding belly kept her from appearing on the stage. She barely survived until I was born and deposited with the nuns."

Crivelli spoke up again. "And then she sang for her supper at every provincial opera house between Parma and Perugia."

Caterina crossed the room to the old *castrato*. "Did you know her then?"

"Our paths crossed several times."

"What was she like, back in those days?" Anger had abandoned Caterina's face and been replaced with a shining, expectant longing.

Crivelli took her hands. "There will be many hours for me to share my reminiscences with you. Right now Tito and I are pressed for time. What can you tell us about your mother's last days that would help us find her killer?"

"My mother," Caterina said with a wondering smile. "What incredible words those are. I don't think I would ever have become used to them." Her eyes focused dreamily, as if viewing someone invisible to the rest of us, then hardened into sharp points of dark light. "You want to know who poisoned Adelina. So do I. Her killer stole the most precious gift I had ever been given the minute it touched my fingertips. I want him found. I want him punished."

She knew something; I could feel it. "What do you think happened, Caterina?"

"Viviani is behind this somehow," she flung out. "Like everyone else, I always assumed Adelina used his attachment to ensure her place as prima donna, but that wasn't her motive. She really didn't need such craven advantage. Did you know that she'd had offers from half the theaters in Europe?"

Her sharp chin jerked. "No, she seduced Viviani for my sake. She was determined to see that I was well placed to work toward a successful career. When his passion was new and glowing, when he could deny her nothing, she had him hire me out of the Mendicanti chorus." Caterina gave an empty laugh. "I thought he chose me because he had admired my voice when he made his rounds with the other Governors. In truth, I don't think he had ever noticed me."

"What makes you suspect him?" I asked.

"It's because of opening night, when he came up to our dressing rooms to congratulate us on the opera. Remember how he pulled Adelina close to him, then gave her that vile kiss? Adelina was so angry she was shaking. He threatened her over something."

"Over what? Did she tell you?"

"At first Adelina wouldn't say. She just called Viviani every name a woman can use to describe a treacherous lover. I had nearly convinced her to confide in me when Torani came in to smooth things over. Then it was time for places and we went down for the second act. You know the rest."

I thought for a moment. "How long have you been at the opera?"

"A year or so. When I started singing at San Stefano, Adelina tried to advise me and give me guidance, but I was too jealous and stiff-necked to listen."

"What made Adelina decide to tell you the truth?" I asked. "Why now, after a whole year?"

"I suppose she couldn't bear to go on with me treating her as a rival." Caterina hung her head. "I must have been insufferable, so full of spite."

"Don't blame yourself, dear. You didn't know." Conti fussed around the keyboard, straightening musical scores.

I continued. "Did Adelina tell you she was planning to leave the stage?"

"No." Caterina's face showed real surprise. "Why would she leave? Venice adores her."

"Adelina was her own harshest critic. She recognized that her voice was slipping, and she was determined to retire before the audiences noticed. She talked vaguely about setting a plan in motion before she left. Any idea what she could have been talking about?"

Caterina shook her head. Crivelli approached the harpsichord leaning on his silver-headed cane. "Perhaps Maestro Conti can tell us about Adelina's plan." My sharp-eyed friend had noticed something in the music teacher's distracted tidying up that indicted he knew something he would rather not divulge.

The black gown shook and the little man's cheeks grew pinker. "Oh, why did all this have to happen? I'm an old man. All I want is to be left alone to teach my students in peace."

This time it was Caterina who sped to Conti's side. "Maestro, if you know anything, you must tell them."

"Oh, oh…." The syllables trailed off into a quavering whine.

"Please, if you truly love me as a daughter."

Conti regarded his longtime pupil with fond eyes. "Oh, all right. Yes, Adelina told me she was planning to retire. Over the years, little by little, she had built up a comfortable nest egg. She had recently purchased a small villa on the mainland, up the River Brenta, and seemed quite ready to give up singing and devote herself to other pursuits. Her last task in Venice was to make sure Caterina would succeed her as prima donna at the San Stefano. She expected Viviani to easily grant this last request."

"Was she so sure that I would succeed?" Caterina asked quickly.

"She was sure of your talent, my dear. If you would allow her, she planned to guide you through the rest of it…the impresarios, the contracts, the intrigues."

"Had Adelina told Viviani of her plans?" I asked the music teacher.

"Yes. A few days before she died she told him that she would be leaving after *Juno*'s run and requested that Caterina be designated prima donna. He wasn't so upset about losing Adelina—

that didn't surprise her, she'd felt his ardor was cooling—but he refused to allow her to dictate her replacement."

Crivelli nodded. "Viviani is a man who likes to keep a firm hold on the reins."

I was puzzled. "If Viviani was ready for Adelina to leave San Stefano, why have her killed? Why not let her quietly retire to her villa on the Brenta?"

Conti hesitated and his mouth rounded to refrain his annoying whine, but a plaintive look from Caterina persuaded him to give me an answer.

"You must promise, all of you. You never heard this from me. Remember, this man is on the Board of Governors at this institution." As we silently nodded, he continued in low tones. "Adelina had a reserve plan. If Viviani wouldn't promote Caterina for love, perhaps he could be coerced by fear."

"What could possibly cause a powerful patrician like Domenico Viviani to fear Adelina?" I wondered.

Conti shook his head. "That I cannot tell you." He held up his hand to forestall Caterina. "No, my dear, I simply don't know. You can't expect me to tell what I don't know. All I can say is that Adelina Belluna seemed very sure that her wishes would prevail."

Crivelli and I left Caterina and her doting teacher to their private conversation and strolled down the wide hallway toward the Mendicanti's main entrance. On our left, dappled sunshine came from the tall windows covered with grillwork. The buzz of schoolgirls reciting lessons came from the classrooms on our right.

"An unexpected turn," the old *castrato* was saying.

"Not so unexpected for you, I think."

He allowed himself an indulgent smile. "I confess I suspected something of the sort. There were rumors of a child back in the days when Adelina and I sang on the provincial circuit. When Caterina suddenly appeared at the theater, hired over a score of more able and experienced sopranos and unrelentingly fussed over by our leading lady, my old brain went to work."

He paused and asked thoughtfully, "What direction does this send our quest?"

"I don't really know. Caterina's revelation is not the only complication." I gave him a brief review of the attack at the Colleoni statue and my intention to pay a call on Messer Grande.

"I don't envy you that call, but I do agree with your brother. We need to organize our forces, have a council of war, so to speak. If you can find out what the chief of police intends to do with Felice, at least we'll know how much time we have. When can we...."

He was interrupted by a friendly greeting. A stout nun in a white robe and black wimple glided out of a nearby classroom. She raised her palms to Crivelli's wrinkled face, and his expression changed from surprise to delight. They immediately dived into a stream of amicable chatter.

Edging down the hall to give Crivelli and the nun some privacy, I soon reached the foyer. This space was capped with a domed ceiling and embellished with niches containing statues set around the walls. I was admiring a graceful statue of Cecilia, the patron saint of music, when the opening chords of a Handel organ concerto rumbled out from the chapel that lay at a right angle to the stone-flagged passage. I hadn't thought about meeting my father on this visit to the asylum, but there he was, working at his keyboard, surrounded by the towering pipes of his beloved instrument.

I pressed myself against the paneled oak of one of the open doors. The chapel was lit by vertical slits of yellow glass. Dust motes floated in the heavy, golden air and seemed to condense around my father's profiled head. He bent his arched nose to the keys, completely engrossed by the music. And beautiful music it was. I marveled as his hands skimmed over the keyboard and stop knobs while his feet darted over the pedals below. I'd almost forgotten how truly talented he was.

Then I realized that I hadn't seen Father for several days. He usually left before I awoke in the morning, and he was either out of the house or in bed by the time I returned from the

theater. After the debacle of opening night, he had not returned to see me in *The Revenge of Juno*. I wondered if I should make my presence known. Would he leave the organ, happy to see me? Could I tell him what happened last night? Could we talk over family matters? He really ought to be told that, even now, Alessandro was out searching for a monk who might hold the cure to Grisella's illness.

I was still wondering when Crivelli called my name. My friend must have had a pleasant visit with the nun. He was smiling broadly and making one of his old-fashioned, courtly gestures toward the door. "Come along, Tito. The sun rides high in the sky and our dinner awaits."

I looked at his kindly old face and then back at the swaying figure on the organ bench. "I'm coming," I said, and hurried across the foyer.

Chapter 17

My city was devoted to opera. Every Venetian considered himself an expert on singing and was as critical in his judgment as he was generous with his advice. I had to appreciate the spirit, but crossing the Piazza San Marco on my way to confront the chief of police, I would rather have been left alone.

Gray skies had replaced the sun of the morning; the smell of distant rain filled the air. A gusty wind whirled scraps of paper around the piazza and made me draw my cloak tightly around my throat. Despite the change in the weather, the carnival atmosphere still reigned. It was the tenth of December and the merrymakers were determined to make the most of their last few days before the Christmas novena. From December sixteenth through Christmas Day, masking and other carnival entertainments were forbidden. After the holiday, the fun would begin anew and continue until the beginning of Lent.

I had made my way down the Mercerie unnoticed. The shops lining that market thoroughfare displayed an enticing array of rich fabrics, glassware, and caged birds that tended to monopolize the attention of passers-by. I wasn't recognized until I passed under the archway of the clock tower that stands at the north side of the piazza. I cursed my lack of foresight. If I had stuck a mask in my coat pocket before leaving home, I could have conducted my errand anonymously. As it was, I was hailed every few steps.

I'm sure that many *castrati* welcomed the attention, but even if I hadn't been nervous about the upcoming interview, it would have perturbed me. It was unsettling to hear every loafer on the piazza casually referring to me as "the new *castrato*, the eunuch that is causing a sensation at the San Stefano." The whole business made me feel threatened in some undefined way. I had no knowledge of their most intimate parts. Why should they be discussing mine? As much as I loved delighting audiences at the theater, I wished they could forget who and what I was when I wanted to take a walk or transact some personal business.

As I hurried along the arched colonnade of the Procuratie, I'm afraid my admirers that day found me cool and impatient to say the least. As soon as I spied an entry door into the long office-filled building where Messer Grande kept his headquarters, I dived through it. The uniformed guards at the door would keep any riff-raff from following me into the building.

I took a moment to get my bearings. Although carnival gaiety ruled a few steps away, the Procuratie was full of pale clerks with serious expressions managing the business of the Republic. The business of Venice was just that: business. Although my city called herself a republic and held elections to fill the offices of Doge and Senator, she was in fact a trading corporation run by a few hundred noble families whose only goal was their own enrichment through commerce. All government functions were subservient to the needs of the corporation. Any crime, be it violent, immoral, or bloodlessly fraudulent, which threatened to derange the well-oiled gears of the business machine, eventually came up before the State Inquisitors.

The Inquisitors were a triumvirate that capped the apex of Venice's pyramid of authority. By tradition, the Doge should have occupied that place, but over the years, the dreaded Tribunal had usurped the power of that office and reduced the Doge to a colorful figurehead trotted out for pageants and other state occasions. The fact that the present Doge was a feeble old man taken with frequent spells of fever had applied the finishing touch to the shift of power.

I stopped a clerk who looked a bit friendlier than the others and asked where I could find Messer Grande. The clerk's features briefly registered curiosity as he handed me off to a wary-eyed guard who led me up staircases and down paneled hallways. By the time sweat had broken out on my forehead and my stomach had become a rolling, twisting mass, the guard stopped in an anteroom before a heavy door with a brass nameplate. The reception desk was piled with tidy stacks of paper but devoid of clerical staff. The guard shifted from foot to foot and gazed hopefully down the long hallway we had just traversed. Finally, he ordered me to wait, knocked just below the brightly polished nameplate, and was admitted.

I had no idea what arguments I would use with the chief. I was still searching for inspiration that refused to come. I ran my finger around the inside of my damp neckband and straightened the lace. This was as bad as being pushed on stage not knowing which aria I was supposed to sing. I took a few deep breaths and reminded myself that in moments of crisis I had always been able to summon up enough nerve to save the day.

The door opened and my heart jumped. The guard waved me inside. "Messer Grande will see you now."

I entered a book-lined office dominated by a shining expanse of desk. Two carved griffins with folded wings supported the writing surface and seemed to guard the red-robed man seated in a deep chair behind it. I was in the presence of Ludovico Cello—Messer Grande—the State Inquisitors' chief agent. He was making a pyramid of his hands, and the tips of his long, spidery fingers rested just under his bulbous nose. This fleshy process was marked by a deep, neat scar in the exact shape of the crescent moon. I found myself staring at the scar as a rugged young constable slid a chair behind my knees and pushed down on my shoulders.

Moving only his lips, Messer Grande spoke without preamble, "What brings such a delicate nightingale out on such a blustery day? Have you come to favor us with a song, Signor Amato?"

I tore my gaze from the crescent scar and focused on the chief's half-closed, almost dreamy dark eyes. "Signore, I have come to speak on behalf of my friend, Felice Ravello. He has been unjustly accused of the murder of Adelina Belluna."

The figure across the huge desk remained motionless and silent. The young constable settled himself at a small desk in an alcove and began to whittle on the tip of a pen. He interrupted his work on the quill long enough to send me a few surreptitious, loathing glances.

"Adelina's maid must have been mistaken," I continued. "Felice is not a murderer."

Messer Grande stirred. His long fingers shuffled through a stack of papers under a glass paperweight, plucked one out, and sailed it across the desk toward me. "The maid has signed an affidavit detailing the events of that night.

"Let me summarize. After La Belluna leaves the dressing room to attend to her duties on stage, the maid is alone on the third floor. During Act One, she spends the time darning several of her mistress' stockings. The wine decanter is on the dressing table, in plain sight. When her mistress and Signorina Testi come up together, the younger singer goes directly to her chamber. La Belluna and her maid soon join her. Sent next door to retrieve some face paint, the maid observes Ravello handling Signora Belluna's wine decanter. Before Act Two, La Belluna drinks several glasses, becomes feverish with a horrible pain in her stomach, and dies. Your friend runs when confronted, and in his pocket is an empty vial of the sort used to hold poisons."

"I can explain the vial. It was for his throat. Felice's voice had deepened and he was unable to sing. He was gargling water with a few drops of belladonna to ease the inflammation of his vocal cords and regain his soprano." Did I hear a tiny snigger of disgust from the constable's alcove?

"It seems he had another use for it, also." Messer Grande settled back to his former position.

"Perhaps Adelina wasn't poisoned at all. She may have died of natural causes."

"I have questioned the lady's personal physician and the doctor who was called backstage to examine her on the night of her death. La Belluna was in excellent health until she drank the tainted wine. The sudden gastric distress points directly to a deadly substance present in the decanter," he said with finality.

It was my turn to remain silent. My mind reached for more arguments as the scratchy whisper of the constable's pen filled the room.

"Tell me this," I said after a moment. "Why would Felice want to poison Adelina? He barely knew her."

"It is not my job to plumb his mind. It is enough to know that he emptied the vial into the decanter and the woman is dead." He shrugged his shoulders in the age-old Italian manner.

"But still, there has to be a powerful motive behind such a deed."

Messer Grande pursed his lips thoughtfully. "Well, now… since you mention it." He snatched a few more papers from the stack, read, and nodded. "His fellow orchestra musicians all agree that the deceased made a figure of fun out of Signor Ravello a few days before the murder. When he chanced to trip over…what is it?" He held a paper at arm's length. "A spear, yes, some sort of theatrical prop that the deceased had left lying around. The musicians swear under oath that he took her unkind laughter to heart and remained quite angry with her."

"But he wouldn't kill her. Anyway, she had apologized, and the incident was a trifle that would have been soon forgotten."

"These things do fester in the mind, especially a mind already distressed. Had he not had a recent blow to his emotional state?"

The chief's black eyes were hard and wide open now. Their gaze riveted me to the back of my chair. How could he know about my rebuff of Felice's declaration of love? Could his covert spy network see through the walls of my bedroom? I found myself becoming entranced by the crescent-shaped scar, but managed to shake my head negatively.

The marble-hard eyes narrowed again. "But you just said the fellow had lost his voice. How distressing for him...to realize that he had lost the seat of his manhood for...nothing."

"Oh yes, of course he was upset about that, but the decline in his voice had begun many months ago. It could not have led him to kill Adelina. I know Felice. He is not a violent man. You have to believe me."

"Who else is there to speak for his character?"

"Besides me and my family, there is no one. Felice is a stranger to Venice."

The chief stood up and put his fingertips on the desk. Leaning forward to give his words emphasis, he said, "Exactly. A stranger, *a foreigner*, comes to Venice and kills one of our most beloved singers. The only person to step forward to defend him is one of his fellow eunuchs. There are those who would have had him strangled days ago."

I sprang from my chair. "Is one of those His Excellency, Domenico Viviani?"

"Ah, the songbird ruffles his feathers." Messer Grande gave me a wolfish grin. "Is it not natural for Signor Viviani to be interested in seeing justice done? After all, the murder occurred at his theater. His prima donna, who also happened to be his mistress, was poisoned. Why should he not be anxious for the murderer to be punished?"

"I don't know." I was hesitating, unsure how much to reveal to the man who wove the fabric of Felice's fate with those powerful, spidery fingers.

"Indeed? I think you know more about your patron's dealings with his leading lady than you are willing to admit. I can't blame you. To cast suspicion on Viviani would be to bite the hand that feeds you." He regarded me inquisitively. When I didn't answer, he strolled to the window that overlooked the piazza and stared down at the humanity on the pavement with a proprietary air. Someone or something must have caught his eye. He called the constable to the window and pointed toward the south side of the square. With a comprehending nod, the junior officer went

out by a small door between the bookshelves. Some unsuspecting individual enjoying a marionette show or flirting with his lady would soon be set upon by *sbirri* and dragged to the prison behind the Doge's palace.

I gathered my courage. As I did on stage, I lifted my chest and put force behind my voice. "Signore, you asked about my patron. Whether Adelina's murderer is of the highest nobility or is a beggar from the back *calli*, it makes no difference to me. I only ask that you grant me time to discover the truth and bring the real killer to you."

"I have no time for fantastical solutions." He remained at the window and spoke over his shoulder. "But I am a reasonable man. I don't want to deliver an innocent up for execution. For the next five days, Carnival has everyone's attention. After that, there will be no more distractions to prevent me discharging my responsibility to the Republic."

My heart soared. Could I be hearing him right? Was he giving Felice a reprieve?

"Do you understand, Signor Songbird? If I don't have hard evidence that someone else murdered Adelina Belluna by five days hence, Felice Ravello will be delivered to the Secretary to the Tribunal so the Inquisitors can hear the case and pass sentence."

Chapter 18

After that night's performance, I battled lashing rain all the way from the stage door to the Campo dei Polli. I had the good luck to snare a covered gondola, but I was still cold and wet when I sat down at the dining room table with Annetta and Alessandro to preside over what Crivelli had called our council of war. The old *castrato* had promised to join us as soon as he could. He had been delayed by some eager well-wishers from his native city of Bolzano. After enjoying the opera, they had descended on his dressing room and were determined to reminisce about old acquaintances.

"Imagine Adelina keeping her child a secret all those years." My sister arranged the bright blue shawl Alessandro had given her around her shoulders to keep out the chill. "I don't think I could have done it. As soon as I could, I would have run to the Mendicanti, snatched her up, and never let her go."

I moved my damp feet closer to the *scaldino* Annetta had brought down from her room. "I think Adelina suffered a lot of guilt over leaving Caterina with the nuns. That's why she was so determined to foster her daughter's success as a singer. It was her way of making things right."

Alessandro eyed me speculatively. "Are you sorry that Caterina didn't turn out to be the killer?"

My brother's canny merchant's instincts were right on target. I *had* wanted the blame to fall on the obnoxious soprano. Caterina's guilt would have banished certain troubling thoughts from my

mind: Felice pouring out his declaration of love, Felice blaming my friendship with Adelina for my rebuff, Felice's startled look when Crivelli and I met him on the stairs the night of the murder. "It would have been an easy solution," I answered wryly.

"If Caterina didn't do it," Annetta asked, "who did?"

"Our first question should be who had access to the wine decanter." Alessandro planted his elbows on the table. "Let's think back. We were all in the hallway outside the dressing rooms congratulating Tito after the first act. Who else was up there?"

I led off. "Susannah says Adelina had a glass of wine before the opera with no ill effects. There was no one else besides the maid on the third floor until the singers began to come back up to change for Act Two."

Alessandro stopped me. "What about that maid? She had plenty of time to doctor the wine."

"But Susannah had no reason to harm Adelina. I often saw them together during the days of rehearsal. Susannah seemed devoted to her mistress. As well she should be. Adelina was a kind and generous employer. A maid couldn't have hoped to find a more pleasant position."

"Maybe Susannah just couldn't stand the thought of ironing one more petticoat," Alessandro said flippantly.

"Unlikely, I think, but I suppose we should keep her in mind."

My sister leaned forward tentatively. "I think Orlando Martello might have done it. Remember how angry he was after Adelina refused to go to England with him?"

Alessandro snorted. "Think sensibly, Annetta. Orlando wasn't even up on the third floor."

My sister bristled immediately. "Do you think merchants who sail the high seas are the only ones with brains? Why invent dubious motives for poor Susannah while Orlando comes complete with a motive we don't have to hunt up?"

"Just what would that be, your high and mighty braininess?" I had to smile as Alessandro and Annetta squared off. Mature airs set aside, they were suddenly the squabbling brother and sister I remembered so well from my childhood.

"Tito and I were at the Palazzo Viviani the night Orlando asked Adelina to marry him," Annetta flared back. "Orlando had it all planned. They would go to London, she would sing at one of the Italian opera companies, and he would sell his compositions to the highest bidder."

"She refused him?"

"Refused and humiliated him," I added. "When he realized that Annetta and I had overheard the scene, he was enraged."

Annetta shivered under her shawl. "I'll never forget the evil glare he gave us. He looked as if he could murder us on the spot."

I nodded in agreement. "Orlando is a typical Roman…it doesn't take much to ignite his temper. I can imagine him throttling someone who thwarted him, but poison? That's not his type of weapon. Besides, no one saw him go upstairs."

Alessandro continued in a matter-of–fact tone, "That leaves Viviani and his entourage. If Caterina is to be believed, Domenico Viviani said something to anger Adelina right before he kissed her in the hallway. Remember?"

"No one is likely to forget that kiss." I pictured the scene in my mind: Adelina straining away from Viviani's embrace, the nobleman thrusting his tongue deeply into her mouth. "Wait a minute. Could he have pushed something into her mouth, a poison capsule of some kind?"

"Is such a thing possible?" Annetta asked. "If he held some substance in his mouth, wouldn't he also be affected?"

"It sounds far-fetched." Alessandro shook his head. "If Viviani wanted to kill Adelina, he would just order one of his henchmen to do it. Probably Bondini, or even one of his brothers. They are both at his disposal, they know who holds the purse strings in the Viviani family." Alessandro smiled slyly. "I doubt your patron even puts his pants on by himself. He probably has one servant to pull his breeches up, another to fasten his knee buckles, and at least three or four to button his fly."

I began to chuckle as a few responding quips came to mind, but quickly reminded myself of the gravity of the matter at hand.

"Viviani had refused Adelina's request to promote Caterina to prima donna. Yet Adelina told Conti she could force her lover to bend to her wishes. She must have had information that would cause Viviani a great deal of trouble."

Annetta wrinkled her brow. "If I were going to threaten a man like Domenico Viviani, I wouldn't breathe a word to him until I had written my information out and put it somewhere for safekeeping."

"Of course, Adelina would have thought of that, too." As I pondered my sister's bit of wisdom, the bell by the front door jangled.

Annetta bounced up. "I'll get it. I've already sent Lupo to bed." She soon returned with Crivelli and a masked woman. I recognized the woman's damp skirts, but my brother and sister waited in anticipation while the female visitor slowly pulled the lace of her *bauta* from her face.

"I know we've had our differences, Tito, but I want to be part of this. I want to help you find my mother's killer," said Caterina as she rearranged her stringy blond locks.

I drew myself up and looked her in the eye. "There is one conviction that everyone in this room shares—Felice Ravello's innocence. Can you say the same?"

"Unlike so many others, your friend was kind to me. I don't know what Felice was doing in my mother's dressing room that night, but no, I don't think he killed her. You know who I suspect."

With the clock ticking on Messer Grande's reprieve, I welcomed all the help that was offered. I invited our guests to sit and brought the *scaldino* around to warm their wet feet.

For the benefit of the newcomers, Alessandro enumerated our growing list of suspects. My original tally had run to only one ambitious soprano who was no longer on the list. In only thirty minutes, we had added a maid with plenty of opportunity but no apparent motive, a spurned composer with no known access to the wine decanter, and an overbearing lover who may have felt threatened by Adelina's mysterious information. Alessandro

hadn't included a few items I was hoarding at the back of my mind. At this rate, we would be knee deep in suspects before the clock struck the next hour.

"There's one person you didn't mention," said Crivelli.

"Who?"

"Me. Are you so sure I didn't do the dirty deed?"

I laughed at his outrageous suggestion. "You wouldn't hurt anyone."

"Don't dismiss me so quickly. Allow yourself to consider it. How do you know I didn't slip down the hall and fiddle with the wine?"

I regarded him in consternation. Why was he wasting time with this nonsense?

"He's right, Tito," my brother cautioned. "You can't rule someone out just because he's your friend." Everyone around the table nodded in solemn agreement.

"All right." I sighed, feeling outmaneuvered. "Let me retrace your steps that night. That last aria in Act One always takes a lot out of you. I watched your exit. You were breathing hard and I waited until you were ready to go up. We climbed the stairs together and had barely reached our dressing rooms when my family appeared. You stuck your head around the screen to talk to Grisella." I closed my eyes, reaching for a mental picture of the scene. "Then Viviani favored us with his visit. You and I stood side by side in the hall. After Torani ordered us back to our dressing rooms, I heard you whistling over the partition while we changed. Then I followed you back down to the stage level. There was no time during the intermission when I didn't know exactly where you were."

"Excellent! That is how you have to think." The old man rubbed his hands together. "We must analyze every person's movements and take nothing for granted."

"Perhaps we've dismissed some possibilities too quickly." I thought back to Annetta's suspicion of the composer. "I remember that Orlando was carrying a bottle of brandy around backstage. It could have contained poison. I didn't see him go

upstairs, but that doesn't mean he didn't. If Felice had time to slip up to the dressing rooms, so would Orlando."

"Or he could have given Adelina a drink before she went upstairs." That was Annetta, building a case against her preferred culprit.

"No," said Caterina thoughtfully. "Adelina was waiting for me when I made my last exit. We went upstairs together, discussing the phrasing of my next aria. Orlando was still out front."

"Did you see him later?"

"Not until Adelina was dead." Caterina spoke softly and sadly.

"That brings us back to Viviani or someone acting under his orders," I replied. "If only we could get access to Adelina's belongings, we might find a clue to the information that she planned to use to force Viviani to appoint you prima donna."

Caterina brightened immediately. "But that's easy. I have Adelina's things. Her advocate read the will before the magistrate this afternoon. Besides a small bequest to Susannah and a gift to Maestro Conti, Adelina left everything to me."

"Her villa?"

"Yes, her house on the Brenta, her savings, all her possessions in her apartment here in Venice. Everything."

"Have you gone through any of them?"

"I haven't had time, but everything should be as she left it. After Susannah gathered Adelina's things from the theater, the apartment was shut up. I have the key here." She rummaged through her small drawstring bag and held up a brass key. "There. Susannah and I were going to start organizing Adelina's things tomorrow."

"Susannah?" I asked.

"I've hired Susannah as my maid. I'm afraid she didn't seem particularly keen, and I'm not used to having anyone do anything for me, but I suppose we'll get used to each other in time."

"I can help you and Susannah sort Adelina's things tomorrow," Annetta offered.

"I'll come, too," I added. "With only four and a half days until Messer Grande goes to the Tribunal, every minute counts."

Alessandro got up to stretch. He extended his arms, rolled his neck, and tried to disguise a mammoth yawn. He directed a question to Caterina. "Did Susannah have any idea about the relationship between you and Adelina?"

"No, she was as shocked as I was. Adelina kept her secret well, and Maestro Conti was a loyal confidant." Caterina looked around the table with a challenging set to her chin. "I really think we can remove Susannah from the list. No one who witnessed her reaction to Adelina's death could seriously suspect her."

I could see that my brother remained skeptical, but the rest of us nodded and murmured agreement. Closed eyes accompanied Crivelli's nod and soon his chin was resting on his chest. My friends and family were tired and the hour was late, but I needed their counsel on one more point.

"The Albrimani family. I believe their efforts to undermine the opera led to the apprentice boy's death. Is their feud with Viviani vicious enough to include poisoning Adelina?"

"The Albrimani present themselves as a family of merchant statesmen...ancient and dignified. But start chipping that façade away and they are no different from the upstart Viviani." Alessandro turned his chair away from the table and straddled it with his long legs. He sat down and rested his arms on the chair back. A tinge of anger colored his voice. "To get to the quay to bargain on a shipload of goods, the Albrimani will knock you down just as fast as the Viviani. Their bravos' stilettos are just as sharp and their agents' deals are just as crooked."

"Ah, the invaluable voice of experience," Crivelli observed, alert once again. "I can think of one interesting difference between the families."

"What's that?" I asked.

"The Viviani dwell at the confluence of the two widest canals in Venice. The Palazzo Albrimani stands on the Rio della Pieta, hardly a major waterway."

The women wore puzzled frowns, but Alessandro grasped Crivelli's meaning immediately. "The Rio della Pieta is only minutes away from the Colleoni statue. Take a few narrow canals and you're there. But after Tito's attack, his captors' gondola crossed the city and ended up on a major canal."

"Then it had to be Viviani thugs who warned me away from investigating Adelina's death." I recounted the story of my brief abduction to Caterina, who I fancied began to regard me with a little more respect.

Annetta's thoughts had raced ahead. "But who ordered the attack? The Signor or the Signora? The mistress of the Palazzo Viviani had good reason to hate Adelina. Time after time, Elisabetta Viviani was publicly humiliated by her husband's liaison with Adelina."

I leaned back and put a hand to the bump on my forehead, which had started throbbing again. "It gets more and more complicated. What a nightmare this has become."

"You wouldn't have so much to worry about if you would stick to your own business and let this wretched scandal alone," said a cool voice from the doorway. "This is hardly the first time your curiosity has led you into trouble."

Father frowned severely as he shook water droplets off his tricorne. The bell tower on the piazza could not have seemed so solid or unbending as the figure at the threshold of the dining room. Surprised by his noiseless entrance and daunted by his inhospitable attitude, the five of us around the table stared at him in frozen silence.

"Well, will no one greet me? My children may have invited half the cast of the San Stefano to my home at an unseemly hour, but I am still the master of this house."

"We apologize for any intrusion, Signor Amato." Crivelli rose and gave my father a painstakingly correct bow while Annetta sprang to take his hat and coat. "Your hospitality is much appreciated on such a wet night."

Slightly mollified, my father took a pinch of snuff and offered one to Crivelli. "Go ahead," he said, handing the singer a pewter

snuffbox. "My sons do not indulge, but I find the weed most invigorating. You'll need a bit of a pickup. The rain is almost over but it has turned quite cold. Am I right in assuming that is your gondola at the bottom of the *calle?*"

"It is, Signore."

"Then you had better hurry. Your gondolier is growing restless. If you delay, he may decide the warmth of his bed and his good wife is more desirable than another fare."

Annetta ushered our visitors to the door, leaving Alessandro and me in the dining room with Father. The rainstorm outside may have abated, but we were in for a hail of words inside. Father puffed himself up like an operatic Jupiter about to hurl a mighty thunderbolt, but Alessandro deflated him with a few soft words. "Father, where is your gold snuffbox?"

Our father was suddenly perplexed. He patted his waistcoat and looked at the corners of the room as if the snuffbox might materialize out of the walls.

"The gold snuffbox I brought you from my last trip, where is it?" Alessandro repeated.

"Oh, yes. I had to leave it with the jeweler. The clasp broke off. Really Alessandro, you should learn to examine merchandise more carefully before you buy it." With that indignant pronouncement, Father left us for the shelter, if not the warmth, of his bed.

Chapter 19

I couldn't guess when Father had awakened and left the house. When Annetta came to my bedroom with a steaming pitcher of water to fill the wash basin, he was nowhere to be seen or heard. "What time is it?" I asked groggily.

"Almost nine. You looked so tired last night I decided to let you get a good sleep."

I threw the covers off and shuddered when my feet hit the cold floor. "You shouldn't have let me lie here like a lazy Calabrian. We have so much to do and there's so little time." I tore around the room, gathering clothes and shoes. Annetta started toward the window to open the curtains, but I grabbed her around the waist and pointed her toward the door. "Let me get dressed. I'll be down in ten minutes and we'll go to Adelina's."

My sister tarried with her hand on the doorknob. "You've become very modest. I used to dress you when you were little."

"Well, I've grown up and would like some privacy please. Is Alessandro up?"

She smiled affectionately on her way out. "He's already been out to get a gazette, and he's eaten every crust in the house. You're out of luck for breakfast unless you want to wait for Berta's next batch of bread."

"No time," I answered, splashing my face with water.

I was hurrying down the stairs, buttoning my waistcoat, when the bell in the hallway below gave three slow rings. I opened the

door. At our threshold stood a tall monk in a white woolen robe with a heavy stole thrown around his shoulders. A black hood that designated the Dominican order covered his head and threw his face into deep shadow. Despite the cold, his hands were bare. The fingers that clasped the handle of his leather satchel were red and raw. He asked for Alessandro.

My brother was pushing in behind me. "Brother Mark, you're here. Tito, move aside. Let Brother Mark come in and get warm."

The monk stepped over our threshold and shook the hood back from his face. From his close-cropped black hair to his long feet encased in worn work boots, Brother Mark exuded a supple power that suggested the body of a greyhound or racehorse straining under his white robe. His thin face showed an intelligent, honest appearance, but it was his eyes that attracted the most serious examination. A deep slate gray and protected by hooded lids, they seemed to look straight through the reality of our humble hallway filled with the smell of baking bread into a mysterious, unseen realm.

While he and Alessandro discussed the exorcism, I asked myself if this austere man could possibly be the instrument of Grisella's deliverance. Brother Mark's chief concern was whether our sister had been told about the exorcism and had been prepared for the ordeal. In whispers, I asked Annetta if Father had been prepared.

"No," she whispered back with foreboding. "We thought it would be better to risk his wrath and beg forgiveness later than to reveal the plan and have him forbid Brother Mark to come to the house."

I was left alone with the Dominican while Alessandro and Annetta went up to Grisella's room to present their scheme for her approval. According to Brother Mark, the exorcism would be more effective if Grisella truly wanted his help.

"What's involved in this ritual?" I asked as my brother and sister disappeared up the stairs. "How do you do it?"

He turned his solemn gaze on me. "The mazes of the mind are twisted and perplexing. God can fill them with love and light, or the Ancient Serpent can pollute them with filth. If some dark power holds sway over your sister and torments her soul, she and I must fight it together."

"I don't understand. Why—and how—could a demon jerk her body and make her yell obscenities? She is hardly more than a child, who has never caused trouble for anyone." I thought back. "Well, she has had her childish tantrums, but I'm sure her heart is pure and holds no malice."

"Young girls on the brink of womanhood are Satan's preferred prey. In their innocence, they are easily deceived and dominated," he intoned gravely. "Only last month I was called to Verona to fight a demon who had possessed a girl of barely eleven years. Her mother asserted that before the troubles began she couldn't have wished for a more pious or helpful child."

"The troubles?"

"When the girl entered a room, objects would fly through the air. In the kitchen it was pots and pans. In the sitting room, a portrait in a heavy frame detached itself from the wall and smashed itself in the fireplace."

"Did the girl have fits like my sister's?"

"No. The Dark Angel inflicted a different trial on that child. During the manifestations, her hair would stand on end and her skirts would crackle. Her very skin seemed to radiate a strange energy I had never encountered before."

"What happened to the girl?"

A beatific smile spread over Brother Mark's face, and I realized he was younger than I had first thought. His air of gravity added years to his face, but with that smile accompanied by a twinkle in his gray eyes, I saw he was actually little older than Alessandro. "The light of our precious Lord prevailed," he told me. "The girl is well and her household is peaceful."

My brother called from the top of the stairs. "Grisella is ready, Brother Mark. She is willing to accept your help."

I wished the monk good luck in his sacred undertaking and reached for my cloak. I called up to Alessandro. "Send Annetta down, we have to be getting along to Adelina's."

Alessandro clattered down the stairs. "No, Tito, you can't go now. We need you. Grisella won't submit to the exorcism unless we're all there."

"But I have to help Caterina sort through Adelina's possessions. We need to discover what Adelina knew that could threaten Viviani."

My brother leaned over the banister. His expression was intense. "I know, but you have all day to do that. Please Tito, Grisella needs you now."

Annetta appeared at the top of the stairs. She spread her hands helplessly. I turned to Brother Mark, frustration rising in my gorge. He laid his hand on my arm. "If your presence calms the girl and serves to make her more receptive, then your help could be very important."

"And if the devil is powerful, it may take our combined strengths to hold her down and keep her from harming herself," my brother added. "Isn't that right, Brother Mark?"

"Perhaps." He nodded, the weight of years settling on his face once again.

I hesitated, my loyalty to my family struggling with the thought of Felice moving one step closer to the State Inquisitors' chamber. The monk's hand was still on my arm; I could feel its warmth through my sleeve. His voice was compelling. "It will only take a short time to discern what sort of menace we are facing."

Still torn, I hung my cloak back on its peg and reluctantly followed the others up to Grisella's room. We found the girl in bed, propped up on pillows, attended by a fearful, fidgeting Berta. Brother Mark stopped at the doorway and sniffed the air of the room. He directed the women to gather up Grisella's combs and brushes and all the small items on her dressing table. He explained that any loose object could become a dangerous projectile during the struggle ahead. For the same reason, he

instructed Alessandro and me to clear the room of light furniture, leaving only a small table by the bed on which he began to arrange his sacramental armamentarium. Out of the satchel came a prayer book, a large crucifix on a stand, a purple stole, a container of lustral water, and assorted reliquaries and medals.

Grisella watched his preparations with mounting anxiety. She whimpered and called for Berta, but Brother Mark barred the old nurse's way and took a seat on the edge of Grisella's bed. Her face was white and her eyes wide with fear as he began to stroke her hands and talk to her in a comforting voice. The four of us, Berta clutching her apron and burying her face in Annetta's shoulder, watched from the foot of the bed.

"Do you love the Lord, your God, with all your mind and heart?" Brother Mark asked, his hooded eyes studying Grisella's pale face.

"Yes," she answered in a hesitant whisper.

"And Jesus Christ, your savior?"

"Yes," she replied in a stronger voice, her huge eyes locked on his.

As Brother Mark inquired about Grisella's devotion to a litany of saints and martyrs, he pressed the back of her hand against his cheek as if to gauge its warmth and again used his sense of smell on her hand and the air surrounding her bed. With a sudden movement he dipped an aspergillum in the holy water and sprinkled the length of my sister's covered form, ending with the cascade of red-gold curls covering her pillows. Grisella blinked in surprise but smiled up at him sweetly.

"You're a nice man," she said. "At first I was afraid, but I'm not anymore."

The monk did not return Grisella's smile but continued to search her face intently. Did he expect the evil presence to manifest itself on her countenance? His hand flashed again, quick as an eel, and pressed a silver object on her forehead. Grisella gasped but lay still as he held a small crucifix against her skin. I hadn't seen him reach toward the table; he must have had the crucifix hidden up his sleeve. Grisella giggled nervously as the exorcist

removed the cross and inspected her pale, unblemished forehead. My stomach rumbled to remind me I'd neglected breakfast. I was more than ready to set out for Adelina's and was growing weary of this ritual which seemed to consist of nothing more than magic tricks.

Brother Mark stroked Grisella's cheeks thoughtfully. A snake rising from the basket of an Eastern fakir could not have been more entranced than my sister was by the monk's intense gaze. After a moment he wound the purple stole around his neck and placed a reliquary in Grisella's hand. He bent over her, saying, "One more test, little one. Don't be afraid."

With majestic presence, he stretched to his full height and held his arms above the bed. "By the judge of the living and the dead, by your creator and the creator of the universe, I compel you to speak your name."

"But you know my name. It's Grisella."

Brother Mark thundered, "No, foul spirit, that is the name of the afflicted child, the human creature you defile with your poison of eternal damnation. By the power of Christ, I command you to speak your unholy name."

"My name is Grisella Geneviva Amato," our poor sister wailed, close to tears.

The white-robed monk threw his head back and implored the heavens in a roaring moan. He clutched his chest with one hand and shook his other fist at an unseen evil. "Do not despise my command because you know me for a sinner. Ignore my impurities and obey the one who is blameless. By the might of God, the Most High, reveal your name." The air in the room seemed to vibrate under the power of his words, but no spirit heeded his will. Grisella had drawn the covers up under her chin and was weeping miserably. Next to me, Berta sniffled softly and Annetta shook her head disapprovingly. I opened my mouth to stop this infernal performance, but a wave of dizziness overcame me and made the floor lurch under my feet.

The weeping girl on the bed and the figure towering above her receded into the distance, and a strange vision flashed before

me. I was staring at Brother Mark's face surrounded by his black hood that stretched to fill the periphery of my sight. The skin over his nose and cheekbones was translucent and pale. His mouth was set in a gentle, questioning smile. An infinitely vast wave of loneliness spread out from that smile and engulfed me in deep sorrow. The hooded gray eyes that seemed to see so much more than mine had turned to crystal—shiny, reflective facets lit from behind by an energy that begged and beckoned. I felt myself falling forward, but Annetta squeezed my arm and the floor became solid once more.

Brother Mark was kneeling by the bedside reassuring Grisella. She had stopped crying and was clinging to one of his wide sleeves with a plaintive grasp. He turned and addressed the foot of the bed in a dignified voice very different from the booming roar he had used only a moment ago. "Leave us now. Grisella and I must talk in private."

Alessandro put his hands on his hips in an exasperated gesture. "Is that all? Did the exorcism work? Did you drive a spirit out of her?"

"Please go downstairs." The monk's tone left no room for argument. "I'll come to you after we're finished here."

We filed down the stairs in silence. Berta would have lingered at the door of Grisella's room, but Annetta pulled her along sharply and sent her back to her duties in the kitchen. The sitting room was dark and cold. Alessandro began stoking the corner stove with coal from a tin bucket while Annetta straightened the china figurines on the shelves and fluffed pillows that had been perfect as they were.

"We must go, Annetta," I finally said.

"At least eat something first." She cast a wary eye toward Alessandro, who was staring moodily at the flames in the stove. "The bread should be ready by now."

I was still feeling lightheaded and couldn't shake the feeling of aching loneliness that had pervaded me during my lapse. "I'll eat a bite, but then I must get over to Adelina's. With you or without you."

Our brother paced the room, threw the window draperies back, and kicked a footstool out of his way. "We've been duped," he said. "The monk is a fraud and the exorcism was a waste of time. He did nothing to rid Grisella of her spells."

"Maybe possession is not what troubles her," Annetta said from the doorway. She was taking a tray laden with bread and coffee from Berta.

"Maybe, but I'm sure he will expect an ample fee no less." Alessandro tore a hunk off the fragrant loaf and chewed morosely.

"My order survives on alms alone. I ask nothing for myself but a few *soldi* to cover my passage back to the monastery."

Brother Mark had entered the sitting room so softly that we all jumped. He surveyed us with a look of grave concern and refused Annetta's offer of food. "I'm fasting," he said. "Just let me sit by the stove and warm myself a while. The wind on the lagoon almost froze me this morning and the return trip will be little better." He seated himself on a low stool before the fire in a graceful, flexible arc.

Alessandro shifted restlessly from foot to foot but finished chewing the thick bread crust before aiming questions at the Dominican. "What did you find? Are Grisella's fits the work of a demon or just childish tricks?"

"Your sister is not possessed. Nor are her spells mere artifice," the monk replied without taking his eyes off the flames licking the lumps of coal behind the grate.

"How can you be so sure it is not an evil demon?" asked Alessandro.

"Grisella's case lacks the relevant signs. There is no foul stench in her room or about her person. She readily admits her love of God and all his saints without interference from a satanic power." The monk looked up and emphasized his next words. "You saw the crucifix I placed on her forehead. It is a holy relic that has belonged to our order for hundreds of years. A sliver from the true cross of our Lord's crucifixion is embedded in the shaft. If a demon infested Grisella's body, her skin would have burned and blistered at its touch."

"Then what is wrong with her, Brother Mark? We are at our wits' end." Annetta sank to the floor in a puddle of skirts and touched the monk's sleeve.

"She is suffering from a natural illness complicated by guilt and shame. She has been touched by despair and is too easily overwhelmed by imagined terrors."

"My God, is she going insane?" My brother threw the crust of bread back on the table.

"No. At present Grisella is in full control of her mental faculties, but she is suffering. She didn't tell me all that is troubling her, but she revealed enough to make it clear that a fearful anguish is causing her strange behavior. If left unchecked, her malady could end in madness. I have seen such cases."

"You mentioned guilt, Brother," I said. "Guilt over…what?"

"I was hoping one of you could tell me. Grisella was either unwilling or unable to explain."

Annetta was chewing on the edge of a thumbnail. She dropped her hand and began in a doleful voice, "Our mother died when Grisella was born. Of course, we attach no blame to our sister. A babe cannot be held responsible. Berta and the rest of us refrain from even mentioning it."

"But yet, the girl's mind is disturbed by a heavy burden," observed Brother Mark.

"It's Father. Admit it, Annetta." Alessandro began pacing again. "Whenever Grisella is particularly wayward, he calls her the spawn of the devil and accuses her of killing Mother. When she was little and wet her gown or grew fretful, he would hand her back to Berta and say 'take this cursed child, she's brought nothing but misery into this house since the day she was born.'"

I trembled with anger hearing Alessandro repeat Father's cruel words. No wonder the girl was troubled. Annetta sighed. "It's true. What Alessandro says is all true. Has Father's attitude caused Grisella's troubles?"

"It would certainly be enough." Brother Mark nodded. "But I think there's more. She seems very upset about someone named Felice. She tells me that she used to be able to fight the spells and

keep them from totally consuming her, but since the misfortunes of this Felice, she no longer has the will to resist."

"The convulsions have been getting stronger," Alessandro agreed. "The elixir doesn't seem to help much any more."

Brother Mark listened intently as I explained Felice's predicament and the limited time Messer Grande had given us to solve the mystery of Adelina's death. "One of our major obstacles is being unable to communicate with Felice," I finished. "We are allowed to leave food and a little money to see that his cell is kept clean and fresh bedding is provided, but visits or written messages are forbidden."

"Surely he can request to see his doctor or his confessor if he has the need. Even the worst miscreants cannot be denied the sacrament of confession administered by the priest of their choice."

I shrugged my shoulders. "I suppose, but Felice is healthy as a horse and likes to keep his prayers to himself. At school, he only went to Mass when we all had to, and he never went to confession without being dragged there by one of the maestros."

"Unfortunate," said the monk. "If he asked for me I would gladly hear his confession, and tell him of your faith in his innocence and your efforts to free him."

"You'd do that for us?" Alessandro asked in surprise.

Brother Mark stood up and shook out his robe. His cheeks glowed from the stove's warmth and his hooded eyes radiated a kindly light of their own. "I would do that for Grisella. I made her a solemn vow that I would do everything in my power to put her mind and soul at ease. Felice's imprisonment weighs heavily on her heart. I don't think her fits can be cured as long as he is in danger."

"How can we let Felice know that he must request a visit from Brother Mark?" I was asking myself as much as the others.

Annetta shook her head pensively. Alessandro fingered a hunk of Berta's bread, then tossed it in the air and caught it with a grin. "I think I have an idea."

Chapter 20

From my favorite perch atop the Benedictines' spiral tower, I watched the early winter dusk blanket Venice's spires and domes with a creeping gray mist. The damp chill seeped under my cloak, and I wrapped a scarf more tightly around my throat. The curtain at San Stefano would rise within the hour, but I was stealing a few moments to ponder the latest mystery. Who had broken into Adelina's apartment to steal a leather-bound folio, and what information did the book contain?

After seeing Brother Mark on his way and advising him to await a message to come to the guardhouse and minister to Felice, Annetta and I had hurried to Adelina's lodgings. The soprano's rooms were on the third floor of a house in the Dorsodura, a pleasant neighborhood of small squares and narrow alleys nestled in Venice's southwest corner. I expected my friend's possessions to tell me what she no longer could. I was particularly interested in any unfavorable information against Viviani.

When Annetta and I arrived, we were dismayed to find Caterina and Susannah ankle-deep in scattered books, linens, and empty drawers. Cabinet doors hung askew; even the bed hangings had been pulled down. Little was broken but everything was out of place.

"What happened?" I asked.

"We found the door ajar. You can see someone's forced the lock." Caterina indicated the splintered doorjamb. "I've already

knocked on doors and questioned the other inhabitants of the house, but no one saw or heard anything."

"I wonder if the intruder got what he came for?"

"We'll never know if we don't make our own search," Caterina answered.

The four of us set to work. We decided to sort the late soprano's possessions into different categories: books on the table, letters and personal papers on the desk, clothing on the bed, and so forth. Only then would we be able to make sense of the mess. I found myself working in the bedroom with Susannah.

"Are you still convinced of Felice's guilt?" I asked her as she folded shifts and corset covers.

The little maid grimaced uncomfortably. "My new mistress says Signor Viviani is behind the murder, but I know what I saw. If your friend didn't poison the wine, I'd like to know what he was doing in Signora Belluna's dressing room."

"I would, too," I admitted as I crawled over the carpet scooping everything from shoe buckles to hair combs into a large hatbox. "I suppose there is no chance that you would renounce the affidavit you signed for Messer Grande?"

"How can I, Signore? If Messer Grande thinks I set out to deceive him, there's no telling what he would do to me. Besides, I told nothing but the truth."

The truth: what an elusive concept that was proving to be. I shivered on my tower, knowing I needed to exercise my voice before the performance but loath to seek the warmth of the theater until I had mulled the new developments over. After hours of sorting and picking through Adelina's things, we had not found a shred of helpful evidence, and Susannah could be sure of only one missing item.

She described a thick, folio-sized book bound in red Moroccan leather. "My lady used to write in it for hours. She'd come home from the theater and prop herself up in bed with that book. 'Go to bed, Susannah,' she'd say. 'Just leave me a pot of coffee and I'll be fine.' The next morning, there'd be candle wax all over the nightstand, but the book would've disappeared."

"Where would she have kept it?" asked Caterina, surveying the premises with impatient eyes.

"I don't know," Susannah answered with a shrug. "She had hiding places even I didn't know about."

"That means the book could still be here, hidden in some secret space that has eluded both the intruder and ourselves," wailed Annetta in frustration.

"Do you have any idea what she was writing?" I asked the maid, who sank onto the dressing table bench with an exhausted sigh.

"Not really, but it seemed to make her happy. From my room, I'd hear her chuckle and sing little bits of music. Mornings after she'd been at the book, she'd seem quite pleased with herself."

Caterina and Annetta had thrown themselves on the bed among the neat stacks of clothing that Susannah had erected. All three of the women groaned when I proposed going over the apartment again, bit by bit, to look for a secret hiding place. I brought them to their feet with a graphic description of the machine used for execution when the Tribunal ordered a prisoner strangled. By the time I had reached the part where the victim's head was strapped in a crescent-shaped collar and the executioner was using a winch to slowly tighten a skein of wire around the unfortunate neck, my weary allies were tapping floorboards and examining the undersides of the furniture. Using hat pins, tweezers, and every other implement a fashionable lady's boudoir could provide, we poked and prodded every potential crack and recess in the place. It was all to no avail.

"Such rotten luck." My whisper joined the tendrils of mist swirling around my tower like ravenous spirits. "Why can't fortune smile on our quest just once?" I pulled myself away from the parapet. It was definitely time to head for the theater. The low murmur of the monks at their evening service accompanied me as I crept down the spiral stairs in near darkness, plotting my next move. The Palazzo Viviani was uppermost in my mind. I couldn't imagine gaining free rein to prowl over the huge residence in search of the red leather folio, but at least I could question some

of its inhabitants. Of course, the book might be at the bottom of a canal by now, but maybe not. Domenico Viviani had amassed his fabulous wealth through cunning and attention to detail. He would want to examine any potentially damaging information himself. The red book might be sitting in a desk drawer at the *palazzo* waiting for the master to read it at his leisure.

As the curtain at the San Stefano rose, I forced myself to put my musings aside and concentrate on the job at hand. Over *Juno's* run I had warmed to my role as Arcas and enjoyed singing Orlando's score. Adelina had described it as a repetition of his earlier work, but it was new to me and presented certain charms. The libretto afforded me several opportunities to strike heroic or moving poses, and I made the most of them. There were only two discordant elements.

The first was Orlando Martello. The composer was growing bored with conducting the orchestra from the harpsichord. He complained incessantly and paid little attention to the action on stage, leading to many slips between singing and accompaniment. He bragged that he was working on a new opera that would be Venice's most magnificent spectacle yet. If Torani or one of the other theater directors wouldn't offer favorable terms to mount the production in Venice, Orlando threatened to sail for England and offer it to His Majesty's Opera Company at the Haymarket.

Marguerite was a different story. The singer was neither old nor young, neither beautiful nor ugly. She made an impression by the stateliness of her bearing and the sheer strength of her voice. Her soprano could be shrill and graceless, but the pit never dared hiss her because she was known to have several powerful protectors who were particularly ruthless even by Venetian standards. Her lack of virtue didn't concern me—I left that to the gossips—but her stage behavior plagued me. So strong was her penchant for superiority that she used every trick of our trade to overshadow her fellow singers.

Her vanity forced me to develop a few clever tricks of my own. When she pirated my favorite embellishment for use in

one of her own arias, I countered by repeating the phrase with ornamentation she could never hope to match. I doubled her trills, pushed past her high notes, and sustained single tones for triple the length of hers. The audience loved it.

It was after one of these vocal duels that I realized I could put my stage success to work in my investigation. The roar of the pit was deafening as I made a reverential bow in the direction of the Viviani box. My patron had skipped the opera that night, and Elisabetta was entertaining a bevy of titled ladies. They were crowding each other at the box railing, applauding wildly.

"Maestro Torani," I called as I came offstage, "I'm going to pay my respects to Signora Viviani. I'll be back in plenty of time for my next entrance." The director looked surprised but didn't try to stop me. I fancied he thought the adulation was going to my head and I was turning into one of the willful, arrogant *virtuosi* who were more interested in being fawned over than singing.

The spacious Viviani box overflowed with feminine charm. The ladies' skirt hoops clacked together as they shifted from the rail to card table and back again. The enclosed space reeked with their competing fragrances and the mess one of their lap dogs had made under a chair. Besides the footman who was cleaning up after the dog, the only male in the box was Elisabetta's *castrato* attendant. I learned his name that night: Benedetto Benaducci, shortened to Benito by everyone. Dressed in a rich suit of scarlet moiré with a lining of sky-blue silk showing at his cuffs and collar, he carried his lady's fan and handkerchief in jeweled hands and bantered with her guests in a sweet, seductive lisp. I owe him a debt; Elisabetta and her company complimented me shamelessly, but Benito was the only one to suggest an invitation to the *palazzo*.

"*Ma cara signora*, our handsome nightingale should not be caged in this theater. He should be warbling in your audience chamber." When she nodded her head and told me she received guests on Sunday and Thursday afternoons, my entrée to the *palazzo* was assured.

I left the theater in better spirits than I had entered. One goal was in sight, and I hoped that when I reached home Annetta would tell me that Brother Mark had been called to hear Felice's confession. I hadn't covered more than one square's distance from the stage door when another worry popped up.

After leaving Adelina's apartment earlier in the day, I had noticed a knife grinder's cart outside her building. Not an unusual sight in a residential *campo*, but my instincts told me I'd seen the man before. My interest was further piqued when the same cart showed up in the market next to the Benedictine monastery. From my tower roost, before the mist had engulfed me, I had studied the cart owner's movements. His rolling gait and habit of hunching his left shoulder would be unmistakable.

There he was again. He had been waiting at the mouth of the alley that ran by the theater, this time without his knife grinder's implements. I slipped on a mask and directed my steps from *campo* to *campo* in aimless fashion, like a man seeking pleasure but unsure of where to find it. My shadow never wavered. With his cap pulled low to shade his face, he kept well back, but never let me leave his sight. My only other companion was one of Alessandro's Turkish daggers, which he had given me after I had been attacked at the Colleoni statue. I moved it to my waistband for quick access.

Uneasy at the prospect of leading my shadow home to the Campo dei Polli, I strolled toward San Marco's. A stiff wind off the Adriatic had blown the evening mist over to the mainland. The night had turned clear and cold, but the spirit of Carnival, and a multitude of large braziers, warmed the great piazza. A dizzying parade of costumed revelers surged to and fro, pushing frantically from one entertainment to the next, always seeking a bigger thrill. I stopped to watch a troupe of acrobats catapult onto each other's shoulders from a teeter board set on the ground but was soon diverted by a juggler who was keeping three lighted torches in the air at one time.

My shadow's rolling gait followed close behind me as I made my way down the piazza. When I stopped to buy a cup of smoky

black coffee from a vendor who was roasting his own beans at the back of his stall, the faux knife grinder turned to inspect a notice board announcing the arrival of an Egyptian contortionist. I suddenly realized that I was ravenously hungry and looked around for a place to eat. I didn't think I'd be attacked in the middle of a crowded café, so I joined a stream of masqueraders heading for a brightly lit doorway down a narrow *calle* just off the north side of the piazza.

Instead of food, I found a large building of interconnecting salons filled with gaming tables. Masked men and women jostled around tables throwing dice, playing faro, or betting on the wheel. This must be the Ridotto, the state-sponsored gambling house, not what I wanted at all.

I had turned to go when a tall, straight-backed man in a *bauta* caught my eye. Surely that was my father's coat. I had noticed him wearing a patterned green taffeta many times. I slipped behind a thick column to get a good look without being seen. I watched as the man laid wager after wager on the spin of the wheel. The tall stack of coins before him shrank inexorably, yet he continued to lay coins on the black or red squares like an unthinking, mechanical being. Murmurs of "Bad luck, Signore" and "Better try your hand at faro" reached my ears. One woman grabbed his arm and tried to tease him into leaving the table. He shook her off without taking his eyes off the wheel.

He seemed to come back to life only when the stack of coins had dwindled to nothing. He patted his pockets, and his masked eyes scanned the crowd as if looking for someone. Could this really be the Isidore Amato who insisted on a thousand small economies in the household, who wouldn't give Annetta an extra *soldo* to hire another servant, who had kept me on a meager allowance all my years in Naples? It was hard to imagine the thrifty father I had known squandering money at the gaming tables, but I was almost convinced of this man's identity. I wished the cloth of the *bauta* wasn't covering his wig; I would have recognized that without doubt.

Wondering what my shadow was making of my behavior, I followed the man in the green coat as he strode quickly from room to room. On the mezzanine, he entered a particularly sumptuous chamber lit with a wide chandelier and many extra candles. He hesitated on the edge of a group gathered around a richly dressed man who stood out all the more because he was one of the few unmasked men in the establishment. It was Domenico Viviani. I watched as the man who I thought was my father tried to catch his attention. A waiter hung at my elbow, inducing me to buy a glass of Cyprus wine. I had better start spending some money or the management would be ushering me out onto the street.

I gave the fellow an extra coin and posed a question. "Who is that man pestering Signor Viviani?"

"I don't know his name, Signore," the waiter answered. "He is always masked."

"Does he come here often?"

"Yes, several times a week," he said, scurrying away with his coin as if he had told something he shouldn't.

My supposed father was desperately signaling the nobleman.

Viviani seemed to recognize the man despite the mask. He allowed him to step forward and cautioned, "Make this quick."

My ears strained to hear their low-toned discussion. It was no use, but I didn't dare move closer for fear I would be recognized. My Moor's mask was more of a carnival trinket than a real disguise. If the man was my father, I didn't want him to catch me spying on him. I became aware of the approach of several large men who had been lounging against the wall: Domenico's bodyguards. They had noticed my interest in their master and were coming to investigate.

I backed quickly out of the room, ran across the mezzanine, and swung over the rail of the low balcony. I landed clumsily, but upright, on the ground floor. The punters at the tables were so consumed with the passions of the cards and dice that my odd behavior drew little interest. As the Viviani bravos leaned

over the railing with bewildered looks, I slipped my mask into my pocket and blended into the dense crowd.

The salons were as packed as the piazza outside, but the mood inside was much more restrained. Decorum demanded that the gamers conduct themselves with poise and elegance. It was considered bad form to show excitement or agitation at the tables, so fortunes were won with only a hint of a triumphant smile and lost with barely a trace of chagrin. Still, Venice took her gambling seriously. As the Republic's maritime ventures steadily waned, the populace turned to games of chance to provide the delicious intensity it craved. After all, what was sea-going trade but a momentous gamble? To consign a galley laden with valuable cargo to treacherous waters swept by sudden storms and infested with pirates was pure speculation. Past generations of Venetians had risked their lives and their fortunes to create an island paradise of unequaled splendor. My generation seemed intent on throwing it all away for the fleeting rush of excitement on the throw of the dice.

I was still hungry and more than ready to leave the Ridotto. I couldn't detect my shadow anywhere, and grave matters awaited me at home. I was heading for the door when I felt a soft touch on my arm. Whirling swiftly, I found impish green eyes staring out from behind a black velvet oval.

Signora Veniero lowered her *moretta* to reveal a delightfully intimate smile. Her hand was still on my arm. "How is your luck tonight, Signor Amato?"

"My luck is usually better than most. Even so, I don't put my trust in it," I replied, returning her smile.

"Where does your trust lie, then?"

I considered a moment. "My eyes, my ears, my hands. Things that are real."

She moved her hand down my arm and took my hand. Raising it to her mouth, she put my forefinger against her lips. I felt her warm tongue on my fingertip, then the gentle scrape of her small, white teeth. "This hand, Signore?"

The crush of bodies around us, the smell of burning wax and strong perfumes, my own hunger, all dissolved into nothingness at her touch. Unaccustomed warmth flooded my belly and rippled southward. All I could do was nod.

She cocked her head to one side. "I hope you're not losing your voice again?"

"No, Signora," I managed to whisper. "Tonight my faculties will not fail me."

My hand was still in hers when a large man in a *bauta* laid a heavy hand on her shoulder. His cloak was a fine grade of silk and his boots had a military cut. I knew this possessive admirer was not her husband as his fleet was still in Cyprus, but his garb suggested he was a patrician and an officer in the Venetian navy. As I stepped back to make a reluctant parting bow, a flutter of white hit the floor. I scooped up the delicate handkerchief of lace-edged lawn and pressed it in Signora Veniero's hand. I kept the tightly folded paper that she passed to me in my fist until I was back out on the piazza.

I nearly ran to the nearest brazier and used its light to read her invitation to a rendezvous the next evening. The appointed place was a house near the public gardens on La Giudecca, an island to the south of the city that was popular for recreational excursions. This time there was no trick; the lady had given me the message by her own hand. I felt almost as light as I did when I was swung above the stage on a wire suspended from the rafters.

As I pushed through the crowd toward the gondola mooring, I could have been bouncing instead of walking. My head was full of amorous imaginings, but my hand stayed on the hilt of Alessandro's dagger. I was not quite love besotted enough to overlook that I had traded a mock knife grinder with a sailor's walk for a ferrety little follower in a bird mask.

Chapter 21

"Which one do you want, Signor Tito?" Lupo asked, holding my two most presentable shirts aloft for inspection.

I ran the linen through my hands. Both shirts were fraying around the neck, but one was in better shape than the other. It also had the advantage of having undamaged Flemish lace at the wrists. "This one will have to do," I answered.

Lupo eyed the garment doubtfully. The old servant was playing valet to rig me out in splendor for my visit to the Palazzo Viviani. The meager wardrobe I had brought with me from Naples was in a sad state of repair. My salary from the opera house, even after the Conservatorio San Remo had its cut and I gave Annetta something for the household, was more than sufficient to order some shirts, but I just hadn't had the time. While Lupo dabbed at my waistcoat with a smelly cleaning fluid, I finished washing and slipped into the shirt. Alessandro had lent me a fresh neckcloth with a fall of fine ruffles, and Crivelli had insisted that I tuck his gold watch into my fob pocket. "A token to bring you luck," he had said. With these treasures and my own dress coat of ivory silk bordered in gold trim, I felt ready to hold my own in Elisabetta's salon.

One finishing touch remained; Annetta was carrying it in on a wooden stand. To call on the wife of one of Venice's wealthiest aristocrats, my own short curls must be hidden under a fashionable wig. I much preferred to wear my own hair. Wigs were hot

and made my head itch. When I had to wear one on stage, the theater supplied whatever was necessary. Consequently, Annetta had been forced to raid Father's stock of headgear. She had chosen a *parruca* with high curls in front and a little silk bag to gather the tail at the back of my neck.

As Lupo took my shoes down to the kitchen for a final shine, Annetta sat me down before my mirror and went to work. She rubbed fragrant pomade into my scalp and pulled it through to the ends of my own hair, then brushed it all as flat as possible.

"Annetta, do you think Father goes to the Ridotto?" I asked her reflection in the mirror.

"Probably, everyone goes there at some time or another."

"No. I mean does he frequent the place? Spend a lot of money at the tables?"

"Why?"

I told my sister about the masked figure I had followed around the gaming establishment the night before. "The more I think about it, I'm sure it was Father. The man must have lost over a hundred *zecchini*."

Annetta wrinkled her forehead. "Impossible. Father keeps the household on a strict budget, but he always has money to give me at the end of the week. We've always had all we need. With you and Alessandro contributing, we can even afford a few luxuries. I'd say our family lives better than most."

"That's because of your hard work and your eye for a bargain."

She chuckled as she positioned the wig on my head. "That may be so, but we wouldn't have anything if Father was a regular at the Ridotto. Anyone with good sense knows that gamblers lose more than they win."

Her disbelief challenged my suspicions. The masked figure had lost quite a stack of coins. That was more gold than an organ master at a convent asylum would see in a month. After he was played out, the man had gone to Viviani. Was he begging a new stake? My patron didn't strike me as the charitable type. Perhaps the man had been demanding payment for services rendered?

Annetta handed me a cone of stiff paper to cover my face. The wig had been powdered on its stand but needed a final touch-up. The cone prevented powder from getting up my nose and all over my face. As my sister held my silk coat, Lupo returned with my shoes. He had polished the leather to a high gloss. I fastened the shoes with buckles I had shined myself. With my ensemble complete, I was ready to make my appearance at the Palazzo Viviani and see what I could find out about jealous wives, affronted family retainers, and missing books.

The early afternoon sun had not brought much warmth to the Campo dei Polli. Frost still covered the north side of the leafless tree, and the women who came to draw water from the central well covered their winter-reddened cheeks with flannel scarves. I spotted my knife grinder right away. A cart like his was an unusual sight for a Sunday afternoon. I decided he had only one disguise or perhaps was more interested in keeping warm than cultivating an authentic air. He was sitting dejectedly on a low stool beside his cart practically hugging a *scaldino* to his chest. Dog my steps if you like, I thought. I saw no reason to make a secret of my visit to the *palazzo*.

Though I was bundled in a heavy cloak and carried a muff to warm my fingers, I decided not to walk, but to take a gondola and arrive at the *palazzo* in high style. My boatman threaded through the narrow, crooked canals of the Cannaregio and soon propelled his craft into the choppy, jade-green water of the Grand Canal. As we approached the pale, stately palace, I glimpsed several waterways that led into the warehouse area of the Viviani compound. I nodded to see that two of them were barred by gates of latticed iron.

I disembarked at the arched portico which led up to the sculptured bronze doors, the doors Bondini had driven us away from on the night of the *Juno* reception. This time I was admitted and my card was carried away on a silver salver. In a moment I was following a footman clad in the pink Viviani livery up the grand staircase. We passed between marble columns topped by caryatids and crossed the central reception salon where Adelina

and I had sung our first duet. It was hard to believe only two weeks had passed since that night.

Signora Viviani's suite ran the length of the south, and warmest, side of the vast residence. The other Viviani brothers and assorted family members must occupy smaller suites of rooms according to their rank and importance in the family business. Venetian aristocrats tended to maintain close family ties. Only one son of each generation was delegated to marry and carry on the family line. His brothers were expected to set personal ambition aside and devote themselves to the interests of the married brother while the daughters of the house were farmed out to suitable husbands or convents.

It was not always the eldest brother chosen to be the head of the family. Domenico Viviani was the middle of three. The eldest, Carlo, had shown academic promise at the Jesuit school, but his father had forbidden him to continue his studies at the University of Padua, preferring that his son learn the art of statecraft by accompanying an elderly senator in his governmental duties. Unfortunately, the bookish Carlo didn't have a taste for La Serenissima's cutthroat brand of politics and, even now, could often be found with his weak eyes glued to a volume at a bookshop on the Mercerie.

After the disappointment of the scholarly Carlo, Domenico must have seemed like the answer to a father's prayer. Clever, ruthless, and competitive, the second son wore the mantle of the Viviani clan as if it had been tailored especially for him. The destiny of the family was further assured by the lack of leadership shown by Claudio, the youngest son. As a youth, this princeling had shown no interest in study or politics but instead concentrated on acquiring mistresses and dressing exquisitely. Thus, both brothers accepted Domenico's rule without the type of sibling strife that had destroyed many a Venetian dynasty, and the Viviani fortunes prospered as a result.

The footman abandoned me in Signora Viviani's antechamber, an ice-cold room containing only a few woolen tapestries on the walls and an oversize console table holding a bronze bust of a

particularly ill-disposed Viviani. I had plenty of time to ponder what might have given the gentleman his bilious demeanor. They left me there in frozen solitude for over half an hour.

At last the squat, black-clad figure of Signora Albrimani appeared. This day, Elisabetta Viviani's sister and companion was all politeness and showed none of the fiery temperament we had witnessed in her attack on Adelina. Signora Albrimani ushered me into a warm, well-furnished chamber. Elisabetta was trading small talk with a group of ladies gathered before a crackling fireplace. I didn't see any sign of Benito, the Signora's *cavaliere servante.*

"Sister, the *castrato* from San Stefano has come," Signora Albrimani announced.

I winced at the lady's choice of introduction but nevertheless approached the mistress of the *palazzo* with a smile and made a deep bow.

Elisabetta took no notice of me, engaged as she was in listening to an indecent tale about the papal nuncio and a certain senator's wife. I stood and waited, my fingers still numb with cold, then joined self-consciously in the general laughter that greeted the end of the tale.

Signora Albrimani tucked a shawl around her sister's shoulders and drew a silver flask and tumbler within her reach. "Do you want the *castrato* to sing now?"

Elisabetta glanced in my direction and gestured for me to move closer. She looked weary and her skin had a waxen quality. Her voice was flat, and she seemed to need to search for a word before she spoke it.

"You must make the best of my clavier," she said, waving a hand toward the instrument. "It's in abysmal condition, but you could perhaps try it."

"Good lady, I would be delighted to sing for you," I answered with another small bow, "but my fingers are frozen to the bone and my throat is chilled. I beg you to let me warm myself before your fire before I attempt a song."

She inclined her head vaguely and seemed on the verge of forgetting my presence entirely. I added quickly, "I want you to hear my voice as it was when I last performed here." She looked puzzled, but I had her attention again. "Do you remember my duet with Adelina Belluna?"

Elisabetta narrowed her eyes, but her smile was serene and untroubled. "Of course, Domenico arranged the party to introduce the new opera. That was the night I spilled wine on my favorite gown. You sang with the poor woman who was killed at the opera house."

"Yes. She is greatly missed by all of us at the theater."

"You are not the only ones," Elisabetta sighed. "She was one of the best singers the San Stefano ever had. What a pity."

I nodded. "All Venice is mourning La Belluna's death. Her voice seemed heaven sent and her beauty made her a modern-day Venus."

Signora Albrimani resumed fussing with her sister's shawl. As she bent to rearrange the folds of her stiff gown, the older woman directed an ugly scowl my way.

I proceeded in a different vein, as if I were relating insignificant gossip. "Messer Grande has a man in custody, but he has not been charged with the murder. They say his guilt is much in doubt."

Pasting a neutral expression on my face, I watched Elisabetta's features. As I discussed Adelina's death, I was searching for signs of rancor, triumph, jealousy, any telltale emotion that would hint at her involvement in the murder. I observed only mild curiosity. The soprano's death seemed to have made little impression on this pampered woman.

"Is it true?" she asked, unconcerned as ever. "We heard the culprit would go to the executioner before the close of Carnival."

A footman bearing a tray entered and deposited coffee and sweet biscuits on a table at Elisabetta's side. My noble hostess set her sister to the task of dispensing refreshments and directed me toward the clavier with an imperious gesture. "A song, Signore. Sing something lively while we have our coffee."

I played her wretched little clavier, starting with some light, Neapolitan arias that had been popular in that city before I sailed for Venice. The Signora and her ladies never interrupted their activities for a moment but nibbled, chattered, and clinked coffee cups throughout my performance. I felt my throat grow tight and dry with vexation. Why had I thought a simple *musico* would be received with dignity and treated with respect? In this exalted household, I was nothing more than a talented servant, a trick pony who could be commanded to provide an interlude of pleasant diversion.

Under these odious conditions, I soon lost patience. I gave them a few more arias, then stood up. The ladies rewarded me with a scattering of delicate applause.

"An astonishing voice, truly inconceivable," a woman in lavender silk declaimed.

"A marvel," her friend agreed, then added with a giggle, "what a pity he is ruined for the work nature intended for a man."

"He is not a man. He is a creature made to infuse our souls with pure beauty," sighed an overwrought young lady by the fireplace.

"And what a deliciously handsome creature," added a stout matron as she popped a teacake in her overlarge mouth.

Elisabetta set her cup on the table and sank into the depths of her high-backed chair. Her eyes had taken on the glassy stare I had noticed the night of the duet. She favored me with a vague smile and said, "Very entertaining, Signore. We are looking forward to your next opera." She turned back to her guests as a footman materialized at my shoulder. That was it. There were no words of thanks or goodbye, just her patrician way of saying: You've done your turn. Now you may leave us.

Simmering with anger and humiliation, I followed the footman's floating strides down the wide staircase and across terrazzo floors until the huge bronze doors were in sight. More lackeys appeared bearing my cloak and hat. The tall doors were creaking open when a slight figure dashed out of a side passageway.

"That's all right, I'll finish seeing him out." Elisabetta's *castrato* attendant pulled me aside and sent my footman floating back into the marble recesses of the *palazzo*.

Benito was shorter than I was and made with more delicate bones. I found his grip disconcertingly powerful for one so small and decorative in his person. He pulled me into a small chapel with gilded walls and an ornately carved altarpiece. Candles flickered before statues of Our Lady and St. Mark and threw eerie shadows in all directions. The room held just enough pews to accommodate the family members who lived in this communal residence. Their velvet cushions looked as if they had never been sat on.

"Did you find my lady talkative today?" Benito asked without preamble.

"Not especially so."

He cocked his head to one side like an inquisitive canary. "Perhaps I can tell you what you want to know."

I hesitated, fingering the brim of my tricorne. No doubt this *cavaliere servante* knew a good bit about the Viviani establishment, but I feared that every question I asked would be instantly reported back to Elisabetta, or someone else.

"Ah, you are shy." He released my arm and smoothed the fabric of my sleeve. "If you think I cannot keep a secret, you are wrong. I can serve your purposes and not be disloyal to my mistress. Being many things to many people is my stock in trade, you know."

"You were at the theater the night Adelina Belluna died," I said, still reticent.

He nodded. "It was also the night of your renowned debut."

"Well, yes." I decided to plunge in. Felice's cause could not be served by being overcautious. "Did Signora Viviani go backstage that night?"

"No, I am sure she did not. The men left the box during the ballet, but my lady was feeling tired. She received a few friends in our box. She called for some brandy and something to eat, nothing heavy, just a light sweet. She was quite overcome by

your last aria." He paused and bit his lower lip. "We all were. Until we heard of La Belluna's tragedy, the talk was of nothing but you."

"Did Signora Albrimani remain in the box as well?"

He rolled his expressive eyes. "She was glued to her sister's side as always."

"I've wondered why she is called Signora Albrimani. She wears widow's weeds but carries her maiden name."

"There are only the two Albrimani sisters. The younger, prettier one was married into the Viviani clan, an attempt at a power alliance that went awry." He gave a pretty shrug. "The other was married off to a distant cousin who was in financial difficulties. The poor man tried, but her face at table every day and her body between the sheets every night was more than he could bear. He died young and the widow was stashed here."

"Does she still have contact with the Albrimani?"

"I think they've forgotten she still exists. She has no money of her own and goes out only when my lady ventures forth. Despite the petty disruptions she causes, Signora Albrimani has no more independent existence than her sister's lap dog."

I nodded thoughtfully. "I suppose neither sister had any regard for Adelina Belluna?"

He laughed: a tinkling, bell-like sound. "My lady adored La Belluna. And was heartily grateful to her."

"Really? I thought there must be some jealousy, at least some bad feelings."

He drew me over to a pew, and we perched on its pristine velvet cushion. "My lady does not enjoy the physical side of marriage. I am no expert on the female interior." He gave the word an odd emphasis and continued in an arch whisper. "But she tells me that the aperture which should easily swallow its male counterpart is tight shut and gives her pain if she tries to insert so much as her little finger."

"I see," I said and began to understand. If Elisabetta suffered during the act of love, any woman who diverted her husband's sexual appetites would be a welcome relief, not a rival.

Benito continued. "Of course, some pain connected with the act of love can be delicious, but I suppose it's all a matter of taste."

"But the public shame. All Venice knew of the liaison between Domenico Viviani and La Belluna. Sitting in the patron's box at the opera and knowing everyone was whispering and watching her reaction when Adelina was on stage must have tortured your mistress."

The little *castrato* giggled. "My lady is always so full of brandy, she hardly knows where she is much less who is looking at her or talking about her."

As I sat silently, trying to digest all the new information, Benito abandoned his coy role for a more direct approach. I caught my breath as he ran his fingers down the front of my waistcoat toward the place where the surgeon had robbed me. He stretched his slender neck to put his mouth next to my ear.

"Tonight I dine at her table, but I am ready to sup at yours anytime you would care to send for me."

I shrank back from him in slow motion and made my voice remain calm and steady. "I'm indebted to you for all you've told me, but my desires lie in other quarters."

He gave me a pert smile. "Perhaps you will change your mind. I know you would if you would just give me a chance."

I winced inwardly, suddenly reminded of a similar conversation I'd had with Felice. "I must ask you one last question," I said, my back pressing so hard against the cushioned pew I thought I might overturn it. "Have you seen anyone bring a thick, red leather folio into this house? Or such a book anywhere about? Just in the last day or two?"

Benito denied all knowledge of red leather books, but admitted he had little interaction with anyone in the house outside of Elisabetta's circle. With a wink and a conspiratorial smile, he let me out through the big bronze doors that shut behind me with an unequivocal thud. As soon as I stepped into the sunny Venetian afternoon I rubbed my eyes and took a deep breath.

The breeze off the lagoon was crisp and cold but far preferable to the tainted atmosphere in that palace of pride and secrecy.

I decided to walk home and headed for the Ponte delle Guglie, the bridge that would take me back to the Cannaregio, the neighborhood I understood. Industrious housewives leaning from balconies to shake tablecloths free of crumbs, young couples braving the chill to take a Sunday stroll by the canal, even the mongrel dogs hanging around the poultry shop: all comforted me and reminded me why I had returned to the city of my birth.

Chapter 22

It was almost dark and growing colder when I entered the Campo dei Polli. Searching my pockets, I found I had forgotten my house key in the bustle of preparing for my visit to Elisabetta's salon. A pull on the bell cord brought Lupo to the door. Silently, our stooped servant shook his head and rolled his eyes toward the sitting room. I heard Father's voice rumbling through the closed door, then Alessandro, angry and frustrated.

I went in. Father and Alessandro turned toward me with startled looks. Annetta was standing by the stove in the corner, twisting a damp handkerchief in her hands.

"Tito!" my father bellowed. "Did you know about this, too?"

"What are you talking about?"

"This mad monk who has invaded my home. This Brother Mark."

I looked to Alessandro for a clue on how to answer. My brother threw up his hands and said, "Brother Mark just left. He came to talk with Grisella, and Father practically threw him out of the house."

"The monk has no business here. And no right to question my daughter without my knowledge or consent. If I had only known you were planning such a farce, I would never have allowed him to perform the exorcism."

Alessandro whirled around and spoke to me instead of Father. "You'd think he'd be grateful for Brother Mark's help. No one else has been able to do anything for the girl."

Father grabbed Alessandro's shoulder. "Grateful?" he thundered. "Why should I be grateful to a stranger for pushing in where he is not wanted. And how has he helped? He's just sent your sister to her room with the worst fit she's had in weeks."

"Grisella got upset because you started shouting, Father," said Annetta hoarsely. "She likes Brother Mark. She trusts him. He won her over when he promised to help get Felice out of the guardhouse."

"Felice again," Father interrupted with a snort of disgust. "I'm getting a little tired of hearing about Felice. Why is everyone in this house so agitated about the arrest of one worthless eunuch?"

My brother and sister stared at Father with open mouths, then cautiously slid their gazes toward me.

"Is it only Felice who is worthless, Father? Or did you mean to include all of us?" I asked tartly.

"Oh, you know what I mean. Felice was washed up before he began. His voice is spent. He can't compose and he's no master of the keyboard. What else but singing is a cripple like him good for? The devil can take him as far as I'm concerned." Father threw himself into a chair and crossed his arms in a belligerent gesture.

No one said anything for a long moment. Father must have begun to feel he was a bit harsh on my kind for he spoke again, in a mellower tone. "Tito, boy, don't compare yourself to Felice. Your situation is completely different. You have a magnificent voice. As you become known throughout the musical world, you will be able to demand handsome sums. Opera houses all over Italy will be at your mercy. You will make us all rich."

I watched Father actually rub his hands together like King Midas in his counting house. "So it comes down to this," I said. "You think a pair of golden vocal cords is all that I am and all I will ever be."

Father opened his mouth to speak. I'll never know whether he meant to refute me or agree with me because I had heard enough. Shivering with anger, I raced upstairs, threw Father's wig on his bed, then shut myself into my room. I sank down on Felice's cot and hugged his pillow to my chest.

What was I, after all? A monstrosity to some, an angel to others; did anyone believe I was simply Tito Amato, a man no better or worse than any other? If my own father couldn't see beyond my altered form, what attitude could I hope for from strangers? I pounded the pillow with my fist, sick to death of being defined by what I lacked.

And yet, there was another feeling stirring within me, something I was just beginning to acknowledge.

A marvelous thing happened when I heard my own voice resonate through the theater. When I saw Venetians of all ranks shushing their companions and leaning forward to hear me sing, my joy threatened to carry me right up to the rafters. I wanted to take that joy and send it right back to the audience in song. When I hit the notes squarely, projected the melody to every corner of the auditorium, and enhanced the composer's creation with wonderful ornamentation of my own, nothing on earth seemed better. Sometimes I even astonished myself.

A knock at the door interrupted my musings. That would be Annetta. Even my sister who knew me better than anyone else in the world, except perhaps Felice, refused to see me as the man I was. To her I would always be the motherless boy whom she had pledged to nurture and protect.

But it wasn't Annetta. When I answered the knock, my brother's tall form filled the doorway. He brushed past me and shut the door with a well-aimed shove of his boot. "At least there's some good news," he said with a grin.

I raised my eyebrows.

He waved an impatient hand as if to dismiss the unpleasant episode in the sitting room. "Before Father came home, Brother Mark told us he got in the guardhouse to see Felice. My idea worked."

Alessandro, no doubt inspired by Berta's excellent bread, had suggested that Berta and Grisella make up another batch of *frittelle* and fry some with a note tucked deep in the middle of the pastry. They made enough to give the guards a generous portion and, in case the jailers were greedy, they positioned the

all-important message-bearing pastries at the very bottom of the basket. Apparently Felice had eaten his way through the stack of *frittelle* and received the message that he should request the sacrament of confession from Brother Mark.

I clutched my brother's arm. "What did he say? How is Felice?"

Alessandro smiled uncertainly. "The good monk has visited Felice several times. He reports that he is healthy in body but dangerously low in spirits."

"Naturally. In such an unbearable situation, how could Felice fail to be despondent? If only I could speak with him. I know I could give him some courage, plus find out what he was doing in Adelina's dressing room on the night of her death. I'm sure he must have an innocent explanation."

"That's what I'm trying to tell you. Brother Mark wants you to visit the guardhouse with him. He says you must hear what Felice has to say. You are the only one who can make sense of it."

"When? How?"

"He will come to collect you here at the house. Tomorrow, around noon."

I smacked my forehead. "Torani has called a rehearsal for tomorrow morning. He wants to try out Orlando's new opera."

"Do you have to be there?"

"Yes. If I want a job after Christmas, I do." I thought quickly. "Perhaps I could pretend to strain my voice or be coming down with inflammation of the tonsils. Torani wouldn't have me push my voice too hard. He still needs me for three more performances of *Juno*."

Alessandro nodded. "You'll just have to get away."

"I will, without fail, but what if Brother Mark won't wait?"

Alessandro curved his lips as I imagined he must when confronting a merchant bent on cheating him out of his fair profit. "He'll wait. I'll see to that. You just get back here as soon as you can. He'll bring some Dominican robes for you. He plans to pass you off as a young probationer who is serving as his assistant."

"Now that's one role I've never thought of playing. Brother Tito? No, of course not. Perhaps I'll be Brother Theodore and stand by Brother Mark as the columns of Saint Theodore and Saint Mark stand together beside the Doge's palace." I sketched a clumsy cross in the air over my brother's head. "Bless you, my son."

Alessandro cocked a skeptical eyebrow. "I think you had better keep quiet and do as Brother Mark tells you. And be sure to keep your hood drawn forward. For all we know, Felice's jailer may be an opera lover and watch you from the pit every night."

"I'll do whatever is necessary," I replied in a more serious vein. "I only wish our meeting could be tonight. The time is growing short. Today is Sunday, so the theater is dark. That leaves three days. Wednesday marks the last performance of *Juno* and the end of Carnival. If I haven't delivered Adelina's murderer to Messer Grande by Thursday morning, he will move against Felice." My voice rose and my anxiety grew with every word I spoke.

My brother laid a calming hand on my arm. Again we went over the possible suspects and what we knew of their motives and movements. Again we came up with more questions than answers. Alessandro asked me how I intended to spend that night. I told him about the unexpected invitation from Signora Veniero but expressed doubt about keeping the appointment.

Alessandro gave a low whistle and his brown eyes sparkled. "One of Venice's most renowned beauties requests your presence and you're thinking of not going? Are you daft?" Before I could answer, he continued in an abashed tone, "Oh, I see, you probably can't...."

I stopped him with a rapid shake of my head. "That's not it. I feel sure the lady could inspire me to give a good performance. It's just that...well, it doesn't seem right that I should enjoy myself while Felice is in such distress."

"But there's nothing you can do for Felice tonight. Nothing at all. If it will make you feel any better, I'll go down to the wharves and see if I can pick up any helpful information."

"What do you hope to find there?"

"I know a tavern where Domenico's agents and brokers do their drinking. Several Viviani ships are in port now so there should be plenty of his crew trying to drink the tavern dry."

"What would underlings like that know of their master's private business?"

"Gossip is rife in the business of trade. A clever merchant always keeps an ear open to pick up hints of brewing trouble. Every man's misery represents someone else's profit."

I nodded thoughtfully. If Adelina knew something, chances were good that others would have caught a whiff of something rotten in the Viviani enterprise. "Perhaps I should go with you?" I asked.

"Oh, no." Alessandro nearly choked with laughter.

"Why?" I asked, slightly affronted. "I could play the part of a seaman. I have before, on stage."

My brother spread his hands. "Where I'm going you would stand out like a lighthouse beacon. Besides your voice and your beardless face, you have this distinctive manner about you...no, not womanish, just more graceful, more dramatic than the rest of us. It really is best if I go alone." He smiled to show that I should take no offence. To my surprise, I didn't.

With Alessandro on his way to the wharves, Annetta tending Grisella, and Father off on his own business, I had no more excuses to stop me from meeting Signora Veniero. I divested myself of the formal garments I'd worn to the *palazzo* and washed the pomade from my hair. After putting on a clean shirt and my favorite soft wool breeches, I left the house and walked slowly toward the canal. I looked around for one of my shadows and was surprised and intrigued that neither was in evidence. Not too far down the pavement, I found a gondola and set off for La Giudecca. That island, separated from Venice by a thin strand of lagoon, was famous for its palaces, gardens, and houses of pleasure.

Every nobleman, and some of their wives, had a *casino* on this island or in the warren of allies and canals near San Marco. A

casino was a set of rooms, usually in a larger house on a discreet *calle*, where the owner could relax away from the forced, public gaiety of the piazza and the strained formality of the *palazzi*. Most *casini* were beautifully appointed and attended by loyal, unfailingly circumspect retainers. Luxury and comfort were the only standards allowed.

Following Signora Veniero's instructions, I struck eastward from the gondola mooring by San'Eufemia and soon came to a *campo* set about with a number of middle-class houses. I could see nothing out of the ordinary. The *campo* could have been lifted from my own dull neighborhood. But still, I detected a clandestine atmosphere hovering along with the gray plaits of chimney smoke that made me proceed warily and muffle my footsteps. At the far side of the square, a short flight of damp stairs led to a closely barred door with a grill positioned squarely at eye level. As directed, I gave three quick taps and was instantly admitted by a female servant who reminded me of our Berta. Before shuffling down a dark hallway, she motioned me into a sitting room furnished with pillow-laden sofas, a dainty harpsichord, and a small table set for two. Through a half-open door in the far wall, I glimpsed a bed hung with damask curtains. On my left, my lovely hostess was regarding me gravely with her back to the fire.

I crossed to her side and pressed her hand to my lips. She was wearing a quilted dress of rose red topped by a fichu of silk gauze. Seemingly arranged in haste, the gauze barely covered the swelling of her bosom where the dress opened in front. Her hair cascaded over her shoulders in a fall of loose curls. Ear buttons studded with brilliant gems were her only decoration.

"Signora, you do me a great honor," I said, as I raised my eyes from her hand to meet her emerald gaze.

Her crooked smile spread slowly across her face. "Leonora. We are no longer Signor Amato and Signora Veniero, but Tito and Leonora."

My heart was racing and my mouth was dry, but I steadied myself to follow her lead and play the adoring cavalier.

By entrusting the fortunes of this night to this accomplished beauty, I hoped both of us would end up feeling the adventure had been a success.

We sat down to dinner at the little table where the food had been kept warm by being set on silver boxes filled with hot water. Leonora served me with her own hands. I was heartily surprised to be waited on by a patrician lady, but she smiled and bantered as if nothing extraordinary was occurring. As we feasted on glazed duck and rice flavored with saffron, she told me the highlights of her life up to this point.

Like most girls of wealthy families, she had been shut in a convent for her education and protection until she reached seventeen. Her family had arranged her marriage to Pietro Veniero, then the commander of a navy galley, while she was still at the convent school. Before the ceremony, she had laid eyes on her betrothed only twice. Three days after the priest said the words that would link the fate and finances of their respective families forever, the commander returned to his fleet and Leonora joined the ranks of young, pleasure-loving Venetian matrons. Tender feelings didn't enter into the relationship. Everyone knew that the nobility married to produce heirs who would contribute to the mutual good of their names and properties. In public the couple followed the necessary formalities, in private they tended their own pursuits. Leonora was fortunate to have a particularly indulgent spouse. Even in these profligate times, there were many husbands who would not tolerate a wife's romantic intrigues—despite their own secret amours.

Then it was my turn. She begged me to tell of all my experiences, and the good vintage of champagne I drank throughout dinner loosened my tongue. I found myself telling far too many stories about the Conservatorio San Remo, my brother and sisters, and, finally, Adelina's murder and the galling arrest of Felice. Leonora asked a number of questions about my efforts to free my friend. Her sympathy to Felice's plight made me adore her all the more.

Near the end of the meal, she took the lid off one small dish, as yet untouched. Inside nestled a dozen oysters clinging to their pearly gray shells. She drizzled juice from a cut lemon over the lot and speared one of the mollusks on a silver skewer. Leaning over the table so that the ends of her fichu nearly trailed in the serving dishes, she held the oyster to my lips.

I slid the tasty morsel off its skewer and had to smile. "Did you think I would be needing some help then?"

"A little extra help never hurt anyone," she said, skewering an oyster for herself. "Man or woman."

We lingered over the business of the oysters. To serve me the last one, she dispensed with the skewer and brought it to my mouth with her own beautiful lips. The sweetness of that concoction warmed me from head to toe. I rose and covered her face with kisses. She returned my passion for a moment, then wiggled away. When I took her hands to pull her in the direction of the bedroom, she shook her head and put her hands on either side of my face.

"I know," she said breathlessly. "Sing for me, Tito."

"Sing? I didn't come here to sing for you."

"I don't want you to sing like you're on the stage. I want to hear something soft and sweet…a song no one else has heard from you." She thought for a moment. "Do you know any lullabies?"

"Lullabies?"

"The songs that mothers sing to put their babies to sleep."

"I know what a lullaby is. I'm just wondering why you want to hear one."

She didn't enlighten me, just smiled her crooked smile and led me over to the harpsichord. "Go on. Put your hands on the keyboard. Just play."

I did as I was told. With Leonora standing close behind me, I closed my eyes and played a few chords. My training at San Remo had not included songs for infants, but a memory from my days before the *conservatorio* floated lazily to the top of my mind. It was of my mother singing an old folk song by my bedside. I hadn't thought of that scene for many years, but once the

song was in my head, the words and notes flooded effortlessly back. With Leonora swaying in time to the simple tune, I sang of starry nights, parted lovers, and the moon's magic glow.

When I was done, she leaned over me and placed the fingers of her right hand over mine. She had supple hands with long, tapering fingers.

"Sing it again," she breathed near my ear. "Let me play it with you."

I repeated a verse. Her hair brushed my cheek. Her warm hand lay on mine, following its every move. As I pressed a key, her finger pressed mine. We were so close, I could feel the vibration in her throat while she hummed along with my song.

Again I felt her lips against my ear. "Tito, you do what no other can. You make me feel the music from the inside." This time, she didn't protest when I led her toward the bedroom.

Chapter 23

Torani waved his arm in a wide arc across the back of the bare stage and addressed the assembled singers. "Here the set designer will build a mountain promontory, very craggy, probably covered with brush. No, pine trees, I think." The little director stepped back for a thoughtful moment, then paced to the other side of the stage, rubbing his chin and muttering under his breath.

I stifled an irritated yawn as he described the proposed sets for *Eurydice in Erebus*, the opera Orlando had written for the next production. The libretto recounted the myth of Orpheus, the incomparable musician who tried, but ultimately failed, to bring his beloved Eurydice back from the underworld.

Now promoted to *primo uomo*, I would play the juicy role of Orpheus. Ordinarily, I would have been walking on air, but with my lack of progress in freeing Felice, a depression as gray as the smoke hovering over a charcoal burner's kiln had settled on me. I should have been home, waiting for Brother Mark. My frustration at going through the motions of learning a new part must have been obvious. Caterina threw me a sympathetic glance every time our eyes met.

Torani had changed his mind about getting rid of the young soprano; Caterina would be singing Eurydice. Perhaps the kindlier, more cooperative attitude she had exhibited of late had influenced our director. More likely, however, was the excitement that the news of her true parentage was generating. Caterina had made it public knowledge that she was Adelina Belluna's

daughter. Torani knew how favorably the swell of gossip about such a delicate matter could influence ticket sales. Marguerite, our other female soprano, had not been left out. She would sing Proserpina, the queen of Erebus. The role of her consort, Pluto, and the other, smaller roles had not yet been cast.

At deep stage right, Torani sketched a large triangular shape with his hands. "We'll put the entrance to the underworld right here. Tito, this will be the scene of your most dramatic aria. You see, the opening in the rock will be shut, or perhaps open just a crack. As the grief-stricken Orpheus begs the mountain to allow him to follow his beloved into the land of the shades, the earth, seemingly moved by his sad refrain, will actually split in a huge crevice. The whole mountain will shake and boulders will rain down from everywhere. It will make a splendid finale for Act One. The audience will go mad for it."

He called toward the orchestra pit, "Orlando, play a bit of that aria." The composer complied, and we were treated to a lovely passage, melodic but full of pathos.

"You hear it, Tito?" the director continued. "Orlando has created a masterpiece. You'll be singing that aria for years to come."

I nodded vaguely, longing to wipe the composer's insufferably self-satisfied smirk off his face.

Torani ignored my lack of enthusiasm and continued in an expansive vein. "Once inside the great cavern, Orpheus must confront Charon, the ferryman who conducts the shades of the newly departed across the River Styx. That's where Crivelli comes in. Where is he anyway? He was supposed to be here at nine o'clock." Torani paused in his perambulations to lift a handkerchief to his perspiring forehead.

"I'm here, Maestro, just a bit late getting going this morning." We turned to see Crivelli coming across the pit in a fur-trimmed cloak, raising his silver-headed walking stick in greeting.

Orlando launched into a sprightly march tune while the old *castrato* made his way to the stage. I was heartily pleased that Torani had also reversed his decision about getting rid of

Crivelli. The role of Charon, the hoary boatman, was perfect for my friend. While we had gathered for rehearsal, Orlando had played a few bits from the opera, including Charon's lament. The haunting solo could have been written especially for Crivelli, so closely did its range and style follow the old man's remaining talents. Surprising, and uncharacteristically charitable, of Orlando to write a role that would induce the management to keep a singer who had been marked for forced retirement.

Crivelli came onstage spewing good-natured, witty banter. Even the haughty Marguerite unbent sufficiently to smile and laugh at his quips. Torani seemed to forget that the elderly singer had been late and got busy handing out sheets of music. Except for my private woes, it seemed nothing could dampen the spirits of the company that morning.

Torani had us begin with a pivotal scene. He ordered Caterina and me to the far right of the stage, the place traditionally given to the most important singers. Marguerite was placed at the less respected downstage left. In song, I was to beg the underworld majesties for permission to take my bride back to the world of the living. Crivelli was in the wings, waiting to enter as Charon the boatman.

I have to admit that I enjoyed singing my recitative and aria. Orlando had abandoned his stock musical gestures and composed in a fresh, totally modern style. Marguerite did not fare as well. Perhaps she was peeved at being relegated to the left side of the stage or perhaps she was just being Marguerite. She halted her aria a dozen times with questions or complaints. Each time she asked for clarification on a passage, Orlando rummaged for something at his feet and spent more precious minutes in deep study.

While Orlando sparred with Marguerite, I gathered Caterina and Crivelli to the back of the stage, recounted the latest developments concerning Felice, and begged their assistance in bringing this rehearsal to a speedy close so I could meet Brother Mark in good time. Fate seemed to oppose us. Marguerite's aria lurched along by fits and starts, straining tempers and dissolving the

genial mood of the earlier morning. Everyone gave a sigh of relief when Torani gave us a break and went down to the harpsichord to have a word with Orlando.

"Well, I never saw anything like that," said Marguerite, as we settled ourselves around the table in the lounge downstairs.

Crivelli reached toward the window ledge for the ever-present bottle of wine and poured some for each of us. "What do you mean, Marguerite?"

"The man seems like he barely knows his own music. My score was copied so hastily and had so many blots that I could barely follow it. When I asked Orlando what he meant by this or that passage, he got all flustered."

I nodded. My copy had been rather messy as well.

"Orlando has always been a hothead," Caterina put in. "Don't let him rattle you."

Marguerite drew herself up, and the slack tissue under her jaw quavered. "It wasn't I who was rattled. But I must say, I expected better from this theater. Whoever heard of a composer who knows his music so poorly that he has to consult his original score every time there's a blotch on the copy?"

"Is that what he was doing?" asked Crivelli thoughtfully.

"Oh, yes," answered the huffy soprano. "He keeps the original composition in that satchel he's been guarding like a mother lion with her cub. Each time he wrestled that big, red book out of his bag and started thumbing through the pages, I knew he would take forever. Meanwhile, Torani is pacing back and forth and breathing down my neck like it's all my...."

Caterina's hand shot out. She laced her fingers around Marguerite's wrist, causing the older woman to halt her tirade and draw back in alarm. Caterina spoke very evenly, "What did you just say?"

"What are you doing? Has everyone in this company lost their senses?" Marguerite jerked her arm away from Caterina.

"The book Orlando was consulting, what did it look like? I must know." Caterina's eyes blazed.

Marguerite smoothed her hair, regarded the cracked ceiling, and sighed heavily.

"Please, Marguerite. The book?" I begged.

"Well, I don't see that it matters. But, all right…it was large, folio-sized, bound in red leather.…"

The other three of us traded portentous looks.

I couldn't get to the stairs fast enough. Caterina was close on my heels with Crivelli clumsily bringing up the rear.

We crossed the stage on a dead run. Torani and Orlando looked up in surprise as our shoes clattered down the short flight of stairs into the orchestra pit. The director's frizzed curls seemed to stand on end. "What's the meaning of this? Is something wrong?"

"We think something is very wrong." Caterina's sharp chin jabbed the air. "There, in Orlando's satchel."

The composer made a lumbering dive for the leather bag, but Caterina beat him to it. Her fingers fumbled to unbuckle the straps.

Orlando erupted with an unintelligible bellow and threw himself at the soprano. Caterina ended up on the floor in a jumble of skirts but managed to keep her prize clutched tightly to her chest. When Orlando actually started raining blows on the slight, but determined woman, Torani added physical intervention to his verbal protests.

While I fought to restrain the composer's flailing arms, Torani helped Caterina to her feet. The unpleasant bout ended with Torani in firm possession of the satchel. He stood between Orlando and Caterina, both of them breathing heavily and eyeing each other like back-alley cur dogs about to fight over a meaty shinbone. Marguerite watched with unbridled curiosity, and an open mouth, from the stage above.

"Will one of you please tell me what is going on?" asked a bewildered Torani.

Caterina and Orlando were still locked in a combat of gazes, so I answered, "The red book that Orlando has been consulting, we need to examine it."

The composer broke his hostile stare and made another grab for his bag. "That's my property and I'll thank you to return it." Torani retreated a few steps and questioned me with his eyes.

"A folio bound in red leather was stolen from Adelina's apartment after she died. We've been looking everywhere for it. Now it seems to be concealed in Orlando's satchel."

"That's preposterous. I've had that book forever. It's just pages of blank musical staffs bound together. Very convenient for composing. You can buy one like it at a score of different shops around the city."

Crivelli's reedy tones sounded out. "Then you won't mind if we take a look at it."

While Orlando sputtered protests, Torani opened the satchel and removed the large folio. His eyes slowly scanned the first leaf, then quickly devoured the next few pages. The little director tightened his jaw. "Do you have any explanation for this, Martello?"

The composer's face turned an angry red, and he silently opened and closed his mouth like a freshly caught fish flopping on a riverbank.

Caterina held out her hand, and Torani gave her the volume with a gentle smile. "Yes, my dear, this rightfully belongs to you."

Crivelli and I crowded behind the young soprano and read over her shoulder. The title page ran:

Eurydice in Erebus
An Opera in Three Acts
By Adelina Belluna
With Libretto by Riccardo Guardi

Caterina slowly turned the pages. Musical notes written in Adelina's small, firm hand danced across line after line. I stopped Caterina when she reached the aria I had just rehearsed. In the margin, near a run of rapid roulades followed by a lung-busting trill that had taxed my skill to its limits, the true composer of the opera had written: How do you like this, my dear Tito?

Drops of water hit the page and blurred the ink. The tears fell from Caterina's eyes, but they could just as easily have been mine. With this wonderful creation, Adelina was reaching out to us from the realm of the dead as surely as the heroine of her masterpiece had called to her lover from the mythological land of Erebus.

Crivelli had clapped a hand on my shoulder when he saw Adelina's message. Now he tightened his grip. "We can't let Orlando just walk out of here like nothing has happened."

The composer had retrieved his leather satchel and was stuffing it with loose papers. He snatched his heavy greatcoat off the railing and pushed his way through a flock of orchestra chairs, scattering them this way and that. He was on the point of leaving. Quickly, I jumped on the stairs to block his way.

"Where do you think you're going, Orlando?"

"Away from these so-called musicians who don't appreciate a genius when he's right under their noses."

"How dare you call yourself a genius when you've pirated someone else's work?"

The composer twisted his sensual lips into an ugly sneer. "You don't understand, none of you do. Adelina's opera was just a stopgap. I need something to earn my living while I finish my own masterwork. You can't imagine what it is to be hemmed in by the demands of people who don't understand what it takes to create an opera. I mean a real opera, not the fluff and spectacle you Venetians love." He shifted his gaze among us, never making full eye contact. "They expect me to turn them out every month or two. I must have scope, latitude. I need time to nurture my music to greatness."

"But you stole Adelina's creation. How can you defend that?"

"I did the woman no harm. Adelina is sleeping with the worms on San Michele. She's beyond such worldly matters." He tossed his dark head. "Actually, she should be grateful to me. If I hadn't retrieved the book, *Eurydice* might have moldered in a drawer until it crumbled to dust. At least I made sure the opera would be heard."

Crivelli spoke up. "How did you know *Eurydice* existed?"

"Adelina had never done any major composing before. Oh, she had written a few vocal serenades, but putting an opera together is a much more complex business. She wanted to keep the piece a secret until she felt more sure of herself, but she asked me enough questions to let me guess what she was doing. It amused me to help her. I thought we might become a team." Surprisingly, he had the grace to hang his head at the memory.

"You wanted her to go to England with you, but she refused," I said, still blocking the stairs.

"You're remembering the scene you and your mousy sister spied on after Viviani's reception."

"We weren't spying, but we did overhear. Were you planning to live on Adelina's earnings while you polished your *masterpiece?*"

He raised his chin provocatively. "And what of it? Adelina should have been happy to help me. I would have written wonderful parts for her. Together, we would have taken London by storm. She was a fool."

"Take care, Orlando, you're talking about my mother," Caterina said, still simmering with anger.

The composer whirled on the soprano. "Not exactly a model of maternal devotion was she? Too busy being Viviani's whore I suppose. I'll never understand why she refused my offer of marriage to stay in this dying city and be used by that vain, self-important aristocrat."

He saw me shake my head, and his voice rose in intensity. "Yes, you preening capon, your precious Venice is dying. Have you been over to the shipyard lately? Half the men are idle and their tools are rusty. The trade is to the west now, to the New World. England's star is rising and Venice's will soon sink below the horizon. It's the same with our profession. The center of opera is moving north, to London, and I'm going with it."

Orlando tried to brush past me and climb the stairs, but several hands reached out to grab him. Crivelli spoke the words

Caterina and I were both thinking. "Please, Orlando, spare us a few more minutes before your flight to greatness. We are all aching to hear about your secondary plan."

Surrounded by disdainful colleagues, Orlando threw himself into the nearest chair and regarded us all sullenly. "I don't know what you're talking about. What plan?"

Crivelli continued in a smooth voice. "I can see it all before me as if it were a play being produced right here on this stage. Adelina wouldn't even consider leaving Venice, and she flatly refused your offer of marriage. I would suppose her refusal came as something of a shock. You had thought you were irresistible to the fairer sex, even to charming, worldly wise beauties like Adelina. Licking your wounds, you decided that if you couldn't have Adelina, you could at least have her opera. You'd already been paid for *Juno*, so you would lose nothing by killing the poor woman, purloining the score she had been laboring over, and presenting *Eurydice* as your own work."

Orlando's eyes flashed, but he kept his temper. "You value Adelina more highly than I did, old man. Her refusal meant nothing to me. For all her celebrity, Adelina was just another woman quick to sacrifice her virtue to obtain comfortable rewards. Venice is full of her kind. London will be too, I imagine." He leaned forward with an elbow on one knee. "Unlike you capons, when I want a woman, I always manage to find one. Besides, I was nowhere near Adelina on the night she died. I was out here at the harpsichord the entire evening."

"Your memory is faulty, Orlando," I said. "You came backstage after the first act. You were so excited about *Juno's* success that you were practically babbling. Or perhaps it was the brandy you were carrying around that had gone to your head."

"What of it?" Orlando asked with a frosty smile. "That doesn't mean I killed Adelina."

"You could have run upstairs and offered her a nip of your brandy, after you had added a vial of poison, of course."

"I believe I offered you some as well."

"Your memory suddenly improves. Yes, you offered me a drink and I turned you down. If I hadn't, would I be keeping company with Adelina and the worms right now?"

"Why don't you ask Torani? If I poisoned the brandy, he would be dead ten times over."

The director shrugged his shoulders. "I suppose that's true. I confiscated the bottle from Orlando and never returned it. I kept the brandy in my office. I believe I finished it off yesterday." His voice trailed off uncomfortably.

Orlando rose from the chair and once again reached for his accursed satchel. "There now, with the matter of the brandy settled, I'll take this as my cue to depart."

Rather sullenly, I backed up the stairs to let him pass, but Caterina wasn't through with Orlando. "The poison didn't have to be in the brandy bottle. You could have poured something in Adelina's wine decanter, just as Felice is accused of doing," she cried in her most strident voice.

Orlando was losing patience. His hulking shoulders seemed to widen as he challenged Caterina. "But I didn't go upstairs," he snapped.

The soprano stood her ground. "How do we know that? Are we supposed to take the word of a thief?"

Orlando's deliverance came from an unlikely source. "Excuse me, please, but I might be able to make matters clear," said a French-accented voice. While we had been confronting the composer, several groups of curious workmen and other theater staff had gathered on the stage. Madame Dumas, the costumer, detached herself from a group of seamstresses and crept toward us. She addressed Torani. "Perhaps it isn't my place to speak?"

"No, Madame," the director gently encouraged her. "If you know anything, we want to hear it."

The woman drew herself up and straightened the scissors and other implements that hung from a belt at her waist. As if she were giving a schoolroom recitation, she began, "On the night of Signora Belluna's sad death, I came to the wings right before the end of Act One. This I do every night of the current

production so that I can take charge of Monsieur Crivelli's royal robes. If I don't collect them, they are thrown in a corner and the white fur becomes filthy. It is impossible to clean, believe me, I have tried. On that night Monsieur Crivelli needed to sit and rest. I waited for the robes as is my job. I saw Monsieur Orlando Martello come backstage. He seemed so cheerful, laughing and slapping everyone on the back. I watched him until he went back out to play the music for the ballet."

"Did he go upstairs to the dressing rooms?"

"No, Monsieur Torani."

"Could you have lost sight of him, even for a bit? There were a lot of ballet girls running around backstage."

"No, Monsieur. The girls make their entrance from an archway at the back of the stage. They weren't in my way at all. I had Monsieur Martello in view every moment he was in the wings."

Orlando began to chuckle in coarse, quaking gasps. He practically skipped up the stairs and amazed Madame Dumas by giving her withered cheek a long, loud kiss. Then, whistling the aria that Adelina had written for me, he made a beeline for the stage door.

Chapter 24

Less than a quarter of an hour after Orlando infuriated us all by swaggering out of the theater like an unrepentant pirate, I was outside in the late-morning sunshine, hunting for a gondola that could get me home in a hurry. The theater moorings had been deserted, so I trotted over to the Riva del Ferro. According to Venetian regulations, certain points on the Grand Canal must keep at least two gondolas ready for public service at all hours; nevertheless no boats were available.

I left the quayside in frustration and pushed on toward the Rialto Bridge. Despite the cool weather, this noisy place was doing a brisk trade. Fruit stands displayed plump golden pears, tangerines, and nuts clad in papery sheaths. The pungent fragrance of decaying, slightly frostbitten tuberoses filled my nose as I passed through the flower stalls. Near the butcher's, the crowd of shoppers vying for cheap cuts of meat blocked my way, and a second-hand clothier seized the opportunity to try to interest me in an old cloak with a balding fur collar. I ignored the fellow and edged toward an area of relative peace on the other side of the huge German warehouse that dominated the north side of the bridge. Searching for an alley that would lead back to the canal, I spied a familiar figure.

"Alessandro, wait," I cried, neatly sidestepping a pyramid of rough work boots.

My brother turned and greeted me with a surprised frown. "Tito, you should be at home. Brother Mark arrived just before I left. Annetta is plying him with polenta and sausages."

"I'm trying to get a gondola, without much luck." I pulled my cloak tightly around my chest as a jovial group of maskers jostled me from behind. "They're starting early today, trying to make the most of the last days of Carnival, I suppose. What are you doing here?"

"I had some business with the Germans, so I decided to catch two fish on one line. Last night I learned of a wine merchant who keeps a shop near here. He has always bought his stock off Viviani vessels that import Muscat from the Ionian Islands. He recently switched to buying from the Albrimani. He's not the only one. Tradesmen are backing away from Viviani, but I don't know why."

"You think this wine merchant will talk to you?"

"Perhaps. I directed some trade his way one time. He may recall the favor; if not, there are other ways to loosen his tongue." Alessandro lifted an eyebrow and patted the pocket where he kept his purse, then the one that housed his dagger.

"Your merchant may be the only way we'll ever find out what information Adelina planned to use against Viviani. The red book has turned up. It's not a diary of Viviani's crimes, but an opera that Adelina had been composing in secret." I gave Alessandro an abridged version of Orlando's treachery as we walked down the narrow alley to the canal.

"That sets us back. And lets Orlando off the hook," he mused. "Annetta will be disappointed that her prime culprit has been cleared."

"Yes, it looks more and more like Domenico Viviani or someone in his service poisoned Adelina to keep her quiet. But which one of them did it and, more importantly, what proof can we take to Messer Grande?"

"We must hope Felice can shed some light on the events of that night. If you want to see him, you need to get home and

don your Dominican disguise," my brother said, as he waved down an empty gondola.

⁓

By the time the clocks of Venice were striking one, I was again near the Rialto Bridge, this time on the opposite side of the Grand Canal. As promised, Brother Mark had outfitted me as a monk of his order. Following his long strides, I strove to walk naturally in the heavy, white robes that seemed determined to twist themselves around my legs. As on the day before, I could not detect any furtive followers.

It had been ten days since I had seen my friend Felice. As each hour passed, my anxiety over his plight swelled in my chest like an expanding balloon, but right then, my fear that I would be recognized as a fraud overshadowed all other emotions.

We arrived at the squat building of weathered stone that served as the headquarters for the *sbirri* who patrolled Venice's central area and also confined prisoners awaiting trial. Once a man had faced the Tribunal he would be moved to the prison behind the Doge's palace. If merciful fortune was with him, he might succumb to the horrid conditions before meeting the executioner. The upper rooms of the prison were crammed beneath the building's leaden roof. Called I Piombe, The Leads, these cells baked prisoners like an oven in the summer and froze them in winter. No less feared were the damp, chilling cells behind the foundation stones. Built under the water line, these cells held inmates chained in water up to their knees.

Brother Mark and I passed the first test easily enough. He presented himself to the constable at the reception desk while I kept my chin tucked into my chest and my face shadowed by the black hood. Our presence aroused little interest until we reached the corridor ruled by Felice's jailer. This rotund fellow displayed a luxuriant, albeit greasy moustache and a belt full of iron keys with equal pride. He planted his bulk in front of Felice's cell door and expressed curiosity over two monks instead of one.

Brother Mark focused his calm, intense gaze on the doubting jailer. "My young novice needs to hear the confession of this

penitent. It is part of his training. Seldom do we have the oppor-
tunity to minister to such a wicked miscreant."

"If you only knew, Brother, what sort of criminals come under
my charge. This prisoner is a small fish, a simple poisoner. They
do say poison is more of a woman's weapon. Anyway, this one is
very quiet and unassuming. Ah, some I've had," he boasted with
a deliberate wink, "they'd tell you of deeds that would make the
Devil himself blush."

The Dominican bowed his head as if to acknowledge the
importance and vast experience of the scoundrel who stood
between us and my poor Felice. I kept silent, barely breathing,
with my eyes downcast in what I hoped was a model of piety.

Brother Mark made the sign of the cross over the jailer and
whispered a few Latin words. Switching back to our Venetian dia-
lect, he praised the man's bravery and sense of duty and granted
that the Republic would be overrun with cutthroats and thieves
if it were not for the dedication of men like our worthy jailer.

"And now," the monk finished, "if you would be so kind, we
need to see this prisoner. We have many calls to make today."

The crucial moment was upon us. The jailer fingered his lush
moustache; he jiggled his keys thoughtfully. A drop of sweat
formed at my armpit and rolled down my side to lose itself in
the fabric gathered around my waist.

A young constable stuck his head out from a doorway at
the end of the corridor. "Dinner's here, Sergeant. Your soup is
getting cold."

Our jailer's eyes lit up and his nostrils flared as if he could
smell the soup's aroma from where we stood. He grabbed a thick
key off the belt that strained to contain his girth and opened the
lock on the stout door made of oaken planks lined with iron.
"Give a yell when you're done," he said as he quickly shoved us
inside, closed the door, and shot the bolt home.

I looked around the dim, cramped cell. There were no fur-
nishings except a narrow bed and no other trappings except a
bucket provided to serve the needs of nature. Felice was on the
bed. He sat with his legs curled under him and his back pressed

into the corner formed by two grimy walls. His head was bowed, and he appeared to be sunk in deepest melancholy.

"I've brought you a surprise, my friend," whispered Brother Mark.

Felice roused at the sound of his voice. He welcomed the monk with an expression of joyful longing, but in the space of a breath, despair once again covered his features. In two long steps, Brother Mark was on the narrow bed hugging Felice to his chest.

"You came back," Felice said as he leaned back into the corner, eyes glittering with unshed tears. "I knew you would if they'd let you."

"And I'm not alone."

I pulled my hood back far enough so that my friend could get a good look at my face. The tears overflowed and coursed down his cheeks as he shakily stood to embrace me. Never cloaked with abundant flesh, Felice's back and shoulders had become alarmingly bony. Looking closely at his face, I saw sunken cheeks and lines around his mouth that had never been there before. With a sudden jerk and the ghost of a whimper, he pointed to the small, square grating in the door.

"Don't worry," I said. "The guard has gone to eat his dinner. We should have a few undisturbed minutes. How are you faring?"

Felice sank back on the bed. "Oh, Tito, my life is over. It ended with Adelina's on that horrible night."

"Don't say that. We're going to get you out of this mess. Crivelli and I, Alessandro and Annetta, even Caterina, we've all been working for your freedom."

"Caterina? She's been helping you?"

I told Felice about Adelina's abandoned daughter who had grown up at the Ospedale Mendicanti to become the singer we knew as Caterina Testi. I was launching into our theories about who might have killed Adelina and why when Brother Mark broke in, "Time is short, Tito. You'd best pose your questions before the jailer returns."

"Of course." I sighed. "What happened that night, Felice? Why were you up in Adelina's dressing room?"

"Adelina, that poor woman. She didn't deserve what happened." Felice hung his head, untended dark locks straggling about his shoulders. When he looked up again, his eyes burned with an unidentifiable emotion. "I am sorry she's dead, but, by God, I had come to hate her very soul."

I opened my mouth to speak, but Brother Mark laid a hand on my arm. "Let him go on," the monk whispered.

"Now I realize it wasn't Adelina that stood between us. It was my own longing for a love that could never be." Felice gave me a thin-lipped smile. "From the time Maestro Norvello led you into my classroom at the *conservatorio*, all big eyes and homesickness, we have been closer than most brothers. I know I must content myself with that. When it comes to physical love, you and I are made differently." He hung his head. "I've come to accept it. I've certainly had plenty of time to think about it in here.

"But before *Juno* opened, I wanted to believe that I still had a chance to make you love me. Blaming Adelina for capturing your affection was just a trick I played on myself, an excuse I used to delay facing the inevitable truth. When she laughed at me the day I stumbled over the spear and made such a fool of myself, I hated her more than ever. I started having a dream, the same one night after night. I was back in Naples, on the stage at San Remo. It was a very important performance. Even the Duke and his family were in attendance. When it was my turn to sing, only ugly croaks and screeches would come out of my mouth. Adelina was on the stage, too. She pointed at me and started laughing just like she did when I fell. The audience echoed her laughter. It seemed like those soprano giggles would never stop and she would go on ridiculing me forever."

I knelt beside the narrow bed and crushed one of Felice's hands in mine. "So you hated Adelina. I didn't realize. Under the circumstances, I suppose I can understand your feelings...but you cannot give up, Felice. After all, you didn't kill her. We've got to find out who put the poison in her wine decanter. Then we can get you out of here."

Felice regarded me for a long moment, then said, very gently, "You don't understand, Tito. I did it, I killed Adelina."

My eyes flew wildly from Felice to Brother Mark. "No, no. It can't be. It's impossible."

Felice resumed his pitiful position in the corner. I shook him by his shoulders and begged, "Tell me it isn't so." But my friend had gone mute and limp as a rag doll.

Brother Mark restrained me with firm hands. He hovered over Felice's sagging body. "May I tell him?" he asked. Getting a shallow nod in return, the monk continued Felice's story.

"Felice wanted to take Adelina down a peg or two. He thought if he could make her look ridiculous, you would cease to be infatuated with her. He recalled an incident from your student days when someone slipped you a substance that ruined your singing voice for the evening. He decided to try the same thing with Adelina."

I nodded, barely believing what I was hearing. "Felice had a vial of belladonna that he was gargling for throat inflammation."

Brother Mark continued, "Unfortunately, yes. He slipped up to the dressing rooms, ready with a pretext to account for his presence there. Finding Signora Belluna's chamber empty, he poured a small amount of the noxious liquid in her wine decanter. He thought he'd gotten away with it until a maid walked in and surprised him."

I groaned miserably. "How much, Felice? How much belladonna did you put in the decanter?"

"Just a few drops, five or six at most," he answered in a ragged whisper. "I didn't mean to kill her. I just wanted her to know how it felt to have her voice dissolve in front of hundreds of people." He began to sob. "I didn't want her to die. I didn't mean to do it."

I grasped his shoulder. "Pull yourself together, Felice. You couldn't have killed her with that small amount."

"But I did and now I'm going to die." He stared at the opposite wall with empty, heavy-lidded eyes. "I don't even care. It's no more than I deserve."

"You are wrong," Brother Mark groaned in low, desperate tones. "Justice is never served by the execution of an innocent man."

We had missed the footsteps coming down the hall, but the sound of iron rasping on iron brought us all to our feet. I had just enough time to shield my face and assume the manner of an apprentice cleric before the jailer was upon us.

"Surely you two have completed your business with this prisoner. You've been in here long enough," he wheezed through a soup-dampened moustache.

Brother Mark leaned close to Felice and whispered in his ear. The jailer rattled the keys on his belt, and a suspicious look took possession of his heavy face. "I'll set you on your way, Brothers. Your other devoted souls must be wondering where you are."

I controlled myself until we rounded the outside corner of the guardhouse and were well out of sight of any curious *sbirri*. Then I gave vent to a litany of curses that would have seemed perfectly natural coming from one of Alessandro's seamen but put my disguise as a Dominican monk in considerable jeopardy. Brother Mark tried in vain to shush me. He finally enclosed the back of my neck in his hand and marched me to an open square before the nearby church of San Giacomo. He sat me down on a stone bench and didn't spare his disapproval.

"What's gotten into you? That kind of talk won't help. Are you angry with Felice or just frustrated with what passes for justice these days?"

I shook my head vigorously, trying to clear my mind of the miserable confusion that reigned there. "I don't even know. I had convinced myself that Felice was blameless, and now he tells me that he did put poison in Adelina's wine decanter."

"You said yourself that the few drops he administered would not have caused her death," Brother Mark reminded me in a matter-of-fact tone.

"It would seem so, but I'm no physician."

"Nor am I, but we have a brother in our monastery who is learned in herbs and medicinals of all sorts. I took Felice's story

to him. He assured me that the small dose of belladonna would have given Adelina only a temporarily dry mouth and maybe not even that."

With the sun on my back and Brother Mark's steady presence by my side, I began to calm down and marshal my swirling thoughts. My ignorance dismayed me. I thought I knew Felice's mind almost as well as my own, but I had severely underestimated his dislike of Adelina and his thirst for revenge. I couldn't help but wonder how many others in my immediate circle I had misjudged.

Brother Mark broke in on my unhappy ruminations. "What can I do?"

I hesitated, not sure of his question.

"To help you find Adelina Belluna's killer, what can I do?"

"You have done so much already. More than we could have ever hoped for."

The monk's sensitive nature was finely attuned that day. In my voice, he managed to detect an undercurrent of suspicion that even I was barely aware of. He focused his hooded, gray eyes on the tower of the great church before us and explained, "When I agreed to Alessandro's scheme to get in the guardhouse to see Felice, it was only your sister's condition that concerned me. I was—and still am—convinced that Felice's imprisonment is adding a dangerous burden to Grisella's already besieged mind.

"But then I met Felice." Brother Mark's solemn countenance lit up with the illumination of a hundred wax candles. "Your friend is so noble in the face of his suffering. All those years, his voice was the very center of his existence. When his vocal prowess fled, he bore the loss bravely and trusted that Our Lord would heal him and restore his life's work. Then, just when he was convinced a cure was within his grasp, he stumbled. His jealousy toward Adelina threatened his very soul. Now, he reproaches himself so deeply for his hateful thoughts and actions toward her. He is willing to die to atone for them, but I, *I mean we*, can't let that happen."

"You have come to care for Felice," I said, picking my words carefully.

His gray eyes took on a crystalline shimmer that carried me back to the vision that had engulfed me during the exorcism. "His suffering heart speaks to my lonely one as no one else's ever has," he answered simply.

"Then the best way you can help Felice is to spend as much time with him during the next several days as that rogue of a jailer will allow."

"You have my word that I will," he replied with a heartfelt urgency.

The clock on the church tower struck and I knew I must go, but Brother Mark's assessment of my sister's mental state troubled me. I barely dared to ask, "If the worst happens and we are unable to save Felice, what effect would his death have on Grisella's condition?"

Inside his black hood, the monk shook his head gravely. "We can't afford to let that happen, for Felice or Grisella."

Chapter 25

On stage, the hero is never truly abandoned. Though he may find himself pitted against insurmountable odds or unbeatable foes, all is not lost. Just when the hero reaches his most desperate straits, the clouds part and a golden chariot carrying a godly figure floats down to the stage to effect a heavenly rescue. They call it a *deus ex machina*, a god from a machine. That's what I needed just then: a miraculous deliverance complete with a thrilling chorus in the background.

It was Tuesday morning, two days before the Carnival would pause for the Christmas novena and signal Messer Grande to deliver Felice to the spurious justice of the Tribunal. After a night of useless activity, my dejected steps had led me to the Benedictines' ancient tower. I climbed the spiral staircase, slowly moving from sunlight to damp shade with every turn. On the summit, I scanned Venice's azure sky for any sign of a dramatic miracle that might help me save my friend from an excruciating end. Though I was as desperate as any embattled hero I had ever played, I knew the puffy clouds drifting in and out of the morning sun's slanted rays held no promise of rescue for me or Felice.

After leaving Brother Mark the previous afternoon, I had gone home to undo the transformation to Dominican friar, then proceeded directly to the Palazzo Viviani. I was sure that Domenico Viviani held the key to the mystery of Adelina's death, and I meant to confront him and get the truth if I had to pummel

it out of him. It no longer mattered if I never sang in Venice again. There were other cities that loved opera and were beyond the scope of Viviani's power and influence. Of course, my boldness gained me very little. The lackeys that guarded the stately entrance refused to admit me. Threatening to bang on the doors and yell for their master until my dying breath only brought Bondini around to deal with the obstreperous intruder.

Austere and flinty-eyed as ever, Viviani's steward accosted me on the portico. "What is your business here, Signor Amato?"

"I must see your master right away. It's a matter of utmost importance."

"Theater business should be taken to Maestro Torani."

"This has nothing to do with the opera." I hesitated, trying to match his frosty demeanor. "It is a personal matter."

He allowed himself a distasteful sniff. "A singer-boy such as yourself can have no personal business with a noble lord of the Republic."

Hot, angry words rose in my throat, but I left them unsaid. I realized I had let my emotions play me for a fool once again. When would I learn that badgering would never bring results at a household of Viviani's social standing? It took all my will, but I managed to hang my head and humbly beg Bondini's pardon. By playing the penitent, I managed to find out that Signor Viviani planned to attend the opera that night and extracted a half-hearted promise that Bondini would tell his master I wanted to speak with him.

I don't remember singing a note of that night's performance. My body moved around the stage in a daze while my mind raced uselessly to and fro like a hunting dog that has lost its quarry's scent. Before the first act, Leonora sent a footman to my dressing room. He carried an invitation to another intimate supper at her *casino*. In my reply, I had to beg her forgiveness and plead the pressing urgency of Felice's case. When I made my first entrance, it pained me to see that her box was dark. I began to wonder where she had decided to spend the evening and who was enjoying her company, but realized that I must drive those

thoughts from my mind and concentrate on matters at hand. I fully expected that, before the night was over, I would either have uncovered Domenico Viviani's role in Adelina's murder or be at the bottom of a canal with a Viviani dagger in my ribs.

Neither eventuality had come to pass. As I sang my way through the opera, hoisting my spear in a lusty hunting song or praising the tranquility of a pastoral meadow, I kept my eyes glued to my patron's box. The ranking scion of the Viviani clan occupied the middle seat on the railing. Even at a distance, I could feel the charismatic power emanating from the man. He followed Marguerite's arias with some interest, gave mine wavering attention, and whispered in his brother Claudio's ear while Crivelli and Caterina were singing. Behind him, Elisabetta kept raising a glass to her lips in a bored, distracted manner. I could just glimpse Bondini hovering like a wraith in the recesses of the box.

At the first intermission, I threw a cloak over my short tunic and mounted the stairs to the third-level gallery that led to the patron's box. My progress was impeded by a hall full of well-wishers who broke into spontaneous applause when they caught sight of me. As I attempted to push my way through, I felt a tap on my shoulder. It was a buxom courtesan in a scarlet gown. She grabbed my face between her fleshy hands and kissed me squarely on the mouth. I struggled out of her grasp and pressed full tilt to the box at the end of the hall. My haste and my gathering entourage startled the pink-coated footmen stationed at the door. This time I didn't stop to ask their permission, but half pushed, half crashed my way into the luxurious box.

The interior of the Viviani box was a miniature drawing room scene. Carlo read a book by the weak light of a wall lamp, Claudio lounged against the railing with several other fops, Elisabetta and her disagreeable sister picked at a box of sweets, and Benito hovered delicately at his lady's side. They all turned toward me with open mouths. But where were Domenico and his major-domo?

Claudio rose to his feet with a pugnacious set to his jaw. "A rather unceremonious entrance, isn't it? I'd have thought you

would be in your dressing room by now, Signore. What brings us this honor?" he asked in a sarcastic drawl.

Strains of ballet music floated up from the orchestra pit. The box overhung the stage so closely, I could hear the thump of the dancers' feet as they landed their leaps and pirouettes. I bowed to the assembled family. "Excuse my awkward intrusion, the crowd in the hall was overflowing with a bit too much admiration. I came to pay my respects to Signor Viviani and congratulate him on the opera's successful run."

Somewhat mollified, Claudio sat back in his seat and reached for his snuffbox. "Would you say *The Revenge of Juno* has been a success, then?"

"Certainly, we're near the end of the run, and the audience still deafens us with applause and begs for encores."

"But is it making money?"

"I should think so. The house is full every night."

Claudio and Carlo traded private glances. "I told you Domenico made the right decision," the younger brother said as he took a pinch of snuff. To me, he added, "After the initial interference from our rivals, and then that awful mess on opening night, there were those who advocated closing the theater entirely. But Domenico knew we had a winner on our hands. He is never wrong where profit is concerned."

"Yes, His Excellency clearly understands what Venice wants these days," I said dryly. "Er, where is he? I wish to congratulate him in person."

As Carlo stifled a cough and went back to his book, Claudio shrugged and trained his eyes on the ballerinas in their flimsy skirts. "I doubt that he will return tonight. Some other time perhaps."

Again, Benito was willing to give me more information than his aristocratic benefactors. Whatever else the fellow might be, he was certainly persistent. He scampered nimbly to the door to usher me out and took my arm as we strolled down the now cleared hallway. As we neared the top of the staircase, I felt his hand slip under my cloak. Enduring his surreptitious caresses,

I learned that Viviani had been called away just a few minutes before I entered the box.

"Where was he going?"

Benito rolled his eyes upward and smiled coyly, "Let me see. I'll have to think. Might take me a minute."

I took a firm grip on his roving hand. "Think fast. I'm due on stage in a few minutes and I still have to get to my dressing room and change."

His face brightened. "I'll go with you. I'll help you. No one can get someone out of their clothing faster than I can."

"I'm sure that's true, but if you really want to help, just tell me where Viviani and Bondini were headed."

"I don't really know. A man who works in the warehouse came to the door and asked for Bondini. They talked out in the hall. I couldn't hear a word, although I did try." He pursed his lips in a fleeting pout. "Bondini came back in a few minutes and whispered something to His Excellency. They were both gone in a flash."

"Did you catch anything? A word even?" I asked desperately.

"Bondini said 'Hurry' and 'Urgent' several times. I think I heard something about the East. It made me think of incense and veiled women. Ah yes, he mentioned the Sultan and the Turkish provinces."

"Anything else?"

The little *castrato* thought for a moment, but shook his head.

"Thank you, Benito. This is the second time you have helped me, and I won't forget it." I smiled and squeezed his hand before running down the stairs. At the first landing, something made me pause and glance back. Benito still stood at the top of the stairs, following me with his bird-bright eyes. His face seemed to have been wiped clean. With his features devoid of the usual playful coquetry, all that remained was a pained, affecting sadness that lingered in my thoughts for the rest of the evening.

After the opera, Alessandro met me at the stage door. "My merchant wouldn't talk," he said shortly. "He's afraid of something… something a lot more powerful than my paltry threats."

"No matter," I replied as I pulled my brother down the alley. "We have to find Viviani. He's the key. Whatever game he's been playing, I think his luck has finally run out."

Alessandro and I had spent a long night searching for Viviani in every place that had even a feeble Turkish connection. At a coffeehouse that catered to Eastern visitors, we encountered a huddle of Turkish merchants from Salonica. Alessandro spoke with them in the lingua franca that allowed East and West to bargain in the Levantine markets. He asked if they knew Viviani or any of his agents, but they kept their elongated pipes firmly between their teeth and favored us with no more than doleful shakes of their fantastically turbaned heads.

We had a flurry of hope when a former shipmate told Alessandro of a Turkish vessel that was ready to sail for Alexandria as soon as favorable winds arose. We hurried to the wharf, and my brother got us aboard by inquiring after fine merchandise, but the old captain threatened to send us packing when he realized that information was our true quest. To appease him, we spent nearly ten *zecchini* on useless trinkets. His mellowing humor grew black again when Alessandro mentioned Viviani. Before we knew it, we were out on the dock with lighter purses and no new information about my wily patron.

We looked for the nobleman everywhere from elite gaming rooms to seamy waterfront taverns. But even as we scoured the city, we sensed we were on a fool's errand. When the dawn broke to reveal a masked populace dragging home in disarray after a night of debauchery, we knew we had failed. Wherever Viviani had gone to ground, he had no intention of being found.

A sudden commotion jerked my thoughts back to the present. Several gondolas shot into the usually quiet canal to the west of my tower perch, their rowers pushing the oars with vigor. The shouts of the excited gondoliers bounced off the surrounding masonry and dissolved into echoed snatches of garbled names and words. As the commotion invaded the market in the next square, women stopped haggling with the merchants in the stalls and piles of produce went unattended as everyone ran to tell his

neighbor what must be a truly startling piece of news. I leaned dangerously far over the stone parapet, but still couldn't make out what was causing the excitement.

I descended the spiral staircase at top speed and hurried toward the great piazza. The closer I came to the heart of Venice, the denser the crowds grew. One of the huge bells in the Campanile began tolling mournfully. It was too early for the *nona*, the noon bell. Was it the *malefico* that warned of dire circumstances?

A boy of about ten was running toward me. I grabbed him by the shoulders. "What's going on? Has the old Doge died?"

"No, not him. A nobleman's turned traitor. They're going to execute him for commerce with the Grand Turk."

"Who? What's his name?" I demanded of the squirming ragamuffin.

"Don't know," he cried, wrenching out of my hands. "I've got to get my mother. She won't want to miss the hanging."

The boy clattered off down the paving stones, and I pushed on toward the huge square. I found a man hawking news-sheets under the Vecchio Procuratie. For two *soldi*, I received a flimsy sheet of newsprint that carried an official-sounding proclamation.

"Let all well-informed persons know," I read, "that Domenico Alvise Viviani is guilty of serious sedition and wickedness against our Most Serene Republic." Scanning the page, I saw that Viviani had been declared "an enemy of the state and the entire Christian race" for entering into a private business arrangement with the Ottoman Sultan in Constantinople. In a midnight session, Mateo Albrimani, Viviani's archrival, had denounced my patron before the Tribunal of State Inquisitors. He had delivered a highly charged account of Viviani's crimes against the state coupled with an eloquent plea for harsh retribution. As proof, the Albrimani patriarch had proffered documents drawn up by no less a personage than the Sultan's Grand Vizier. The papers authorized the governors of several far-flung provinces to bypass the official trading colonies established by the Venetian government and deal directly with Domenico Viviani's agents.

"So that's where Viviani's new-found wealth has been coming from," I said to myself. Skimming the profits off Venetian trade in the Levant was risky business indeed. Undermining Venice's business interests was an offense punishable by death. And it would be no hasty, hidden execution for such a full-blown traitor. Only a very public pageant featuring one of Venice's foremost patricians swinging from a gibbet would do. By Viviani's hideous example, the State Inquisitors would remind the populace, high and low born, where supreme authority lay.

My eyes flashed to the bottom of the grimy news-sheet. A reward was offered: one thousand silver ducats for Viviani's delivery to the Tribunal. The rebel merchant must still be at large.

My fist crumpled the news-sheet into a ball while my brain worked furiously. Was Viviani's apostasy the secret that Adelina planned to use against her former lover? Had she promised her silence in return for her daughter's promotion to prima donna at the theater? My poor dead friend, she should have realized Viviani would stop at nothing to protect his family's fortune. Such a ruthless soul would never trust another to keep a dangerous secret of that magnitude. More to the point, with Viviani on the run or at the end of a rope, how would we ever be able to prove that Felice didn't kill Adelina?

I was halfway to the theater before I realized where my feet were taking me. I found Torani, Caterina, and some of the other musicians gathered in the foyer of the San Stefano. Despite the early hour, candles blazed in the wall sconces and illuminated the plaster reliefs that covered the walls and ceiling. *Sbirri* were guarding the doors to the box office and the auditorium.

As I came through the doors on the water entrance, I heard Caterina arguing with one of the guards. "But the things in the dressing room are mine, not Signor Viviani's. I have jewelry and clothing that belonged to my mother. You must let me get what's mine."

The man cringed under her hectoring tone but stood his ground. "Everything in this theater is now the property of the

Republic, and nobody goes through these doors except on Messer Grande's orders."

Caterina stamped her foot in disgust, then caught sight of me. "Tito! Thank God, you're here at last. Tell these men to let me through."

The stout constable stood a little straighter and gave me a challenging look. Torani was nearby but beset by orchestra musicians and theater staff demanding wages and information about their jobs. I took Caterina's hands and told her what I had learned on the piazza. "What's going on here?"

"Torani decided to go ahead with *Eurydice* and credit the opera to my mother. He had me come in this morning to rehearse Eurydice's death scene. Crivelli and Marguerite were here, too. I was just starting to sing when suddenly the building was full of *sbirri* and Messer Grande was barking orders." She stopped and clenched her fists.

"Go on," I urged.

"Messer Grande told us Viviani had been condemned and all his assets within the boundaries of the Republic were hereby seized. Then he had each of us brought to the room downstairs and questioned us."

"Were you mistreated?" I asked quickly, running my eyes over her form for signs of bodily harm.

"No, that is not his way," she replied with a sharp jut of her chin. "After I told him I knew nothing of Viviani's business dealings or where he might have fled, Messer Grande simply asked me, very softly and almost regretfully, had I not witnessed the last public execution of a traitor."

"I see," I whispered thoughtfully. "Is Crivelli all right?"

"You know the old man, always so calm and assured. He probably took the questioning better than any of the rest of us."

"Where is he?"

"Marguerite went into hysterics. You can imagine the scene. She was so unmanageable, Messer Grande let Crivelli take her home."

Wishing that the old *castrato* were here to provide his usual wise counsel, I drew Caterina away from any curious ears. Under a pair

of grinning plaster cherubs, I asked, "Do you think Adelina knew about Viviani's Turkish dealings? Were they her secret lever?"

She sighed wearily, and the anger seemed to drain out of her face. "I don't know, Tito. I wish I did, but there's just so much I'll never know about my mother." With slumped shoulders, Caterina half turned, then paused and drew a folded paper out of a pocket in her skirts. "I almost forgot. Susannah gave me this note last night. It was stuffed into one of Adelina's gloves that had been left in her old dressing room. Marguerite found it when she was looking for a tube of paint that had rolled behind the sofa. It has nothing to do with this." She waved an impatient hand at the constables and the clamoring musicians. "But it might be important for Felice's sake. It shows somebody was very unhappy about my mother's romance with Viviani."

I tucked the tightly folded paper in my waistcoat, intending to read it as soon as I reached a place of relative privacy. First, I wanted to speak with Torani. If anyone at the theater could help me it would be the director. I hadn't forgotten all the time he spent closeted with Bondini. I was wondering how to get a word with the besieged director when the door to the box office opened and everyone fell silent.

A tall, spare figure with his red robe of office thrown over an elegant silk coat stood in the doorway. Messer Grande cast his cool gaze over the foyer, but a vaguely amused smile played over his thin lips. He was flanked by the young constable I had encountered in his office in the Procuratie. The constable strained to carry a large, and evidently very heavy, cash box.

"Ah, our beloved songbird has flown in," announced the dreaded instrument of the Inquisitors. "How nice to see you again, Signor Amato. I don't suppose you know the whereabouts of your former patron?"

"I regret to say that I do not. If I knew where to find him, I would be on my way. I have my own business with the man."

Messer Grande's amused smile widened into a wolfish grin. "Yes, Signore, I'm sure you do. Perhaps we will have a chat about that at a later date, but just now I am rather busy. Signor Torani

has agreed to be my guest for a few days, and we do want to show him the best our hospitality has to offer."

He snapped his fingers; two *sbirri* grabbed Torani and hustled the perspiring, glassy-eyed man away. I felt bad for the little director. As the one-man overseer of the opera house, he had not shown me any partiality, but I had come to respect his musical intuition and his devotion to excellence in all things concerning the company.

I reluctantly took my leave of the Teatro San Stefano. On its stage, I had made my debut as a novice singer struggling with mixed feelings about the career that was so violently thrust upon me. From its seats, my generous admirers had praised me and helped me realize how much I truly valued the voice that had been gained through so much adversity. Now Venice had lost a venerable opera house, and I was out of a job.

I longed to return to my secure tower retreat, but the note Caterina had pressed in my hand demanded immediate attention. I found a gracefully arched bridge above a quiet canal near the theater. Leaning on the stone railing warmed by the bright, midday sunshine, I unfolded the slender missive.

There it was: my *deus ex machina*. It had not come as a thunderbolt or chariot from on high, but as a thin sheet of paper scrawled in a childish hand. The prize that could effect Felice's release lay in my trembling fingers, but it gave me little pleasure. The crisp December day could have been a July potboiler; sweat beaded on my forehead, and I could barely get my breath. I stared at the note dumbly. Though I longed to deny it, I knew the schoolroom writing as well as my own. I also recognized the paper. It was delicate rice paper, almost translucent, hand-inked with a unique motif of dueling dragons.

Part Three—*Cadenza*

Chapter 26

Annetta stopped reading long enough to give me a look of uncomprehending anguish, then forced her eyes back to the sheet of Chinese writing paper. "Heed my warning. A great misfortune is hanging over you," she read the last lines aloud. "If you don't stay away from Signor Viviani you will be very, very sorry."

My usually serene sister's neck and cheeks were flushed. Her shoulders were shaking. She tossed the paper on our dining room table and backed away as if it were a poisonous scorpion. "What does this mean, Tito?"

"It sounds like a childish threat from a very possessive and jealous young lady."

"But Grisella doesn't even know Domenico Viviani. She has probably not laid her eyes on him more than three or four times in her life."

"Yet, she writes that he adores her, that he is hers alone. How does she put it?" I reached for the delicate sheet. "Here it is. She says, 'He is mine. He thinks you are a fat old cow. Stop trying to steal him away from me.'"

"Grisella couldn't have written that," Annetta said in a strained whisper. "It's just not possible."

"This paper is hers. It was the gift Alessandro brought her from his last trading journey. I checked it against the sheets left in her box of writing paper."

Annetta kept shaking her head, so I was forced to go on. "The hand is hers. Thanks to all Grisella's notes that you tucked into the letters you sent me in Naples, I recognized it right away.

"Even the words are hers. How many times have we heard her call Berta a fat old cow?" I paused before stating the most painful but obvious fact. "Even more telling, Grisella is gone and so is Viviani."

Annetta began to cry in noisy, racking sobs. I crossed the floor and folded her into my arms. "What are we going to do?" she asked between spasms.

I dug for my handkerchief and wiped her cheeks. "Don't cry, Annetta. I need the resourceful big sister I always rely on." She managed a strained smile, and I knew she was gathering the reins of her emotions. I said, "Tell me what we know. Start when you went to wake Grisella this morning."

"Father left the house earlier than usual. He didn't say why, just mentioned he had a great deal to attend to. I assumed he had a lot of errands and didn't want Grisella tagging along being a nuisance." Annetta's mouth twisted and her tears welled up again. I squeezed her hands until she was ready to go on. "You know how upset and easily agitated she has been lately. I decided to let her sleep, but when ten o'clock struck, I thought I should look in on her. I opened her door and found everything in its place. Except Grisella, she…she just wasn't there." Annetta finished with a strangled gasp.

"Had her bed been slept in?"

"Probably not. The bedclothes were barely rumpled and nothing was missing except the clothing she was wearing yesterday."

"Have you questioned Berta? She sometimes checks on Grisella during the night."

"Berta's been no help. She's in the kitchen, blubbering into her apron. She and Lupo both slept the night through. They heard no sign of a disturbance and neither did I."

Exasperated, I paced the dining room floor. "Grisella must have left the house willingly. She can certainly make enough noise when she wants to."

"Unless someone overpowered her suddenly, without warning." Annetta shivered, but her tears had dried.

I waved Grisella's threatening note to Adelina. "This would seem to indicate that force wasn't needed. What a farce this would make for the stage. A playwright couldn't devise a more ironic scene. While Alessandro and I were combing the city for Viviani, he, or someone under his orders, was right here at our house, stealing our sister."

A heavy sigh commanded our attention. Alessandro slouched in the doorway. Sweat stained his shirt, and his face was haggard.

Annetta ran to him. "Did you find Father?"

He shook his head. "For the second time in twelve hours, I've been all over Venice. Father didn't show up for his classes at the Mendicanti, and he's not at his coffeehouse or guild. No one knows where he is." He straddled a chair, put his elbows on the table, and began to massage his forehead. "Any word about Grisella?"

Silently, I put the sheet of Chinese writing paper in front of him. As he read through the note, his face was a study in extremes. Puzzled, astonished, incredulous, and, finally, furious, Alessandro shot up from his seat. "That bastard. That degenerate, sneaking bastard. Grisella is hardly more than a child." He beat his fist on the table. "How could this happen?"

"I'll hazard a guess," I replied. "The only place where Grisella and Viviani's paths cross is the Mendicanti. She attends classes and takes part in concerts there. Viviani is on the Board of Governors. He can tour the place anytime he likes, and his family is given choice seating at all the events. Grisella is a striking girl. We think of her as a child, but a man like Viviani would doubtless see her in a different light."

Alessandro nodded, understanding dawning on his face. "So she caught Viviani's eye, a man used to satisfying his every whim...."

"But Father..." Annetta interrupted, "Father is always there to watch over her. He would never let anyone take advantage of her. Would he?" she finished on a stricken note.

"Did he protect me? When the agents from San Remo carted me off to the surgeon, did Father protect me then?"

"Oh, Tito," Annetta replied. "That was an accident. You fell. The surgeon only did what was necessary."

"Did you see me climb on the bridge? Did you see me fall?"

"No. I didn't know anything about it until Father carried you in the house all bandaged up."

"And you," I asked my brother. "Did you see the fall?"

As he slowly shook his head, Annetta grabbed my arm. "But Father explained it all, Tito. He said you could profit from the accident, turn it to good advantage. He made it sound almost like a stroke of good fortune…such a lucky coincidence that the agents from Naples were in Venice when you happened to fall."

"Do you believe that, Sister?"

"I did then." Her voice faltered.

"And now?"

The look in her eyes gave me my answer. Annetta held me and cried into my chest while Alessandro put his hand on my shoulder and stroked our sister's hair. We stood like that in the dining room of our little house for some minutes, sorely aware of what our hearts had known all along. We might as well be complete orphans. God's will had taken our mother and left us with a father who was not to be trusted. To see us down the road of life, we had only our wits, our talents, and our love for each other.

Alessandro spoke first. "We have to get her back. We can't let Grisella's future be shackled to a rogue like Viviani."

"But he has fled Venice," I said. "Surely you've heard the news about the Turkish scandal. The Tribunal has condemned him to death."

"Yes, of course. The turncoat patrician is the talk of the city, but they'll have to hunt him down to carry out the sentence. All the more reason we must retrieve Grisella before Viviani is found."

"Where do we start looking for them?" Annetta asked.

Alessandro stroked his beard thoughtfully. "I heard several things while I was roving around this morning. I was intent on finding Father so I didn't dwell on them, but now they all begin to fit together."

"Yes, go on," I urged.

"I had it from a reliable boatswain that Viviani sailed from Chioggia on the morning tide. Of course, he was spotted. One of his sleek trading galleys could hardly be missed among the fishing boats of that little port. A military galleass was launched to overtake him, but he had a good head start. They fired on his galley, but the state's heavy ship was too far behind to do any damage. Unable to keep up with the lighter galley, her captain brought her back to port. With the north wind that's blown up, Viviani will be halfway down the Istrian coast by nightfall."

I started to speak, but Alessandro raised his forefinger. "One more thing. Some fishermen trolling offshore spotted a young woman on Viviani's galley. They couldn't describe her face, but as the first rays of the sun struck the deck, they saw her long mane of hair whipping behind her like a red pennant sewn with golden thread."

<div align="center">⌀⏣⏥</div>

As Alessandro and I headed for the Palazzo Viviani, the afternoon sun was starting its dip toward the mainland. The endless procession of narrow houses rising from the water's edge blocked the slanting rays and threw the green water into heavy shadow. Annetta had begged to accompany us, but we finally persuaded her that she was needed in Venice. Though I expected her mission to be futile, I charged her with going to the Procuratie to see Messer Grande. She was to throw herself on his mercy and spare no feminine wiles in begging him for a few more days to unmask Adelina's killer. I watched as Alessandro strained forward in his seat, as if this posture could hasten the gondola's progress through the dark water. He could do no more; he had already encouraged top speed by promising the boatman a double fare.

My brother turned toward me with a frown. "Tito, what if Grisella carried out her threat?"

"What do you mean?"

"Her note threatened a great misfortune if Adelina didn't give Viviani up. I can't think of a greater misfortune than being poisoned."

"Surely you can't imagine that Grisella had anything to do with Adelina's murder?"

"Until an hour ago, I couldn't have imagined that my little sister would be involved in a sexual dalliance with a man over twice her age." Alessandro chewed his lip anxiously. "She was there, you know. We visited your dressing room right before Adelina was taken ill."

The two of us peered down the shadowy tunnel of looming buildings, each deep in his own thoughts. I had no answer for my brother. I saw Grisella's note as a piece of juvenile play-acting. She had heard gossip about Adelina and Viviani, some of it from my own lips. She must have used the dress rehearsal as an opportunity to leave the note in Adelina's room. The little minx had been all over the theater that day. But slipping poison into Adelina's wine decanter? Surely that was beyond Grisella's ability to plot and plan. Besides, she had no access to poison, and she couldn't have known that she would be in the vicinity of the dressing rooms on opening night. Visiting me between acts had been a spur-of-the-moment decision on Annetta's part. No, Viviani was the guilty culprit. Adelina had become aware of his Turkish dealings and threatened him with exposure. He arranged her death to protect himself and his family's interests. That was the only scenario that made sense.

With a warning shout, our gondolier propelled the boat onto the shining surface of the Grand Canal. As I closed my eyes against the sudden glare, an unpleasant memory popped to the surface of my mind. It was the lingering, intrusive kiss that Viviani had forced on Adelina during the first intermission of opening night. The adults in the hallway had recognized the embrace as a show of dominance, but what would Grisella have made of it? I cast back to my own youthful crushes and the days when a frown from the object of my adoration seemed like the end of the world.

I looked at my brother. "You may be right. We've got to find them. For Felice, for Grisella, for everyone's sake we've got to find them quickly."

Chapter 27

The scene at the Palazzo Viviani recalled the uproar at the theater earlier that day. Constables were guarding the entrances to the warehouse, but the doors were standing wide open. We could see state clerks in black coats and wide-brimmed hats poking into crates, thumping barrels, and recording it all in bound ledgers. At the front portico, workmen were moving rolled carpets and gilt furniture down a wooden ramp into a covered barge. Before long, every possession that the Viviani had accumulated over years of trading would be stored in a government warehouse or, more likely, be transferred to the residences of the State Inquisitors and their friends.

No one stopped Alessandro and me from entering the *palazzo* and mounting the grand staircase. I was harboring vague ideas of finding Benito and pumping him for more information or even throwing myself at Elisabetta's feet with the tale of our errant Grisella. I suspect that Alessandro had some ideas of his own. When we reached Elisabetta Viviani's suite of rooms, we found that most of the furniture in the antechamber and reception room had been removed. The ashes in the fireplace were stone cold. We passed into the private apartment beyond and were immediately confronted with a squat, black-clad figure.

"Keep your hands off those trunks, you vultures. Those are my sister's gowns, and Mateo Albrimani will have your heads if you so much as touch any of her things," Elisabetta's sister

shouted in a shrill voice while she shifted an armful of feminine finery stacked nearly as high as her head.

I bowed to the angry woman. "Signora, we're not here for the trunks. I'm Tito Amato, the singer from San Stefano. This is my brother, Alessandro."

"Oh, so you are," said Signora Albrimani, dumping her armload and looking me up and down with a squint. "What are you doing here?"

"We're looking for Signora Viviani or her companion, Benito."

The little woman addressed us with hands on her wide hips. "You've come too late then. My sister and her pretty boy have gone ahead to the Palazzo Albrimani and left me here to pack up this lot." She indicated the bulging wardrobes and chests. "My Betta always needs her cavalier at hand to massage her temples and hand her the smelling salts. But her sister? Oh no, sister Maria gets left with the donkey work as usual."

"Signora Viviani will be staying with her family?"

"What else is she to do?" asked Maria Albrimani, tossing her head impatiently. "After her husband absconds in the middle of the night calling her an accursed Albrimani whore? Of course we're going back to live with our brother. A family of devils, Domenico called us. Can you believe it? I just thank the good Lord my sister never had children. It sickens me to think of Viviani and Albrimani blood mingling."

"Signora, I beg you. I am at your feet. We must find out where Signor Viviani is headed."

"Why ask me?" she snorted. "I'm the last person my shameless brother-in-law would confide his plans to. If that's the information you want, you'd best find Bondini."

Alessandro cleared his throat. "That would be difficult, Signora, as the steward is surely on the ship with his master."

"Bondini? With Domenico? I think not." The widow Albrimani sank into the nearest armchair and laughed so hard that she ripped some bodice stitches. "That has been the only bright spot in this whole sorry night and day."

We kept silent and let her malicious gloating tell the tale. "Domenico must have known danger was in the wind when Bondini called him away from the opera last night," she began. "As the rest of us were getting in from the theater, Domenico was sending Bondini to ready a ship down at the wharf. 'Wake the captain of the Eastern Pearl, our flagship must be ready to sail by dawn,' he was saying. Claudio questioned him, but Domenico silenced him with a wink and pushed his steward out the door to carry out his orders. When news of Mateo's accusations before the Tribunal reached us, Domenico was ready. He gathered his brothers in a covered gondola packed with all the valuables it could carry and set off down the canal.

"Then Bondini returned." Signora Albrimani gave an evil laugh as she rose to continue her packing. "It was delicious. The steward who cracked the whip with such gusto suddenly found himself at the tip of the lash. Domenico had used him as a decoy. While the most conspicuous ship in the Viviani fleet bustled with activity at the Venice wharf, Domenico and his worthless brothers disappeared into the night without so much as a goodbye for Signor High and Mighty Bondini."

"Perhaps Signor Viviani had made arrangements for Bondini to meet him somewhere at a later date?" Alessandro ventured.

"Oh, no. The man was livid, livid I tell you. I've never seen anyone so surprised and angry at the same time."

Alessandro and I traded impatient glances, but I gave Signora Albrimani my sweetest smile. "Is Bondini still here at the *palazzo*?"

"You're a bigger fool than he is if you think he'd wait around for Messer Grande's men to cart him off. I haven't seen Bondini since early this morning, and I hope to never see the scoundrel again. Now, since the maids and footmen have scattered like the flock of ignorant chickens they are, I've got my hands rather full." The little woman in black gave us an icy stare and bent to open a nearby chest. We left her shaking her head and clucking her tongue over a tumbled pile of laces and ribbons.

"We seem to have hit another dead end." My brother hit his fist into his other hand as we hurried back through Elisabetta Viviani's suite of rooms.

"Maybe not," I answered, thinking back to a conversation I'd had with Torani in this very household. "Bondini hails from Bolzano. His family still lives there."

"You think he would go to ground at his family home?"

"Why not? Bolzano is well beyond the borders of the Venetian state. It lies in the jurisdiction of the Prince-Bishop of Trento. Messer Grande has no more power to arrest anyone in Bolzano than he would in Paris or London."

"Let's suppose Bondini did set off for his native town. He could choose from several northern routes that all lead to Bolzano. Of those, the shortest road out of Venetian territory goes by way of Bassano."

"Exactly," I agreed. "The only other handy escape route would be by sea, and our man doesn't strike me as a sailor."

Alessandro nodded his head. "I've never seen Bondini on a Viviani vessel. He tends to his master's interests in Venice only."

The bronze doors were still open. The workmen had progressed to moving the smaller goods. We picked our way through a labyrinth of bric-a-brac and paused at the canal's edge in the late-afternoon sunshine.

"It's time we made a decision, Tito. Do we set off for the mainland?"

"What else can we do? Bondini is the only person who could possibly guess where Viviani will light at the end of his flight."

My brother stroked his beard as he did when he was besieged by conflicting thoughts. "Even if we can persuade Bondini to tell us where to look for Viviani and Grisella, we could never catch up to them in time to stop Messer Grande from handing Felice over to the Tribunal. Tomorrow marks the deadline he imposed."

"I know, I could hardly forget that. But there's nothing we can accomplish in Venice that would help Felice. Just getting into the guardhouse to see him would be risky. I was amazed

that the trick with the Dominican robes worked once. I certainly wouldn't want to try it again. Besides," I finished with a burst of pique that took me by surprise, "right now, Felice needs Brother Mark by his side more than he needs me."

Alessandro dropped his hand from his beard; his jaw was set in a firm line. "Let's go then. The day grows late and we haven't a moment to lose."

Chapter 28

Rather than wait for a gondola, we started down the pavement at a dogtrot. The San Giobbe quay at the north end of the Canal Regio would be our starting point for the crossing to Mestre. From that mainland port we could arrange the rest of the journey to Bolzano.

We had covered about half the distance to the quay when I heard a feminine voice shouting my name. I looked around and discovered Leonora waving at me from a covered gondola that was angling toward the pavement. For a moment, my heart soared as if I had nothing weightier on my mind than floating down the canal in the company of this bewitching beauty. Alessandro's tug on my elbow brought me back to our unhappy reality. Even so, I implored my brother to run ahead and promised I would meet him in a few minutes.

Leonora's gondolier deftly positioned the boat alongside the pavement. The patrician coquette leaned out so far I feared she would end up in the murky water. She grasped my forearms. "Tito, I've been looking all over for you. I must see you." With that, she pulled me into the boat with an iron grip. I had hardly settled on the cushion under the canvas cover when she threw herself astride my lap and began to cover my face with kisses. Her flowery scent and the proximity of her swelling bosom overwhelmed me.

"You are a hateful wretch," she said playfully, between kisses, "refusing my invitation and then practically disappearing."

"My adored one, you must forgive me. I long for your company, but my circumstances are more complicated than ever."

She remained on my lap, stroking my cheeks and playing with my hair while I tried to distill the events of the past day into a coherent explanation. When I had finished, she declared herself amazed at Grisella's daring in the affair with Viviani.

I shook my head. "Recklessness, I'd call it. And on his part, sheer perversion. He's almost as old as my father. Who knows what coercion he subjected the girl to?"

She gave a throaty laugh. "I've never met your sister, but I do know Domenico Viviani. I'll wager Grisella enjoyed him as much as he enjoyed her. I only wish I hadn't been locked into the convent when I was her age," she finished wistfully.

As the boat bumped against the mooring at San Giobbe, I tucked her words in an empty corner of my mind to be examined at a later date. Just then, Alessandro was waiting for me, pacing up and down the quay.

I took Leonora's arms and made to rise. "My dear, I must go. I must get to Mestre."

She tightened her legs around my thighs. "Tell me where you'll go from there so I can picture you on the road. I must light a candle in the chapel and pray for your safe journey."

I hurriedly confided our plans and returned her kisses, promising to send her a message as soon as I returned to Venice. She finally released me with a pouty smile and a whispered, "*Addio, carissimo.*"

Alessandro had hired a little fishing boat with two oars and two sails. The vessel was built for speed and agility, and its pair of stout fishermen boasted they were ready to break all records in crossing the lagoon. We embarked. The wind caught the sails at once and we ploughed through the choppy waters with mighty gusts from the Adriatic propelling us toward the mainland. Looking back toward the spires and domes of Venice, I saw that the wind was also driving low, threatening clouds our direction. I shivered and sank into the collar of my heavy cloak. Oblivious to the weather, Alessandro had closed his eyes for a brief sleep.

I was constantly neglectful of my prayers in those days, pre-
ferring to solve problems myself rather than lay them at the feet
of some plaster saint. But the gravity of our mission inspired
me to offer a few prayers to Our Lady and beg her protection
for Felice and Grisella. With her indulgence, plus the favorable
wind, we landed in Mestre in three-quarters of an hour.

Our first stop was the post. Travel by the post diligence was
expensive but generally faster than by hired coach. A helpful clerk
told us two relays had left for Bolzano earlier that day but no
man of Bondini's description had been on them. We proceeded
to inquire at the private stables. The port of Mestre was a way
station to many towns on the mainland, so it seemed as full of
inns and hostelries as its wharf was of sea birds. Alessandro and I
practically ran from inn to inn, always asking after a long-legged,
flinty-eyed man with a face barely more fleshed than a skull.

A host of innkeepers and stablemen had sent us away empty-
handed and the sun was brushing the tops of the low hills when I
spotted something. We had reached a corner far from the central
piazza. A small knot of shopkeepers was gathering down a side
street. We approached the group with flagging feet. A man in a
starched white apron with trousers flapping around his ankles was
just lighting a lamp before a statue of the Virgin bedecked with a
lace collar and a necklace of glass beads. This streetside shrine was
built into the wall of a small but neatly kept inn. Its sign creaked
in the wind: The North Star. After the group had mumbled their
prayers, Alessandro and I approached the innkeeper.

The host listened to our questions as he wiped his runny nose
on a striped handkerchief. We had become so accustomed to
denials that we had nearly turned to go when the man pushed
the damp cloth back in his trouser pocket and said, "You mean
that body that moved like a ghost, like he walked on air, and
gave orders like the lord of the *palazzo*?"

Alessandro's tired face came to life. "That sounds like our
man. He would have been traveling alone and eager to get to
Bolzano as quickly as possible."

"*Eh, si.* He hired my carriage and pair and set off just after dinner. He should make it to Bassano before nightfall."

"He's in a hurry. I'd expect him to push further down the road before stopping for the night," my brother answered.

"Not in my carriage. Horses are costly, and I won't have mine ruined. My driver has orders to stop in Bassano at the Crescent Moon, my brother's place. He has the Moon and I have the Star, see?" The worthy man snuffled and began digging for his handkerchief.

"Have you horses to let?" my brother asked quickly.

"You'd set off tonight?"

"We must."

"Can't help you there, young lads. Wouldn't if I could. It's near dusk. Don't want my horses out there stumbling and coming to grief in the dark. You'd be smart to stay here and find mounts in the morning."

Alessandro thanked the innkeeper heartily and drew me back down the arcaded street. "Hurry, Tito. The last place we tried had a stable full of horses."

"But, Alessandro, can't we take a carriage?"

"No. We can get to Bassano much faster if we ride."

I stopped and refused to budge. "Wait a minute. You don't understand. I can't ride. I've only been on a horse once or twice in my life."

My brother threw up his hands. "Don't tell me that now," he cried in a thoroughly disgusted tone.

"You know there are no horses in Venice," I answered harshly, letting irritation and fatigue get the better of me. "And at the *conservatorio*, there was little opportunity for such things. Where did you learn to ride?"

"In Syria, I think. Over the years, I've traveled on every beast from donkey to camel. Now that I recall, I learned to ride when the chief of a caravan threw me on a horse and told me to hang on. It was learn fast or be marooned in the desert. You can do the same, Tito. Come on."

And so I found myself astride a huge chestnut beast picking its way along a narrow road through the forest of Mantello. We were not traveling in complete darkness. The moon was approaching its full and had managed to avoid the ragged clouds scudding across the dark sky. Even so, the path lay in dim shadow and, from my saddle perch, the ground seemed miles away. The forest was a scraggly collection of trees and brush. In Venice's heyday, the shipbuilders had gobbled the mature oaks faster than they could be replanted. Although sadly depleted, the vegetation lining the roadway formed walls of twisted branches and tangled vines that emitted unsettling rustling and snapping noises. The distant rumble of thunder only added to my growing unease.

When we reached open ground, Alessandro urged his mount to a trot, and mine followed suit. The terrain grew more hilly and the air colder. In daylight, we could have glimpsed the outline of the lower Alps beyond the humped hills. As it was, I could only make out the light patches of scattered sheep on the sloping meadows and an occasional candle in a peasant's window. Another bone-jarring hour brought us to a black river spanned by a covered bridge. Here our way was lit by lanterns hanging in the square openings of the bridge's side walls. We emerged onto a smoother, wider road that wound up a domed hill to a cluster of buildings crowned by church towers. Bassano was just a small town of merchants and artisans; its only point of interest was a Franciscan monastery in the center of town. Even at the late hour, it didn't take long to locate the Crescent Moon. A sleepy stable boy took our horses and confirmed that the carriage in the courtyard had been hired at the North Star and was scheduled to leave for Bolzano at first light.

Chapter 29

"We could have the innkeeper announce us," I ventured as we conferred under the lamp-lit portico of the Crescent Moon.

"That would eliminate the element of surprise," Alessandro answered. "We need to give Bondini a scare. We're sure to get more out of him that way."

The innkeeper turned out to be a pallid copy of his brother. The man answered the door holding a solitary candle. His only apparel was a dirty nightshirt and a limp nightcap pulled down over gray, matted hair. Where the host of the North Star had been sure and decisive, the man who greeted us was uncertain and shiftless. Not surprisingly, his inn was a rundown heap of boards and tiles compared to the neat establishment kept by his brother in Mestre.

We started to explain our mission, talking over each other in our haste. The innkeeper first looked puzzled, then retreated nervously behind his stained counter. He was loath to awaken a paying guest, but Alessandro pressed the urgency of our pursuit and fell just short of claiming that the innkeeper's brother had personally endorsed our request. Using a delicate balance of guile and intimidation capped by an exchange of small coins, my brother persuaded the Moon's owner to conduct us upstairs to Bondini's door.

Alessandro pounded on the planks. From inside we heard a squeal of distress and a frantic scrambling. My brother didn't hesitate. He drew one knee to his chest and, with a mighty burst

of energy, kicked the door open. The innkeeper winced. The last I saw of him was the tail of his nightshirt disappearing around the corner of the drafty hall.

Bondini had one leg out the window. He had thrown his jacket over his nightshirt and clutched a small traveling bag to his chest. By the dim light of the banked fire, we saw our quarry measure the distance to the ground, then search desperately for an alternate escape. Alessandro sprang before Bondini could decide to jump. In less than a minute, my brother had wrestled Viviani's former steward to the floor and thrown him in a rush-seated chair by the fireplace. Bondini breathed in shallow gasps and trained his icy gaze on me as I closed the window, poked at the coals, and lit the candles on the mantle.

Alessandro slammed the door of the shabby room and threw a long leg over a second wooden chair. He settled himself with determination. Confronting Bondini with an implacable face, he said, "Now we'll have some answers. Where's your master gone?"

Bondini buttoned his woolen jacket with skeletal fingers, eyes shifting between Alessandro and me all the while. He finally threw me a controlled snarl. "You have no right to interrogate me, *castrato*."

"We have every right. Alessandro and I are here as brothers of Grisella Amato. We believe your master took Grisella with him when he fled Venice."

"Former master. I owe no further allegiance to Domenico Viviani." Bondini's lip curled. "And yes, he has your sister. He had me retrieve the little whore from your house myself."

Alessandro shot up from his chair. "You damned villain. How dare you insult our sister? You're talking about a thirteen-year-old girl."

"I'm describing her behavior, not her age," Bondini spat back.

I stepped between my brother and the former steward. Placing a hand on Alessandro's shoulder, I whispered, "Sheathe your temper, Brother. We'll never get the information we need if you beat him senseless."

Getting a tense nod in reply, I turned to face Bondini. "Why don't you just tell us the story from the beginning. How did our sister get involved with Viviani?"

The gray wraith in the chair sent us chilling looks but kept his mouth clamped shut.

Calmer now, Alessandro turned slowly and deliberately. He took the poker and worked at the fire. After coaxing a burst of flame from a broken log, he regarded the instrument thoughtfully, then addressed Bondini. "We have a sister in serious trouble and a friend facing execution. Tito here has lost his position at the opera house, and I'm not due to sail with a new cargo until after Christmas. We're determined to get the information we require, and we're ready to stay here, *well within Venetian territory*, until we do. Can you say the same?"

We waited. The brewing storm had followed us inland. A steady rain pelted the windowpanes and wind whistled through chinks in the chimney. I knew Alessandro's anger was as hot as my own, but we forced ourselves to remain silent and wait the villain out.

Finally, Bondini stretched his lips over his teeth in a sickening grin. "Oh, I know where your sister is headed. Let me tell you all about her, then you can decide if you still want her back."

"Go on," I ordered between clenched teeth.

"Signor Viviani noticed your sister at the Ascension Day concert last May. The Pieta and the Mendicanti both sent choirs of girls to sing at the Doge's palace. Grisella stood out like a flaming rose amid a bank of field daisies. Of course, she was a rose in the bud and my former master generally prefers the full blown flower, but he was intrigued, definitely intrigued." Bondini paused for a malicious chuckle, but resumed his story when Alessandro began twirling the poker in his fingers.

"It was simplicity itself to find out that your sister was not a Mendicanti orphan but the daughter of one of the maestros. His Excellency knew of your father. Isidore Amato is a familiar figure at all the gaming houses. He's pitiful really…never knows when to quit and always short of funds. My orders were to slip your father a few *zecchini* here and there, monitor his play, and

report any heavy losses. It didn't take long. The more I gave him, the more the fool lost.

"When Isidore had amassed a sizable debt, I cut him off. Viviani let him receive a few threats, then simmer in the stewpot for a while. When His Excellency finally offered him an arrangement, your father was one step away from ending up at the bottom of the lagoon. But he was still at the tables. I think the man would sell his breeches before he'd stop playing." Bondini couldn't resist a disdainful smirk.

I thought I might have to restrain Alessandro again, but he just shook his head and said, "And you enjoyed every minute of the intrigue. You're lower than a sand snake. How do you abide in your skin?"

Bondini sat up a little straighter. "I followed orders. No one in my master's service was more loyal or fixed in his duty."

"Just look where your loyalty has brought you. You're on the run, abandoned by your master to face Messer Grande and the Tribunal."

Bondini's face turned even grayer, and he slumped down in the chair. "Leave off the accusations," I begged my brother. "Let him go on with his tale so we can follow Grisella." I encouraged our miserable captive. "Go on, Signore. The sooner you finish, the sooner you can get on the road to Bolzano."

Bondini gulped and continued in a subdued tone. "Signor Viviani offered to pay your father's debts in return for time alone with Grisella. It was my job to escort her from the Mendicanti to Viviani's private *casino*. At first the girl was frightened and Isidore had to browbeat her with a combination of threats and bribes, but then there was a surprising change." Bondini looked up with a trace of wonder in his eyes. "She fell in love with my master. When I came to collect her, she would leap in the gondola. If the boat was slow, she would pummel me with those little fists and tell me to make the boatman row faster."

I rested my forehead on the mantle, no longer able to look Bondini in the eye. The blood pounded in my temples. I wanted to strangle someone. Bondini? Father? Or the middle-aged

libertine who had corrupted my sister? Beside me, Alessandro groaned and murmured, "I don't understand. Grisella is an innocent, just a child."

Bondini delivered the next coup with relish. "She *was* an innocent. My master awakened something within her. When I opened the door of the *casino*, the vixen would be in the bedroom on her back before I could even light the candles and lay out my master's dressing gown."

Alessandro leapt for Bondini's chair. He grabbed the collars of his jacket and shook him like a terrier shakes a canal rat. "Where is she? Where has he taken our Grisella?"

"Are you sure you want to find the little whore?"

Alessandro's hands moved to the steward's stringy neck. I clutched at my brother's arm and begged Bondini, "Grisella is our sister and a great wrong has been done to her. Where is she?"

Bondini found a new strength. He broke Alessandro's grasp and answered so forcefully he sprayed our faces with spittle. "Do you still want her back if I tell you she killed Adelina Belluna to keep her lover's favor?"

My brother and I stood transfixed. The howling wind and lashing rain outside the window merely echoed the tumult within us. The fear we could barely express to each other had been flung in our faces by Viviani's noxious henchman. Our poor sister! What madness had Viviani inspired in her?

The creak of the opening door brought us back to life. We looked to find Messer Grande in fur-trimmed cape and traveling boots grinning at us from the doorway. Shadowy figures of *sbirri* filled the hallway behind him. The chief of Venice's constabulary strolled toward us, pulling off his leather gloves as he crossed the floor. He stopped so close to me that the smell of damp fur forced itself into my nostrils and the moon-shaped scar on his fleshy nose took possession of my gaze.

He smiled as his *sbirri* clamped heavy hands on the terrified Bondini. "I don't know about the songbird and his brother," he said, "but I'd be very interested in hearing where Viviani has taken his young mistress."

Chapter 30

I was back in Venice, looking out over the monastery courtyard and its surrounding neighborhood from my well-used tower perch. The storm of the night before had swept winter back toward the mountains and made way for a few days of mellow, sunny weather that behaved more like September than December. I let the gentle evening breeze ruffle my hair as I watched workmen strolling home for supper and lamps twinkling on behind grilled windows and lace curtains.

The city seemed unusually quiet. With the break in carnival festivities, the only excitement on the piazza was a mild stirring that foreshadowed the approaching Christmas holiday. The little shops were cleaning their display windows and putting up greenery and tinsel; confectioners were firing up their vats to make *mandorlato*, a Christmas treat filled with honey and almonds; and the tolling of church bells rang out at unexpected hours.

A welcome sense of peace pervaded my spirit. Messer Grande had obtained what he sought from Bondini. Though the goals of the chief of police differed markedly from my own, we had reached a surprisingly satisfying agreement. Felice had been set free before Alessandro and I had disembarked at the San Giobbe quay. I had not had a chance to see my friend. Brother Mark had bundled Felice away to the Dominicans' lagoon monastery for rest and recuperation from his dreadful ordeal. I would visit him in a few days. For now it was enough to know that Felice

was safe and would never feel the executioner's wire tighten around his throat.

The worst part of returning to Venice had been telling Annetta about Grisella's role in Adelina's death. My older sister reproached herself again and again for her failure to realize that Grisella was in the clutch of Viviani's debauchery. I could only remind her that none of us had seen what was practically under our noses.

Small incidents came back to me. Now I understood the puzzled look on Viviani's face at the *Juno* reception. He thought he had given Torani permission for Grisella to come hear my duet with Adelina and was no doubt intrigued with the idea of his wife and both of his mistresses being in the same room. I surprised him when I introduced Annetta as my sister, but his sharp wits allowed him to recover quickly. I tried to convince myself that no one could be expected to doubt a father's devotion to his daughter's welfare, but the thought gave little consolation. Of all my siblings, I should have realized what Father was capable of.

I gripped the stone railing of the parapet and pulled against it to stretch my tired shoulders. I groaned as my legs and buttocks reminded me of last night's wild ride. My mind was so distracted by my body's aches that I failed to hear the footsteps creeping up the spiral staircase. My heart leapt to my throat when I heard my father's voice at the top of the stairs.

"I've been looking for you everywhere, boy. I ran into old Crivelli at a coffeehouse. He said you might be up here."

With considerable effort, I forced my hands to stay on the railing and not fly to my father's throat. He mistook my self-control for sulking. "Tito, it's time to come home. You shouldn't be mooning about up here. It's almost dark. You and Alessandro did all you could to find Grisella. Don't blame yourself for her faults."

"Grisella's faults?"

Father shrugged his shoulders. "Oh, she's not really a bad girl. At first she wanted to protect her family. And help her father. Of all you children, only my little Grisella truly understands what she owes her father."

"And what is that?" I asked, wondering what twisted logic he would produce next.

"Obedience. I would have obedience from all my children."

"Was it by your order that she sailed away with Viviani?"

"That was her own foolishness. I instructed Grisella to do what she must to preserve the family fortunes, but she came to enjoy her task overmuch. Now she's thrown her lot in with a condemned traitor, and there's nothing we can do about it."

I turned to face him squarely. "Do you not reproach yourself at all?"

He stepped toward the railing and gave me a thin smile. "I admit I am addicted to games of chance. I always believe I can charm the lady Fortune over to my side no matter how shabbily she has treated me in the past. I let myself come to a sorry pass this time, but I've learned my lesson. I'll get these debts paid off and never go over my limit again."

"And when I was robbed of my manhood, did your gambling debts need to be paid then as well?"

His dark eyes searched my face but showed little surprise at my question. After a pause, he said, "You must understand my plight back then, Tito. I was facing utter ruin. I'd sold or pawned everything of value in the house, but it still wasn't enough to pay what I owed. I'd borrowed from my associates until they slipped out of the coffeehouse when they saw me enter or crossed the canal rather than meet me on the street. I even went to your Aunt Carlotta, but the old bat only chastised me and sent me away empty handed."

"So you delivered me to the Neapolitan agents."

"They were threatening to break my hands. My hands, Tito! Just think. Without my hands I couldn't play the organ. We would have starved."

"How much did the agents give you, Father? Two hundred *zecchini*, three hundred?"

He hung his head. "They gave me a stake. I envisioned building it into a great fortune. In the right hands thirty ducats can easily become three hundred or even three thousand. That kind

of luck eluded me, but I did make good use of their ducats. I won enough to cover the debts."

I stared at his lined face. When had he started to look so old? In a strangled whisper I asked, "Thirty ducats? You let them take me for thirty ducats?"

He nodded slowly.

I was stunned, then suddenly blinded by fury. Thirty silver ducats made barely ten gold *zecchini*. Alessandro and I had spent that much on trinkets trying to get information from the Turkish captain at the wharf.

I don't remember striking my father, but I do remember him holding me at arm's length with one hand while he wiped blood from his cheek with the other. He was as angry as I was. "Is this how a son repays his father's love? You should thank me. I did you a favor."

"A favor?" I screamed.

"Of course. Fame and wealth are within your grasp. I created that stupendous voice of yours when I planted my seed in your mother. I preserved it when I handed your unconscious body to the surgeon. If you had not gone under the knife, you would probably end up living in a garret with a slattern of a wife and ten starving children."

I jerked away from Father's grasp. "I could have sung on the stage without the operation."

"As a tenor perhaps," he replied, still defiant. "What do they earn? Chicken scratchings! It is only the eunuchs who are handsomely paid. Every time you take your bows with applause ringing in your ears you should be grateful to your father who made it all possible."

Breathing heavily and barely able to make out his features in the darkness, I faced my father across a stormy gulf of hatred and misunderstanding. It was horrible to think that my destiny had been determined by a roll of the dice or a turn of a card. Black instead of red, a six for a five, those small variations had sealed my fate. Those and my father's cold heart.

And yet, Adelina had urged me to accept my strange circumstances and even welcome the riches that the cutting had brought to my life. I was beginning to understand her advice. I dwelt in glory before the footlights, and that glory could be mine every night of the rest of my life. How many men could say the same? In my heart, I knew the knife had blessed me even as it robbed me.

With sudden clarity, I realized that my deepest anger did not involve the loss of my manhood. My shoulders slumped and I was able to speak calmly for the first time since Father had joined me on the tower. "It wasn't the knife that hurt so much."

"What was it then?"

I took a deep breath. "You sent me away. The men from the *conservatorio* tore me away from everything I knew and everybody I loved. You and my brother and sisters went on as a family and I was condemned to uncaring maestros and endless vocal exercises. If it hadn't been for Felice I would have died of loneliness."

Father's lips parted, but I was never to hear his reply to my heartfelt admission. There was a rush of movement on the staircase and we were suddenly surrounded by three huge bravos in eye masks. They had come for my father. One of the burly attackers pinned my arms behind my back while the others pushed Father to the railing and turned his face this way and that as if making certain of his identity.

Without being told, Father knew why they had descended on us. He babbled about needing more time, about intending to repay their master with interest in just a few days. I cringed to see my dignified parent reduced to sniveling and begging. His whining did him no good; the bravos were deaf to his pleas.

The pair pushed his head over the railing and grabbed his feet. The one restraining my arms must have been the leader. He said, "Our master is at the end of his patience, Amato. He's waited for his money long enough."

I heard a weak squeal from the railing that sounded like, "Please, I'll get the money."

"You're tapped out. With Viviani across the sea, you'll never raise enough to cover your debt."

My father shrieked in fear. One of his captors pulled his head up so I could hear him clearly. "I'll get it. My sons have money. They'll pay you."

"Yes, yes," I found myself screaming. "We'll cover the debt. Let him go."

The two ruffians suspending Father over the railing looked to their leader. I felt him shake his head. His deep voice rumbled. "Go on. He's more valuable as a warning. Anyone who thinks he's going to get away with holding out on our master can take a lesson from Isidore Amato."

Before the bravos could act, the yellow light of a lantern appeared at the top of the stairs. "What's going on here?" cried a startled monk.

"Get him out of here," my captor growled.

One of the men dropped his hold on Father and threw himself at the black-robed Benedictine. The brute and the man of God grappled for an instant, then collapsed in a writhing heap that rolled back down the stairs. The monk's lantern struck the stone floor with a crash. Oil flamed up at our feet. The lead bravo released me to remove his heavy jacket and throw it on the blaze. His burly ally in mayhem still held my struggling father balanced on his midsection over the parapet's railing. The bravo's mouth was agape as his gaze flickered between the man in his hands and his comrade stamping on the flames. I watched in horror as he threw my father's feet into the air and tipped his body over the railing before joining in the frantic dance on the flames.

I covered the distance to the railing in two long bounds. Father had found a tenuous handhold on the lip of the parapet's base. He looked up at me as his body dangled in space, three floors above the hard paving stones of the monastery courtyard.

"Tito, Tito...." His lips contorted in a grotesque smile.

I braced my feet as best I could and leaned over the railing. "Give me your hand, Father. I can pull you up."

He kicked his legs helplessly and shook his head.

I stretched my arm as far as I dared. "Try, Father. Just try to reach my hand."

I saw his twisted face relax a second before the two bravos dragged me from the railing. I struggled desperately, but the pair of them overpowered me as if I were a small boy.

Their fellow had dealt with the monk and bounded from the staircase onto the tower. He ran to the parapet, heaved his bulk astride the railing, and aimed a vicious kick downward.

My captors smashed my head against the back wall of the tower and flung me to the floor before the three of them streaked off down the stairs. Zigzags of colored light filled my vision while Father's final, terrified scream echoed endlessly in my ears. It was several minutes before I could raise myself from the greasy, charred floor.

Trembling, I stumbled to the railing and peered down into the depths of the enclosed courtyard. The twisted body was surrounded by a cluster of well-meaning but totally useless monks. My father was dead.

Chapter 31

"I wonder where Grisella will be tonight? No matter what she's done, I hate to think of her in a country of infidels on Christmas Eve." Annetta sat before the harpsichord, idly striking the keys.

"That's one thing you don't have to worry about." Alessandro had pushed the draperies to one side and was gazing through the frosty window with one boot on the ledge. "They haven't had time to reach Turkish territory. Viviani's galley sailed ten days ago, so they couldn't have traveled much further than the Greek coastline, or perhaps the tip of Crete if they've found constant winds."

We had gathered in the sitting room of our little house on the Campo dei Polli: what was left of my family and the friends bound to us by love and concern. Brother Mark crouched on a low stool by the stove in the corner. The glowing coals illuminated his hooded eyes. They were not the icy crystals of the vision that had linked me to his hidden loneliness. That afternoon the firelight turned his gray eyes into pools of shining contentment. Felice was on the floor at his feet, leaning against the monk's white robes with his ungainly legs crossed in front of him. I smiled. For the first time I could remember, my old friend wore the face of a man who loves and is well-loved in return.

Crivelli and Caterina were chatting across the round table. They had arrived together, arms full of gifts. Caterina brought the traditional fish and mustard. During the Christmas season, the lagoon supplies the Rialto fish market more generously than

at any other time of the year. People of the town buy mullets, sole, whiting, even live eels, and present them to their friends and neighbors with a jar of thick, fruity mustard sauce. Annetta had banished the fish to the kitchen, but Crivelli's offering of a huge box of *mandorlato* nearly covered the small tabletop. I reached for one of the honey-laden treats and let the sweetness of it dissolve on my tongue.

"Here, Tito, let's have one of those," Felice said from the corner. I passed the box of candy. The monk shook his head, but Felice took a handful.

"Have some more," Crivelli encouraged him. "You must eat to get your strength back. We don't want you becoming an otherworldly ascetic like your friend here."

A smile played on Brother Mark's sensitive mouth. "Signore, I assure you that I am quite able to enjoy the honest pleasures of this world without losing sight of the heavenly kingdom. I don't deny myself out of austerity. I just don't care for almonds."

Felice flashed him a grin, then posed a serious question through a mouthful of sticky *mandorlato*. "What will become of Grisella, Tito?"

"Only time can tell us, but I fear the worst. Grisella has no way of knowing that you've been freed and must assume that the Tribunal ordered your execution. She'll be carrying a double load of guilt. She poisoned Adelina in a fit of jealous rage and left you to take the ultimate consequences. If that doesn't push her into madness I don't know what would."

Brother Mark nodded in silent agreement and made the sign of the cross.

Annetta shivered despite the warmth of the room. "Maybe our poor sister was possessed after all."

"Not possessed by an evil entity from without, but by an unstable temperament within," the monk intoned gravely.

Felice was not convinced. "I just can't believe that beautiful child committed cold-blooded murder."

Alessandro dropped the drapery and turned toward the stove. "We'd all like to believe otherwise, but there is no room for

doubt. After Tito and I had cornered Bondini in the inn at Bassano, Viviani's former henchman recounted Father's despicable bargain in sickening detail. When Messer Grande and his *sbirri* arrived, Bondini finished breaking our hearts with the story of Grisella's confession."

Felice's questioning eyes begged my brother to continue.

"Perhaps Caterina would rather not hear this," I put in quickly.

The soprano shook her head and fixed a determined smile on her thin lips. "No, let him go on. I know so little about my mother's life, I can at least understand how and why she died."

Alessandro hesitated, then gestured for me to take up the tale. "On the day after Adelina died," I began, "Bondini came to collect Grisella at the Mendicanti as he so often did. During the gondola ride he noticed she was pale and preoccupied, not her usual self at all. He had barely opened the door of the *casino* when Grisella ran in and threw herself at Viviani's feet. She was agitated and so convulsed with weeping that they could barely understand her words. Viviani made her take a few swallows of brandy and ordered Bondini to stay in attendance in case he needed any help with the girl, who appeared to be losing her wits."

I paused, contemplating all the separate events that had led up to that moment: my return to Venice in Viviani's employ, theater gossip that Felice and I carelessly repeated at home, Father's idea of sending Grisella to *Juno's* dress rehearsal, and her insistence that she return for opening night. If only another opera house had hired me away from the *conservatorio* or Father had sent Grisella to bed instead of bringing her to the opera that night.

Felice's impatient voice interrupted my thoughts. "Tito, what did she tell them?"

"That she hated Adelina from the moment she heard of her affair with Viviani. That she wrote a threatening note intended to scare Adelina away from the nobleman. That she became enraged when she witnessed Viviani giving Adelina a passionate kiss in the hallway outside the dressing rooms."

"But why blame Adelina?" Caterina asked. "Viviani forced that embrace on her. Adelina was furious with him."

"Try to see the scene through the eyes of an undisciplined, irrationally possessive young girl. Viviani may have hastened her sexual awakening, but Grisella was still an innocent in the ways of the adult world. Only the day before, she had left the warning note in Adelina's dressing room. Yet on opening night, Adelina was in his arms. Grisella told Viviani that a towering wave of hatred overtook her when she saw him kissing Adelina. She didn't stop to think about what she was doing, just slipped through Adelina's half-open door, took a bottle of her elixir out of her skirt pocket, and poured it into the wine decanter."

"And no one saw her," said Caterina wonderingly.

"As I recall, half the people crowding the hallway were fascinated with Viviani and his prima donna and the other half were looking at their shoes in embarrassment," said Alessandro.

"How did Grisella come to have a bottle of her elixir?" asked Felice.

"That puzzled us for a while," I answered. "Annetta and Berta each had a bottle, but they kept them under lock and key and dispensed the medication with great care." I regarded my sister sadly.

Annetta bristled under my gaze. She slammed the cover over the keys of the harpsichord. "You don't have to look at me that way. How was I supposed to guess that Grisella had wheedled a supply of her elixir out of Berta?"

"I'm not blaming you, Annetta. We all wish we had paid more attention to what was going on in this house."

Alessandro nodded and explained to the rest of the group. "Berta finally broke down and told us. Grisella kept begging for her own bottle of the elixir. The child said the liquid made her feel all warm and cozy like she did when Berta used to hold her on her lap in front of the stove."

"Of course, Berta finally gave in," I added. "She could never say no to Grisella."

"Where is Berta now?" Caterina asked grimly.

"Lupo has taken her to church," answered Annetta, calm once more. "Since Grisella was taken away, Berta spends most of her time lighting candles to Our Lady or crying in the kitchen."

"She's lucky to have a roof over her head at all," Alessandro grumbled.

"We can't turn her out, an old woman like that," Annetta chided him. "Besides, how could Berta have foreseen what Grisella would do with the elixir?"

Felice uncurled from the floor and crossed to where I stood by the harpsichord. "Was the elixir really strong enough to kill Adelina?"

"You shouldn't keep worrying yourself on that score," Brother Mark said. "The monastery herbalist has assured you over and over."

"He's right, Felice," I added. "After Father's funeral, my first errand was a visit to the apothecary's shop. He explained how the elixir worked. For Grisella, it was a soothing balm that eased the rigors of her frightening spells. She could tolerate a dose that would fell a coach horse because she had become gradually accustomed to it over a period of months. But if someone who did not have that tolerance took a generous portion, especially with several glasses of wine.... Well, we all know what happened." I put my hand on his shoulder. "It was the elixir that killed Adelina, not the drops of belladonna you put in the decanter."

He gulped and nodded his head. Were those tears sparkling in his brown eyes?

Caterina was shedding a few tears of her own. Dabbing at her cheeks with a handkerchief, she asked, "Do you think Grisella really meant to kill my mother?"

Annetta winced. "Surely she was just trying to scare her."

I shook my head. "I'm not sure Grisella herself would know the answer to that question."

We fell silent. A gusty, northern wind rattled the windowpanes. Alessandro held a tightly rolled bit of paper to the fire in the stove and lit the lamps to augment the waning afternoon light.

Crivelli tapped his silver-headed cane on the floor and attempted to lighten the mood. "I don't know about the rest

of you, but I would have given a year's salary to see Domenico Viviani's face when he realized he had a pint-sized Lucretia Borgia on his hands."

Alessandro answered with a weak smile. "Bondini described his master's reaction as equal parts of pride and amazement. Viviani never let a useful opportunity slip by, and if he ever had any moral principles, he set them on the shelf a long time ago. It must have fascinated him to find a kindred spirit in the unlikely guise of a thirteen-year-old girl. At first he tried to protect her by having his bravos warn Tito away from investigating. When his own situation became precarious, he simply scooped Grisella up and took her away with him."

Caterina joined my brother at the window and scanned the gray skies. "The weather is turning nasty. I'll soon have to set off for home. Just settle my curiosity on one more point, Tito. The people in this room know Grisella was responsible for my mother's death, but the rest of Venice believes Domenico Viviani was the killer."

"Yes, Tito. How did you manage to persuade Messer Grande to keep Grisella's name out of it?" asked Felice.

"That was the easiest part. Shifting the guilt to Viviani suited Messer Grande's purposes exactly. From the reports of his well-placed spies, he knew that the Albrimani have been gradually turning their interests from trade to politics and have quietly positioned themselves to gain prominent positions in the Republic. By next summer, they will have snared several Senate seats and at least one position on the Tribunal. Mateo Albrimani may well be our next Doge."

"I see," said Caterina. "The more crimes Messer Grande can heap on Viviani's head, the more favor he can curry with the Albrimani."

"Especially if he can use Bondini's knowledge of Viviani's Turkish strongholds to present the Albrimani with the nobleman's whereabouts," added Alessandro.

"Exactly," I said. "Messer Grande never believed that Felice poisoned Adelina, but he was willing to hand him over to the

Tribunal if he couldn't fix the blame on his chosen target. The chief's theory was similar to our own. He thought Viviani had arranged Adelina's death because she had found out about his treasonable activities. Holding Felice's impending execution over my head, he let me, and all of you who helped me...." I bowed to the assembled company as if acknowledging the Doge's box at the opera house. "He let us dig for the hidden truths."

"How did he know you and Alessandro had trailed Bondini to Bassano?" asked Felice.

"I was hoping no one would ask me that." I shrugged uncomfortably. "After Messer Grande gave me the deadline, he had me followed for several days. Then he found another way to keep tabs on our progress." I paused, struggling with embarrassment.

Annetta continued for me. "Leonora Veniero. She was making up to Tito to keep Messer Grande informed. We think her notoriously flagrant behavior must have finally attracted the Inquisitors' interest. Turning *confidente* would have allowed her to avoid any unpleasant consequences."

Alessandro cleared his throat at the window. "If anyone's interested, it's started to snow."

We crowded in behind him. It had been many years since I had seen a snowfall, and this was Felice's first, but the others were just as excited as we were. Despite his many winters, Crivelli's eyes were sparkling like a schoolboy's as he gathered his cloak and tricorne to assault the descending flakes. He gave his arm to Caterina and offered to see her back to her snug apartment on the Calle Stretta.

Felice lingered in the hallway and resisted Brother Mark's efforts to get him into his greatcoat so they could get back to the monastery for Christmas Eve services.

"What is it, Felice?" I finally asked.

He gave me a shaky smile, and I had a fleeting image of the gawky boy who had shown me to my place in the San Remo dormitory so many years ago.

"I'll never forget what you did for me, Tito."

"You would have done the same for me."

He squeezed my arm. "Even so, you are a true friend and you have my eternal thanks."

I walked Felice and the monk as far as the narrow *calle* that connects our square with the nearby canal and watched their tall figures disappear into the wavering curtains of falling snow.

A blanket of white lace was falling on the chimney pots and ironwork balconies of the Campo dei Polli, hiding the stains of everyday life and transforming our humble square into a stage set worthy of the greatest designer. Thoroughly chilled, I returned to our door and let myself into the warm hallway. The clanging of pots and pans told me Annetta was in the kitchen preparing Caterina's fish. In the sitting room, Alessandro had moved the *mandorlato* and spread a shipping map out on the round table. Inside a ring of yellow lamplight, he was deep in study. I sat down at the harpsichord. I didn't need a lamp. I simply let my hands rove where they willed, emptying my mind and filling our little house with the music of love and regret.

Glossary of Baroque Opera Terms

Abellimenti: Improvised ornamentation supplied by the performer, designed to enliven the original melody.

Cadenza: A concluding passage that allows the performer to exhibit his virtuoso skills.

Canzona: A songlike overture popular in Venetian opera.

Castrato: A male singer castrated before puberty to preserve a soprano or contralto voice. *Castrati* were known for an unusually wide range, great power, and a special timbre that listeners found fascinating. Also termed *evirato* or *musico*.

Deus ex machina: Theatrical device of lowering a god from above to resolve a tangled plot dilemma.

Libretto: The words spoken or sung during the opera. Most were taken from plays, novels, or poems. Audience members could buy a libretto to help them follow the action on stage.

Maestro: Title of respect for a teacher, composer, or conductor.

Opera seria: Main form of opera during the eighteenth century. Pageantry, classical heroes, and the gods of myth prevailed.

Prima donna: Principal female singer, generally a soprano.

Primo uomo: Principal male singer. In the eighteenth century, a *castrato* soprano.

Recitativo: Declamatory singing that describes the plot of an opera.

Virtuoso: Master singer.

Author's Note

Perhaps the greatest mystery concerning the *castrati* is what they actually sounded like. In the absence of recording devices, music is a fleeting art. A note is sounded, strikes the ear, and however glorious it may be, immediately dies. Contemporaries from the heyday of the *castrati* tantalize us with descriptions of vocal pyrotechnics that nearly defy belief, but the voices that drove those seventeenth and eighteenth-century listeners into a frenzy will never be recreated for the modern ear. Although singers who describe themselves as "endocrinologic *castrati*" exist today, the rigorous training and secrets of breath control that produced *virtuosi* like the great Farinelli have disappeared into history. For the reader wishing to learn more about these enchanting singers, Patrick Barbier's *The World of the Castrati* (Souvenir Press, 1998) is an excellent resource.

Happily, some baroque delights echo down the ages. One of the greatest pleasures of writing this book came in discovering that a new breed of countertenor has revitalized the production of some nearly forgotten operatic gems. The works that Tito sang never existed, but if the reader would like to share in a major source of inspiration for his fictional performances, I recommend Johann Adolf Hasse's *Cleofide* (William Christie, Capriccio, 1987). Countertenors Derek Lee Ragin, Dominique Visse, and Randall Wong hit gorgeous high notes and probably come as close to recreating the *castrato* voice as modern listeners

are likely to hear. Any recording by David Daniels or Andreas Scholl is also sure to delight fans of the high male voice.

I would like to thank the following people for helping me bring Tito and his world to life: My family, for their love and cheerful support through the years. My fellow members of Sisters in Crime-Ohio River Valley Chapter, for their ever-helpful criticism and encouragement. The staff of the Louisville Free Public Library, where I probably hold the record for inter-library loan requests. My agent Dan Hooker, for sticking with me through the rough patches. Lastly, Barbara Peters, Robert Rosenwald, and everyone at Poisoned Pen Press, for treating my words with such care.

To receive a free catalog of other Poisoned Pen Press titles, please contact us in one of the following ways:

Phone: 1-800-421-3976
Facsimile: 1-480-949-1707
Email: info@poisonedpenpress.com
Website: www.poisonedpenpress.com

Poisoned Pen Press
6962 E. First Ave. Ste 103
Scottsdale, AZ 85251